RETHINKING BORDERS

D0887936

Rethinking Borders

Edited by

John C. Welchman

University of Minnesota Press
Minneapolis

First published by Macmillan Press Ltd., 1996

Published simultaneously in the United States, 1996
by the University of Minnesota Press
111 Third Avenue South, Suite 290
Minneapolis, MN 55401–2520

Printed in Great Britain

Library of Congress Cataloging-in-Publication Data
Rethinking borders / [collected by] John C. Welchman.
p. cm.
With one exception the essays gathered here were first presented
in March 1993 at the International Symposium of the Ninth Biennale
of Sydney—CIP introd.
Includes bibliographical references and index.
ISBN 0–8166–2868–8 (hc). — ISBN 0–8166–2869–6 (pbk.)
1. Aesthetics—Congresses. I. Welchman, John C. II. Biennale of
Sydney (9th : 1993)
BH39.R36 1996
111'.85—dc20 95–45761
 CIP

The University of Minnesota is an
equal-opportunity educator and employer

Contents

List of Illustrations

Chapter 6

Chapter 7

Chapter 8

Response to Chapter 8

Acknowledgements

The editor makes grateful acknowledgement to Tony Bond (Artistic Director, 9th Biennale of Sydney) and the Board of Directors of the Biennale of Sydney for the context and their financial and organizational support of the symposium (in March 1993) that made this book possible.

Many other people contributed to the success of the event and I regret that not all of their efforts can be included here. Brenda Croft, Pam Hansford, Sarat Maharaj, David Bromfield, Dipesh Chakrabarty, Fay Brauer and speakers from the floor all participated in responses and debate. Their time and effort is greatly appreciated.

Thanks are due to John Brotherton, in Sydney, for his translation of Chapter 4 by Nelly Richard; and to Kate Haug, Liza Johnson, Graciela Ovejero and Chandon Reddy at the University of California, San Diego.

The Biennale of Sydney JOHN C. WELCHMAN

Notes on the Contributors

David Avalos is a Chicano from National City, who has lived and worked in the San Diego – Tijuana border region all his life. He was artist-in-residence at the Centro Cultural de la Raza 1978–88, and co-founder of the Border Art Workshop/Taller de Arte Fronterizo in 1984. Currently Professor of Visual Arts at California State University San Marcos, his work and writing was featured in the *La Frontera/The Border* exhibition, organized by the Centro Cultural de la Raza and the Museum of Contemporary Art, San Diego (1993–94).

Sue Best teachers feminist theory, aesthetics and contemporary art in the Department of Art History, University of Western Sydney, Nepean, where she is currently completing her doctorate on sexuality and space. Her recent and forthcoming publications include chapters in Catriona Moore (ed.), *Dissonance: Feminism and the Arts 1970–1990* (Sydney: Allen & Unwin, 1994); and Elizabeth Grosz and Elspeth Probyn (eds), *Sexy Bodies: Strange Carnalities of Feminism* (London: Routledge, 1995).

Beatriz Colomina teaches in the Department of Architecture at Princeton University. She edited the innovative anthology *Sexuality and Space* (Princeton, NJ: Princeton University Press, 1992).

Bracha Lichtenberg Ettinger is an artist and a psychoanalyst, based in Paris. Among her one-person exhibitions: The Israel Museum, Jerusalem (1995); Museum of Modern Art (MoMA), Oxford (1993); the Russian Museum of Ethnography, St Petersburg (1993) and the Centre Georges Pompidou, Paris (1987). She is the author of *Matrix et Le Voyage à Jerusalem de C.B.* (1991); *Time is the Breath of the Spirit* (conversation with Emmanuel Levinas), 1991–1993; *A Threshold Where We Are Afraid* (conversation with Edmond Jabès); and *Matrix. Halal(a) – Lapsus: Notes on Painting 1985–1992* (Oxford: MoMA, 1993).

Brian Massumi is Professor of Communications and Comparative Literature at McGill University, the translator of works by Gilles Deleuze and Félix Guattari, including *A Thousand Plateaus* (University

of Minnesota Press, 1987), and author of *A User's Guide to 'Capitalism and Schizophrenia': Deviations from Deleuze and Guattari* (Cambridge MA: MIT Press, 1992).

Charles Merewether is an art historian currently working at the Getty Center for the History of Art and the Humanities in Santa Monica, California. He contributed to the catalogue of the exhibition *Latin American Artists of the Twentieth Century* at MoMA, New York (1992), and his study of Ana Mendieta will be published by Rizzoli in 1995.

Celeste Olalquiaga's *Megalopolis: Contemporary Urban Sensibilities* was published in 1992 by the University of Minnesota Press. She has written for *Art & Text, Lusithania,* and the *Village Voice;* and for exhibition catalogues for the New Museum of Contemporary Art (NY), the Museum of Contemporary Art (Sydney), and Exit Art (NY). She currently teaches at the Cooper Union, New York.

Paul Patton is a Senior Lecturer in Philosophy at the University of Sydney. He has recently edited *Nietzsche, Feminism and Political Theory* (London: Routledge, 1993), and translated *Difference and Repetition* by Gilles Deleuze (New York: Columbia University Press, 1994).

Nelly Richard, based in Santiago, is one of South America's foremost cultural critics, known especially for her work in the unofficial culture which emerged in Chile after 1977. She is editorial director of the journal *Revista de Crítica Cultural* and author of *La Estratificación de los margenes: sobre arte, cultura e politica* (Santiago: Zegeres, 1989); and *Masculino – Femenino* (Santiago: Zegeres, 1993).

Trinh T. Minh-ha is a writer, filmmaker and composer. Her recent works include the films *Surname Viet Given Name Nam* (1989) and *Shoot for the Contents* (1991); and the books *Woman, Native, Other: writing, postcoloniality and feminism* (Bloomington: Indiana University Press, 1989); *When the Moon Waxes Red: representation, gender, and cultural politics* (New York: Routledge, 1991); and *Framer Framed* (New York: Routledge, 1992). She has taught at the Dakar Conservatory of Music (Senegal) as well as at Harvard, Cornell and San Francisco State universities in the USA. She is currently Professor in Women's Studies and Film at the University of California, Berkeley.

John C. Welchman teaches in the Visual Arts Department at the University of California, San Diego. He is co-author of *The Dada and Surrealist Word-Image* (Cambridge, MA: MIT Press/Los Angeles County Museum of Art, 1989), and author of *Modernism Relocated: Towards a Cultural Studies of Visual Modernity* (Sydney: Allen & Unwin, 1995). His study of naming and institutional space is forthcoming with Yale University Press.

Introduction

The eight essays and three responses collected in *Rethinking Borders* were commissioned from an exciting range of leading younger writers, artists and intellectuals whose work has raised significant questions about the border cultures in which we live and have traversed in the middle of the last decade of the twentieth century. The contributors (with one exception) came together for the International Symposium of the Ninth Biennale of Sydney in March 1993, where their papers were read, responded to and discussed. Revised versions of these papers are collected in the present volume.

The condition of borders has been crucial to many recent exhibitions, intellectual projects and conferences. But there does not yet exist a convincing critical frame for border discourse. *Rethinking Borders* attempts to outline such a introduction and to develop a context for the proliferation of 'border theories' and 'border practices' that have, as much as any other manifestation in the early 1990s, marked a new stage in the debates over postmodernism, cultural studies and postcolonialism.

Each of the discourses and practices represented here has negotiated its own positions in relation to the general issues that lie behind *Rethinking Borders*. The contributions take their place within the many horizons of border theory that have developed during the last two decades; but they do not set out to offer systematic summaries of the feedback between popular and high culture, of the new imaginations of visual (and other) space engendered by virtual technologies, of the emergence and of new subjects in postcolonial and ethnic studies, or of the renegotiations of gender, identity and sexuality taken on in recent feminisms and 'queer theory'. Many of the intensities of these new thresholds are taken up, but always in relation to a specific context, whether this be the renegotiation of immigrant identity, the cultural politics of visual practice in South America, or the strident delimitations of Le Corbusier's masculinist architectural modernism. Some contributors point to the conflictual empowerments of particular border spaces; others to the forfeitures and losses they can subtend. All engage provocatively with the social productivity of border conditions.

Rethinking Borders opens with a strikingly intense and poetic essay by Trinh T. Minh-ha. 'An Acoustic Journey' meditates on the conditions of migration and 'home-making', and on the experience of displacement, disempowerment and economic and linguistic homelessness that are staged in (and in between) the First and the 'other' worlds of the 1990s. She conjugates the social passions of the refugee and the resident, of the neighbourhood and the *barrio*, of the marginal and the centrist. Using moments from the writings of Maurice Blanchot, Julia Kristeva and Edward Said, and crossing them with fragments of Vietnamese poetry and Indian philosophies, Trinh T. Minh-ha weaves a parable of social becoming that refuses the violence and polarization which animate so much contemporary critical theory.

She thinks about the inseparability of home and exile in the migrant condition. She reinterprets marginality as a function of the centre. She reveals the potency as well as underlining the predicaments of 'hyphenated identity'. Finally she uses the visual, textual and aural intensities of painting, poetry (especially the haiku) and contemporary music as metaphors for a new becoming: one that is sensitive and alert, but one that is also powerfully aware of its own fragility and the mediations and exploitations that circulate around and even sustain it.

Can the West be tuned? This is a manifesto for taking back the cultural and political worlds from those who are blind and passive in the face of the differences which make up our reality.

In 'The Bleed: Where Body Meets Image', Brian Massumi elaborates a theoretical 'landscape' centred on the body-image of the 'half-actor', a figure that is symbolically encoded in the persona of Ronald Reagan. The chapter develops a close reading of Reagan's co-authored autobiography *Where's the Rest of Me?* The former president's performance as an amputee veteran in *King's Row* suggests a new form of virtual existence, a 'reality "short of" the actual'. This truncated reality produces a location of spatial and temporal disjunction within which the body is cut off from its image. The body is re-articulated and retechnologized in a process Massumi describes as *'making seeming being'*. He concludes that 'the appearing of the body without an image with Reaganism made the social field an annex of a leading quasicorporeality'.

The quasicorporeal body is a body punctured by its own boundaries, and reinscribed among its contexts with a knowing immateriality. The 'inbetweenness' of this body constructs politics as a

hallucination. It is the body's ghostlike negotiation between the supposed polarities of the Western corporeal tradition – subject/object, past/present, reality/virtuality, presence/absence – that renders the new inter-body so powerful, so frightening and so symbolic. Massumi's is a theoretical horror story rereading the recent political past. Reagan is its Frankenstein.

Paul Patton's response, 'Reagan and the Problem of the Actor', develops from Massumi's paper to offer a more historical survey of the debate of the role of the actor in its metaphorical mobilization by several Western philosophers (including Plato, Nietzsche, Deleuze and Guattari, and Derrida). Patton asks: 'Are we dealing here with a new form of technological realisation of the virtual body that has always "completed" the body politic?' Is the precarious border between the (bad) actor and the (good) politician only particular to a post-Vietnam War America, which left many bodies tragically 'incorporeal'?

Beatriz Colomina provocatively stakes out her opening 'Battle Lines' by disputing the binarisms which have conventionally articulated the relations between the 'inside' and an 'outside' and between 'private' and 'public' space. Like the other contributors to *Rethinking Borders* she is concerned to replace this primitive cartography with a more dynamic model of discursive interactivity that overturns the disputed 'reality' of these relationships.

She takes up the experience of violence, which has usually been consigned to a public-outside (as in the case of war), showing how 'externalist' theory makes other forms of violence, particularly the domestic violence carried on against women in the 'private' sphere, invisible, or irrelevant. As a figure for the interstitial, border space that forgets neither the inside nor the outside, Colomina considers the space of the balcony. She develops this border space as a new model that circulates from the 'inside' to the 'outside', and distinguishes it from the divisionist mentality that cordons off the spatial experience of everyday life. If the conventional border-producing experience is both a product and an effect of the media, Colomina proposes to challenge this understanding and to change the status of the wall.

These possibilities are developed in relation to an important but overlooked moment in architectural history produced in the encounter between the definitively famous modernist architect, Le Corbusier, and the conspicuously marginalized woman architect, Eileen Gray. The focus of their encounter is a building designed by

Gray, an architectural wonder called E.1027 ('a modern white house perched on the rocks, a hundred feet above the Mediterranean sea . . . in Roquebrune at Cap Martin'). Colomina's rereading is based on Le Corbusier's 'Graffiti-Mural' which he painted violently (without permission) on its walls.

The revisionism here points in several useful directions. It exposes the 'orientalist' phantasies of Le Corbusier (manifest in his obsessive depictions of Algerian women). It reveals his defacing and effacement of Gray's work and achievement, which participated in her erasure from architectural history (E.1027 is attributed both to Le Corbusier and to Jean Badovici, but rarely to its real architect). Finally, it points to the fact that Le Corbusier's architecture is 'depend[ent] in some way on specific techniques of occupying and gradually effacing the domestic space of the other'.

In a response to Beatriz Colomina's 'Battle Lines', Sue Best takes up some of Colomina's ideas and suggests how they might be recast for feminisms in general. 'Crossing the boundary is always breaching the boundary as Colomina indicates in her concluding pages . . . If this condition is generalizable in this fashion, and indeed I firmly believe it is, then violence is the basis.' Best claims that every intervention, including her own into the text of Colomina, is a form of appropriation, and a (necessary) violence. We must, claims Best, remain aware of our own 'critical complicity', so that while we might look across to scenes of 'violence, such as Le Corbusier's', we must remember 'to be included in the same critique'.

Best, then, figures the edge, the critical border, of transgressive discourse, suggesting its benefits and its limits for a feminist critique. There are no longer (and there never really were) any empty spaces, either physically or theoretically. There is the outline of a politics of intrusion here, incursions that are always bordering on, yet always bordering beyond.

In 'The Cultural Periphery and Postmodern Decentring: Latin America's Reconversion of Borders', Nelly Richard discusses the history of Latin America as a colonized space. She begins by outlining previous theoretical work (including the practice of cartography), and then sets out to demonstrate how these projects renarrate – in fact, translate – the multiple, heterogeneous, even illogical events within the historical formation of South America as singular, homogenous and logical. Richard goes on to deploy critical postmodern theories in order to disrupt and rework the centre/periphery models that have enabled and enacted such translations.

If we turn to the experience of the *Mestizaje*, for example, we witness the particular strategies that have been translated as the work of postmodernism: 'these present day crosses and appropriations tie back into the history of sycretism and hybridization which Latin America inherited from its colonial past: a true expert in the operations of cultural transvestism which today the aesthetics of *simulacrum* and of *fragmentation* rename as postmodernist operations'.

Richard reconfigures Latin America itself as a border, as a cultural periphery. The subcontinent is immersed in a Latin American space-time with its own 'situational specificity' that necessitates an 'irregular combination of uneven series which come to form part of an active *multiplicity* of conflictive temporalities'.

Celeste Olalquiaga's 'Vulture Culture' flaunts the spectre of non-western postmodern pop. She claims the popular cultural activities, icons and strategies she foregrounds as politically and socially empowered, even as they are released and circulated by the multiply transgressive conditions of 'international postmodernism'. Olalquiaga mobilizes the discrepancies and unevenness operative between various postmodern narratives, noting the occasional impossibility of changing or diverting discourses that are circulating faster than they can be dismantled. Postmodern theory, she believes, does in fact help to position the highly disparate cultural variables she takes up in her work: their 'introduction of simulation in the realm of representation has dethroned referentiality and its accompanying attributes of fixation and hierarchy from the court of reality'.

She notes further that 'the conflation of mainstream codes . . . with sub-cultures whose access to hegemony is hindered by a cultural marginality . . . produces a border-like persona that is the sum of the codes it chooses to use'. Olalquiaga's 'border-like persona' who is constantly borrowing/stealing from one cultural 'position' and transferring knowledge and objects to another, always establishes herself as 'other than'. It is in this sense that the persona is a 'border'. Yet the persona can be situated and displaced in many ways: on the same side of the border as the 'original icon'; at the parodic extremes of that cultural icon; or on the other side of the border, in this sense transporting the 'original icon' from one cultural 'real' to another.

Olalquiaga's work makes a striking contribution to the heterogeneous formation of a popular culture that is post-industrial, hyper-

capitalist and global, and yet is not simply 'Western' in origin, cir-
culation or reception. While Western popular culture is exported
and transferred in such as a way that it reinforces the geographical
borders between the 'West and the Rest', the mutated form that
Western popular culture takes on (or is given) in these *other* locales
(among Chinese Hong Kong pop artists or Venezuelan shoppers)
gives rise to counterfeits 'that tacitly acknowledge the iconic aspect
of their referents in a way that the West could not begin to discern
on its own'.

Like Olalquiaga, Charles Merewether discusses cultural objects
made in the Spanish-speaking Americas. His focus, however, is on
a number of visual artists (from Colombia and the Caribbean) who
have disputed the understanding of public space negotiated by
Western postmodernists. Following his discussion of the artist Ana
Mendieta, he locates a practice that violently exceeds the conditions
of colonial subjection as they have been theorized outside the colon-
ized world. Mendieta's work is focused through the abjection of
death and the contradictory 'liberations' of desire. It is articulated
through the 'second economies of the street', the expenditures of
prostitution and the ghastly dis-location of the brothel.

Works such as these force a new understanding of the effacement
of death and memory in one of the most violent and destructive
cultures in the world. Merewether reaches here for a reconcep-
tualization of non-western 'passional' practices that circulate around
the catastrophes, silences and horrors of authoritarian culture. This
is a cultural horror story from South America that answers to the
North American political horror story set out by Brian Massumi.

Christine Buci-Glucksmann describes Bracha Lichtenberg
Ettinger's 'border work' as moving 'to the point where non-places
and borderline situations replace the classical "places" of remem-
brance'. The images give rise to 'images of absence'. They create 'a
world of the beyond-the-visual, subjected to the constant double
violence of the sexual and of history, in a single attempt to destroy
bodies reduced to pieces, partial objects, or the infinite metaphor of
what has been or could have been' (p. 13).

In Lichtenberg Ettinger's terms this place is the 'matrixial' meet-
ing point between the I and the stranger in-side. She claims that one
of the conditions of 'modernity' figures the invention, if not quite
the necessity, of the 'nomad'. The nomad is characterized as one
who 'symbolizes a lack of roots, a non-relation to territories, a lack
of "borderlines".' The 'matrixial' then, is the location of a 'woman'

nomad. It is the blurring effects, the overlapping of images, the repetition of the visual border within and outside its own scene, the convergence of history, memory, and the past with the present, that calls for the dissimulation of identity into the beyond-the-phallus 'nomad'.

Rethinking Borders concludes with my study of 'The Philosophical Brothel', and a response by David Avalos. I review the implications of the return of understandings of the border as they have appeared metaphorically or thematically in recent critical theory, particularly (though not exclusively) in the theoretical formation of postmodernism.

The spread of ideas concerning the margin, the limit and the border has always been articulated in relation to historically specific conditions of reading, writing and producing. The border as returned to in the texts of recent critical theory is almost always *measured out* (explicitly or otherwise) against the social and political efforts of centralization achieved (and imposed) in the Enlightenment and its aftermath. One of the most consolidated enterprises of the Enlightenment *philosophes* was to proscribe and efficiently to broker the proper limits, edges and borders of the increasingly institutionalized nation state, and its political, social and intellectual structures.

Thus, from the Kantian articulation of a regime of legitimate moral, metaphysical and rational epistemological frames, which notably embraced his description of the work of art as a 'finality without end', to the deconstruction of the parameters of knowledge (and of the unitary *work*) by Jacques Derrida, the project of Western philosophy has consistently taken up the notation (and de-notation) of the boundary. Derrida, for example, poses it as the question 'of the frame, the limit between inside and outside . . . the *parergon*' (a 'supplement outside the work').

I go on to discuss a number of 'weak' and a number of potentially 'strong' theories of bordering and transgression. The work of Derrida and, differently, of Deleuze and Guattari seems to stand in between these two possibilities of border knowledge, sometimes partaking of the zoneless *bricolage* of much postmodernism, yet sometimes challenging the rigidities and closures of both modern and postmodern theory. In conclusion I discuss the ideas of Donna Haraway, Luce Irigaray and Homi Bhabha, which attempt to articulate the operative multiplicity of the borders in and across gender and race.

In 'Speaking from San Diego', the Chicano artist David Avalos provides the collection with a provocative conclusion taking on the social and political inscription of his own bordered place (San Diego-National City-Tijuana). Avalos speaks directly, and in a different voice, to the events, policies, cultures, experiences and readings which mark his region and his identities. But this end-piece is really another moment of beginning in the necessary project of *Rethinking Borders* in the age of NAFTA, of thinking them again (and again) for the next millennium.

1

An Acoustic Journey

Trinh T. Minh-ha

Every people felt threatened by a people without a country

(Jean Genet, *Prisoner of Love*)

In the current political and cultural landscape a crucial shift has
been emerging, and maturing: a shift in the (dis/re)articulation
of identity and difference. Such articulations remain informed by
an awareness of both the enabling and disenabling potentials of
the divisions *within* and *between* cultures. Constantly guarded, rein-
forced, destroyed, set up, and reclaimed, boundaries not only ex-
press the desire to free/to subject one practice, one culture, one
national community from/to another, but also expose the extent to
which cultures are products of the continuing struggle between
official and unofficial narratives: those largely circulated in favour
of the State and its policies of inclusion, incorporation and valida-
tion, as well as of exclusion, appropriation and dispossession. Yet
never has one been made to realize as poignantly as in these times
how thoroughly hybrid historical and cultural experiences are, or
how radically they evolve within apparently conflictual and incom-
patible domains, cutting across territorial and disciplinary borders,
defying policy-oriented rationales and resisting the simplifying action
of nationalist closures. The named 'other' is never to be found merely
over there and outside oneself, for it is always over here, between
Us, within Our discourse, that the 'other' becomes a nameable
reality. Thus, despite all the conscious attempts to purify and
exclude, cultures are far from being unitary, as they have always
owed their existence more to differences, hybridities and alien ele-
ments than they really care to acknowledge.

1

MIDWAY TO NOWHERE

As the twentieth century has been referred to as 'the century of refugees and prisoners', so the 1980s might well be termed the 'decade of refugees and the homeless masses'. No longer an extraordinary occurrence that requires a temporary solution, refugeeism has become a normative feature of our times. In 1945, the phenomenon was still mostly confined to Europe; today it is visible almost everywhere, including Africa, the Middle East, Latin America and Asia. Multi-faceted 'border wars' continue to be waged on an international scale, accompanied by an unavoidable hardening of frontiers, tightening of control, and multiplication of obstacles and aggressions at the borders themselves. A matter of life or death for many, the act of crossing overland and overseas to seek asylum in unknown territories is often carried out – especially in mass flight – as an escape alone, with no specific haven of refuge in mind. Thus, the creation of refugees remains bound to the historical forces and political events that precipitate it. It reflects a profound crisis in the policy of the major powers, the repercussions of which are made evident in the more specific, devastating crises of the millions of individuals directly affected. The myopic view that the refugee problem is Their problem and one on which Our taxpayers' money should not be wasted is no longer tenable. The tragedy of tidal waves of people driven from their homes by forces beyond their control keeps on repeating itself as victims of power re-alignments, cross-border hostilities and orgies of so-called 'ethnic cleansing' continue to grow to alarming proportions, and detention camps proliferate on the world map without gaining more than fitful, sporadic attention from the international community.

How does a journey start? What un/certainties compel one to take up, again, the by-now familiar question of 'Those Who Leave'; to depart (again) through the conditions of 'the Border', a 'place' so widely and readily referred to in the last few years that it already runs the risk of being reduced to yet another harmless catchword expropriated and popularized among progressive thinkers? To ask this question, here, is already to answer it. To speak about the concept of border-crossing as a major theme in contemporary cultural politics is, in a way, further to empty it, get rid of it, or else to let it drift; preventing it, thereby, from both settling down and being 'resettled'. One is bound through speaking and writing to assert one's ability to displace all attempts – including one's own – to

rehabilitate key concepts, for the politics of the word or the 'verbal struggle', as Mao called it, will never end. Words have always been used as weapons to assert order and to win political battles; yet, when their assertions are scrutinized, they reveal themselves, above all, as awkward posturings which tend to blot out the very reality they purport to convey. The listener or reader is then invited to engage in the vertiginous art of reading not so much between the lines as *between the words* themselves.

> *Whole nations don't become nomads by choice or because they can't keep still. We see them through the windows of aeroplanes or as we leaf through glossy magazines. The shiny pictures lend the camps an air of peace that diffuses itself through the whole cabin, whereas really they are just the discarded refuse of 'settled' nations. These, not knowing how to get rid of their 'liquid waste', discharge it into a valley or on to a hillside, preferably somewhere between the tropics and the equator . . . We oughtn't to have let their ornamental appearance per-suade us the tents were happy places. We shouldn't be taken in by sunny photographs. A gust of wind blew the canvas, the zinc and the corrugated iron all away, and I saw the misery plain.*[1]

The journey starts with the discomforting memory of the 'dis-carded refuse of settled nations' which Jean Genet evoked in his attempt to recapture the years he spent with Palestinian soldiers in Jordan and Lebanon. *Refuge, refugee, refuse* . . . Genet's writing of his travel across identities and his erotic encounter with the 'other' – or more specifically the Palestinians (previously it was the Algerians and the Black Panthers) – appeared in a volume titled *Un Captif amoureux*. Significantly enough, the 'accurate' English translation of this title would have to be found somewhere between 'prisoner of love' and 'prisoner in love', embracing the passive-active action of both capturing and loving. This movement back and forth between maintaining/creating borders and undoing/passing over borders characterizes Genet's relationship with writing as well as with the people to whom he was passionately committed from the late 1960s until his death in 1986. His suicidal scepticism (isn't every critical autobiographical writing a way of surviving suicidally?), deployed with subtle humour, not only translates itself in the refusal to ro-manticize a struggle, its setting and its people, but also in the way the writer positions himself within a 'we' who, as in the above passage, safely 'see them through the windows of aeroplanes' and on the pages of 'glossy magazines'.

Entry into or exit from refugee status is, in many ways, neither voluntary nor simply involuntary. *I saw the misery plain.* In the past, attempts to reclassify this 'liquid waste' have always been carried out according to the interests of the settled nations involved. As in the case of the Boat People, the historical and official adaptation of such terms as 'displaced person,' 'illegal immigrant' or 'voluntary immigrant' – rather than 'refugee' – proved to be a useful device through which the host society could either endorse arguments by those at home who opposed giving entry to the influx of unwanted aliens, or deny the problem of refugees by hastily declaring them 'resettled', and hence equivalent to voluntary migrants. It seems adequate to say, therefore, that the resistance of many refugees to their being reclassified in a 'voluntary' category was not a resistance merely to the termination of direct assistance (as was often asserted among researchers and social workers), but rather to the denial of the state of indeterminateness and of indefinite unsettlement that characterizes the refugee's mode of survival. Here, refugeeism differs from voluntary immigration in that it does not have a *future* orientation (the utopia of material, social or religious *betterment*). Official re-labelling in this instance primarily means deciding who is worthy of humanitarian assistance from the international community, and who is not. Again, what seems constantly to be at stake is the problem of identification and of 'alignment' in the wider (religious, ideological, cultural, as well as class-, race-, and gender-determined) senses of the term. *Refuse.* Which side? But above all, which boundaries? Where does one place one's loyalties? How does one identify oneself?

> *As you walk or drive through the refugee camps, one phenomenon noticed after a while is the constant movement within the camps . . . the strolling seemed endless and the constant patternless flux of this tide of humanity was lulling, nearly hypnotic to watch.*[2]

Of the many movements of flight and migration witnessed across international borders, it was noted (somewhat patronizingly) that: 'The story of the Indochina refugees is the story of people *refused* – refused first and most painfully by their own governments, refused too often by neighboring countries where they sought temporary asylum and refused, initially at least, by the West and Japan, the only nations with the capacity and the heart to save them.'[3] Although feelings of gratitude for participation in a process of successful readjustment are never missing among Those Who Leave,

the 'midway to nowhere' malaise of the transit and camp period does not in any sense come to an end with resettlement. (The expression 'midway to nowhere' was used to characterize the transit situation of the Vietnamese refugees before they became immigrants in a specific country).[4] To the accusation that refugees are a burden to taxpayers, the dutiful response obtained among the 'unwelcomed guests' has been, faithfully enough, that: 'Most refugees have only one hope: "to have a job and become a tax payer"'.[5] Without endorsing the ostracizing connotations of a psychiatric diagnosis, such as the 'displacement syndrome' associated with psychological disorders among refugees, one can further state that this specific but elusive form of surviving is not a transitional malaise limited to 'long-stayers' (refugees whose prolonged stay in the camp – five to six years, or more – has often led to a situation of deteriorating morale).

The long-stayers' agonizing bind between *waiting* in uncertainty for the unknown and longing with fear for *returning* home continues to be experienced, albeit in different forms, even by those happily 'resettled'. A well-known example is that of the Hmong people among whom a 'sudden death syndrome' was said to prevail: a person, regardless of age or state of health, dies a sudden death during his or her sleep at night, without any apparent reason. Since the phenomenon could not be explained in medical terms, despite the autopsies that were carried out, the phenomenon has remained unnegotiable to Western science, and was unfailingly spoken about in the press as one of those mysterious, inscrutable phenomena of the Orient. Considered to be a reaction to the stress of both displacement and integration, this death-during-sleep is understood among the Vietnamese as the outcome of acute sadness: *buon thoi ruot*, or sad to the extent that one's bowels rot, as a common Vietnamese expression goes. A slightly different interpretation of the same phenomenon exists, however, among the Hmong, who say that the soul has taken flight during dreamtime and has here embarked on: a no-return journey.

YOU ARE THE BATTLEGROUND

They knew just how to keep us in our place. And the logic was breathtakingly simple: If you win, you lose.

(Henry Louis Gates, Jr, *Loose Canons*)

From one category, one label, to another, the only way to survive
is to refuse. Refuse to become an integratable element. Refuse to
allow names arrived at transitionally to become stabilized. In other
words, refuse to take for granted the naming process. To this end,
the intervals between *refuge* and *refuse*, *refused* and *refuse*, or even
more importantly between *refuse* and *refuse* itself, are constantly
played out. If, despite their relation, noun and verb inhabit the two
very different and well-located worlds of designated and designa-
tor, the space in between them remains a surreptitious site of move-
ment and passage whose open, communal character makes exclusive
belonging and long-term residence undesirable, if not impossible.
Passage: the state of metamorphosis; the conversion of water into
steam; the alteration of an entire musical framework. Intervals-as-
passage-spaces pass further into one another, interacting radically
among themselves and communicating on a plane different to the
one where the 'actions' of a scenario are explicitly situated. In inten-
sity and *resonance* (more than in distance actually covered), the jour-
ney here continues.

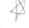

> *. . . caught in the crossfire between camps*
> *while carrying all five races on your back*
> *not knowing which side to turn to, run from;*
>
> *. . . In the Borderlands*
> *you are the battleground*
> *where enemies are kin to each other;*
> *you are at home, a stranger,*
> *the border disputes have been settled*
> *the volley of shots have shattered the truce*
> *you are wounded, lost in action*
> *dead, fighting back;*
>
> *. . . To survive the Borderlands*
> *you must live sin fronteras*
> *be a crossroads.*[6]

'Never does one feel as solitary as when fleeing in the midst of
millions', a refugee once said. A solitude born in/with the multi-
tude is a solitude that remains potentially populous: utterly sin-
gular and yet collective, always crowded with other solitudes.
By refusing to partake in categories of both the Refused and the
Integrated, even while refusing and integrating, it may seem that

one gives oneself no place on which to stand, nowhere to head for. But to resort here – whether positively or negatively – to the popularized 'infinite shifting of the signifier' (often equated with the endless sliding/slurring of liberal-pluralist discourse) is merely to borrow a ready-made, an all-too-dwelled-on expression, that is bound to lose its relevance when irrelevantly used. Raising the doubt, however, invites contribution to the current struggle around positionalities (identities and differences); a struggle which, by its unsettling controversies, has at times been referred to as 'the war of position' in cultural politics. *You are the battleground/where enemies are kin to each other.*

Much has been written in the last few years about the totalizing nature of the logics of borders and of warring essences. Yet the questioning of oppositional stances that aim exclusively at reversing existing power relations is constantly at work among marginalized groups themselves. What has been 'a necessary fiction' to allow for the emergence of counter-narratives by second-class citizens seems to be no more and no less than a strategy in the complex fight for and against 'authorized marginality'. As Stuart Hall puts it, 'Once you enter the politics of the end of the essential black subject you are plunged headlong into the maelstrom of a continuously contingent, unguaranteed, political argument and debate: a critical politics, a politics of criticism.'[7] For many members of long-silenced cultures, if the claim to the rights of (self-)representation has been in some ways empowering, the shift to the politics of representation proves to be still more liberating, for what is renounced is simply an exclusive form of fictionalizing: namely, the habit of asserting/assigning identity by staking out one's/the other's territory, Africanizing the African, or Orientalizing the Oriental, for example, and reproducing thereby the confine-and-conquer pattern of dominance dear to the classic imperial quest.

Permanent unsettlement within and between cultures is here coupled with the instability of the word, whose old and new meanings continue to graft onto each other, engaged in a mutually transformative process that displaces, rather than simply denies, the traces of previous graftings. *You are at home, a stranger.* In the historical context of ethnic discrimination and devalorization, the re-appropriation of a negative label as an oppositional stance in cultural politics often functions as a means both to remind and to get rid of the label's derogatory connotations. At best, such a stance makes use of existing boundaries only to counter-politicize them,

leading thereby to a concurrent tightening and loosening of pre-established limits. *You are wounded, lost in action/dead, fighting back.* The question as to when one should 'mark' oneself (in terms of ethnicity, age, class, gender, or sexuality, for example), and when one should adamantly refuse such markings, continues to be a challenge. For answers to this query remain bound to the specific location, context, circumstance, and history of the subject at a given moment. Here, positionings are radically transitional and mobile. They constitute the necessary but arbitrary closures that make po-litical actions and cultural practices possible.

The difficulties faced in the struggle around positionalities can also be found in the current, conflicted, debate over political repre-sentation between members of marginalized and centralized cul-tures. As has been pointed out, political criticism usually works by demonstrating what a text *could* mean (the possibilities in the pro-duction of meaning) while insinuating what a text *does* mean (the issue of its reception and political effectivity).[8] Thus, discussions of the 'politics of *interpretation*' often turn out to be complex, indirect interpretations of the 'politics of *interpreters.*' Uneasiness in 'trading on this ambiguity' has been repeatedly voiced by members on both sides; but, with the critical work effected in cultural politics, it has become more and more difficult to approach a subject by asking 'what', or even 'how', without also asking 'who', 'when', and 'where'? Power has always arrogated the right to mark its others, while going about unmarked itself. Within an economy of move-ment, the dominant self, the 'universal subject', represents himself as flexible, explorative, 'uncoloured' and unbounded in his moves, while those caught in the margin of non-movement are represented as 'coloured', authentic: that is, uncomplicatedly locatable and custom-bound. Always eager to demarcate the other's limits, We only set up frontiers *for ourselves* when Our interest is at stake.

While for many members of dominant groups, designating one's white ethnicity (to mention only one positioning) still appears largely 'useless' and 'redundant'; for members of marginalized groups, signalling one's non-white ethnicity remains as questionable, or even as objectionable, as denying it. *If you win, you lose.* When multiculturalism and cultural diversity (as defined by the West's liberal tradition) become sanctioned, the danger faced, predictably enough, is that of control and containment. Authorized marginality means that the production of 'difference' can be supervised, hence recuperated, neutralized and depoliticized. Unless they 'force' their

entry, therefore, marginalized 'interpreters' are permitted into the Establishment only so long as the difference they offer proves to be locatable and evaluable within the ruling norms. As Henry Louis Gates disarmingly puts it: 'Once scorned, now exalted ... It takes all the fun out of being oppositional when someone hands you a script and says, "Be oppositional, please – you look so cute when you're angry."' (see fig. 2)[9]

Reflecting on the Black Panthers of the late 1960s, Jean Genet offered another view of the movement that further contributes to this discussion of the politics of representation. Like the Palestinian people, the African American people, as Genet saw it, are without land and have no territory of their own. Since 'land is the necessary basis for nationhood', it provides a place from which war can be fought and to which warriors can retreat. Being able neither to take refuge from, nor to stage a revolt in, the ghetto, nor, again, to march out from the ghetto to do battle on white territory – all American territory being under White Americans' control – the war the Panthers waged would have to 'take place elsewhere and by other means: in people's consciences'. Thus, the Black Panthers' first line of attack was launched by sight, by effecting visible changes in the way they saw themselves (hence in the way other people saw them). Metamorphosing the Black community while undergoing a metamorphosis in themselves, they emerged from non-visibility into extra-visibility. Not only did they build an unforgettable image of their own people ('Black is Beautiful'), they also brought to consciousness the link between every people that had ever been oppressed and robbed of its history and its legends ('All Power to the People'). Their strategy of war was to re-affirm and to push to ever greater *excess* their African identity, and their weapons may be said to consist of leather jackets, revolutionary hair-dos and *words* delivered in a 'gentle but menacing tone'. Despite the fact that they were heading for death or prison, the change they brought about with their metamorphosis made the Black struggle 'not only visible, but crystal clear'. The dramatic image deliberately created 'was a theater both for enacting a tragedy and for stamping it out – a bitter tragedy about themselves, a bitter tragedy for the Whites. They aimed to project their image in the press and on the screen until the Whites were haunted by it. And they succeeded.' In the end, 'the Panthers can be said to have overcome through poetry'.[10]

They won by losing, and they lost by winning. The forceful rejection of marginality thrives here on a vital attraction to marginality.

The conflict is only in name. 'The black words on the white American page are sometimes crossed out or erased. The best disappear, but it's they that make the poem, or rather the poem of the poem.'[11] Words and images can be starting points for actions; together they form memory and history. The powerful image wrested from the reality of despair continues to live on beyond the individuals who created it. But, with no programme to aim for, the movement quickly wore out; the spectacle of Blackness always ran the risk of being consumed as (colourful) *spectacle*. According to Martin Luther King, the slogans, which enchanted both Black and White youths, were necessary rallying cries for Black identity.[12] But above all, they were painful, reactive attempts to romanticize a cry of disappointment through the advocacy of an impossible separatism. For Genet, 'Power to the People' soon came to be a thoughtless habit, and, despite its seductive power, the Panthers' flashy image was too quickly accepted and 'too easily deciphered to last'.[13] But if, in his moments of reflexive speculation, Genet saw the Panthers as 'flamboyant youngsters' who 'were frauds', and their spectacle as 'mere figment', he also openly recognized that his 'whole life was made up of unimportant trifles cleverly blown up into acts of daring'.[14] (Genet's own tumultuous life and gay identity have been made a spectacle both in his own work and in the works of other well-known writers such as Sartre and Cocteau.) The awareness of his being 'a natural sham', invited to go first with the Panthers, and then with Palestinian soldiers to spend time 'in Palestine, in other words *in a fiction*', compelled him to go on playing the role of 'a dreamer inside a dream', or more acutely, of 'a European saying to a dream, "You are a dream – don't wake the sleeper!"'[15]

Nations and fictions. A man who spent his life drifting as an outcast from shore to shore, who explicitly refused to identify himself with the country of his birth, and whose metamorphosis had turned him into a stranger at home (France and the West having become 'utterly exotic' to his eyes), decided to engage all his energies in supporting the political dreams/realities of marginalized and dispossessed peoples. This is hardly surprising. *The soul has taken flight during dreamtime and has embarked on a no-return journey.* Yet he who persistently rejected any homeland, found himself paradoxically attracted to those (here the Palestinian people) who long for a territory of their own and whose ongoing struggle centres on an unswerving claim to the homeland from which they were driven. A claim? Perhaps the word again serves to block out another reality,

for longing here is also specifically refusing to be 'resettled.' In fact 'home', in itself, has no fixed territory: depending on the context in which it appears, it can convey the concept of settlement *or* unsettlement. The refusal to move from 'tents to huts' is a refusal to let oneself be duped into moving not only from one form of dispossession to another, but also from a mode of transitional dwelling or of resistance, to a mode of fixed dwelling or of compliance. Better service, better control.

But, the paradox, if any, is only in name. What made Genet draw the line – a line that matters here and now – and take up a position by the side of the dispossessed was not so much the voice of justice in its logic of naming, as the emotions it conveyed, or, better, its musical accuracy: '*I had greeted the revolt as a musical ear recognizes a right note.*'[16] Thus, despite his affectionate support of the Black Panther movement and passionate commitment to the Palestinian resistance, Genet can be said to have written *lovingly*: he wrote not merely to praise, but, more, to expose. To expose both the reality under 'the canvas, the zinc and the corrugated iron', and the acute consciousness of himself as not quite belonging ('a pink and white presence among them'), 'attracted but not blinded', crossing but only to *return*, standing perpetually *at the border*, trying not to pass for one of them nor to speak on their behalf. '*Justice at its best is love correcting everything that stands against love*' (Martin Luther King).[17] So goes the story of this dreamer whose fourteen years of commitment to the revolution were haunted by the memory of a little house in Irbid where he had spent one single night with a Palestinian soldier and his mother: 'An old man traveling from country to country, as much ejected by the one he was in as attracted by the others he was going to, rejecting the repose that comes from even modest property, was amazed by the collapse that took place in him . . . after a very long time, when he thought he'd really divested himself of all possessions, he was suddenly invaded, one can only wonder via what orifice, by a desire for a house, a solid fixed place, an enclosed orchard. Almost in one night he found himself carrying inside him a place of his own'.[18]

A MATTER OF TUNING

Meter is dogmatic, but rhythm is critical

(Gilles Deleuze and Félix Guattari, *A Thousand Plateaux*)

> *. . . like indians*
> *dykes have fewer and fewer*
> *someplace elses to go*
> *so it gets important*
> *to know*
> *about ideas and*
> *to remember or uncover*
> *the past*
> *and how the people*
> *traveled*
> *all the while remembering*
> *the idea they had*
> *about who they were*
> *indians, like dykes*
> *do it all the time*
>
> *. . . we never go away*
> *even if we're always*
> *leaving*
> *because the only home*
> *is each other*
> *they've occupied all*
> *the rest*
> *colonized it; an*
> *idea about ourselves is all*
> *we own*

(Paula Gunn Allen, *Some Like Indians Endure*)[19]

Living at the borders means that one constantly threads the fine line between positioning and de-positioning. The fragile nature of the intervals in which one thrives requires that, as a mediator-creator, one always travels transculturally while engaging in the local 'habitus' (collective practices that link habit with inhabitance) of one's immediate concern. A further challenge faced is that of assuming: assuming the presence of a no-presence, and vice versa. One's alertness to the complexities of a specific situation is always solicited as one can only effect a move by acknowledging, without occupying the centre, one's location(s) in the process of engendering meaning. Even when made visible and audible, such locations do not necessarily function as a means to *install* a (formerly denied or unexpressed) subjectivity. To the contrary, their inscription in

the process tends, above all, to disturb one's sense of identity. How to negotiate, for example, the line that allows one to commit oneself entirely to a cause and yet not quite belong to it? Or, to fare both as a foreigner on foreign land and as a stranger at home? *Be a crossroads.* Amazed by the collapse that is perpetually taking place in oneself (to adapt Genet's words), one sees oneself in constant metamorphosis, as if driven by the motion of change to places so profoundly hybrid as to exceed one's own imagination. Here, the space of representation itself also, and necessarily, becomes a 'content' in the emergence of 'form'.

For Gloria Anzaldua life in the Borderlands has been equated with *intimate terrorism*: 'Woman does not feel safe when her own culture, and white culture are critical of her.'[20] She has to confront both those who have alienated her and those for whom she remains the perennial 'alien.' Terrorized by the wounds they/she inflict/s on her/self, she is likely to assume at least two exiles (external and internal), if she is to live life on her own. I am a turtle, wherever I go I carry 'home' on my back . . . though 'home' permeates every sinew and cartilage in my body, I too am afraid of going home. Though I'll defend my race and culture . . . I abhor some of my culture's ways, how it cripples its women, *como burras*, our strengths used against us, lowly *burras* bearing humility with dignity.[21] *They have occupied all/the rest.* Unable simply to return home to her mother culture where she has been injured as *woman*, nor to settle down on the other side of the border (in the lost homeland, *El Otro Mexico*) as *alien* in the dominant culture, she thus sets about to divest (their) terrorism of its violently anti-feminist, anti-lesbian, anti-coloured legacy. *The only home/is each other.* She 'surrenders all notion of safety, of the familiar . . . [and] becomes a *nahual*, able to transform herself into a tree, a coyote, into another person'. Taking the plunge, she puts in motion a new *mestiza* culture based on an emerging 'racial, ideological, cultural and biological cross-pollinization, an "alien" consciousness, *una concienca de mujer* . . . a consciousness of the Borderlands'.[22] June Jordan writes:

as a Black feminist I ask myself and anyone who would call me sister, Where is the love?[23]

Love, hatred, attraction, repulsion, suspension: all are music. The wider one's outlook on life, it is said, the greater one's musical hearing ability. The more displacements one has gone through, the

more music one can listen to. Appeal is a question of vibration. Was
it Novalis who said that 'every illness is a musical problem'? Isn't
it by the help of vibrations, often through the power of the word
and the touch, that illnesses can be cured? For, in many parts of the
world, music is not an art. It is a language and, for an attuned ear,
the first language. One finds music in listening. In moments of
isolation, alone with oneself or with nature. In moments of collec-
tive tuning, in the midst of a crowd or while working with a com-
munal issue. *We never go away/even if we're always/ leaving.* 'Meeting
across difference always requires mutual stretching', wrote Audre
Lorde, 'and until you *can* hear me as a Black Lesbian feminist, our
strengths will not be truly available to each other as Black
women . . . I am a Black Lesbian, and I *am* your sister.'[24] A dive of
the self into the self and out, unmeasured and unchartered, often
leads to the realization that one does not in/un-habit one unitary,
or two contradictory worlds. Some of us live only in a world exter-
nal to ourselves, so that when we speak, we only speak *out*; when
we point, we point to the world out there; from a largely unques-
tioned place of subjectivity. Others among us think we live in two
contrasting (East–West) worlds, and when we speak, we speak
within binary systems of thought. The 'other' is thus always located
outside Us. When incorporated, it can only be recognized if it stands
in opposition to the known and the familiar. But the dive up and
down within self-set boundaries leads nowhere, unless self-set de-
vices to cross them are also at work. Moving from flight to flight,
more of us have come to see, not only that we live in many worlds
at the same time, but also that these worlds are, in fact, all in the
same place: the place each one of us is here and now.

In Asian cultures, it is commonly said that one should not receive
a word by hearing it only with one's ears, when one can also de-
velop the ability to receive the same word with one's mind and
heart. Caught in a shifting framework of articulation, words and
concepts undergo a transformative process where they continue to
resonate upon each other on many planes at once, exceeding the
limit of some imagined, singular, plane where all the 'actions' are
supposed to be carried out. To develop the ability to receive with
more than one's eyes or ears is to expand that part of oneself which
is receptive but can remain atrophied, almost closed, when its po-
tential lies dormant. For even though everyone is endowed with
such a potential, almost no one is 'naturally' tuned to this pitch
of acute intensity where music, flowing both outside and within

ourselves, defines all activities of life. Wrote a thinker of the West: the faculty of being 'receptive', 'passive', is a precondition of freedom: it is the ability to see things in their own right, to experience the joy enclosed in them, the erotic energy of nature . . . This receptivity is itself the soil of creation: it is opposed, not to productivity, but to *destructive* productivity.[25] *Meeting and parting at crossroads, we each walk our own path.*

Receptivity is a two-way movement. To be receptive, one has to turn oneself into a responsive mould. The simultaneously passive–active process enables one to be tuned by one's changing environment, while also developing the ability to tune oneself independently of any environment. Music, here, is both what makes creation possible and the means of receiving it. *How the people/ traveled/ all the while remembering/ the idea they had/ about who they were.* In the Chinese Yin and Yang principle, such movements of receptivity are nothing other than the fundamental movement of inhalation and exhalation that sets into motion and sustains all of life. Also called the Two *Ch'i* or the Breaths of Heaven and Earth, the Yin and Yang concept is one in which, significantly enough, the two motions inward and outward, or upward and downward, are actually understood as one and the same motion. Thus, Two does not necessarily imply separateness, for it is never really equated with duality, and One does not necessarily exclude multiplicity, for it never expresses itself in one single form, or in uniformity. The perpetual motion of life and death is represented with acuity in the emblem of the disk of the *T'ai Chi*. Here, the Yin and Yang are visually reproduced in the light and dark halves of the circle and, notably, these are not divided by a straight line, but by a curve, whose S-shape ingeniously depicts the constant ebb and flow, or rhythmic alternation, the forward/renewed and backward/decline movement, that regulates the fabric of life down to its smallest details. It stands for the active and passive, masculine and feminine, positive and negative forces found, for example, in mountain and water, sun and moon, South and North, motion and rest, advance and return. And the naming can go on, multiplied a thousandfold (see fig. 3).

Refuse. Return. Resonance sets into motion and sustains all creative processes. It makes all the *difference*. As John Cage used to say, poetry is not prose simply because it is formalized differently, or because of its content and ambiguity, but rather, because it allows 'musical elements (time, sound) to be introduced into the world of words'.[26] The inhaling and exhaling is the work of rhythm, or of

Breath, manifested as voice, sound, word: whether audible or silent, spoken or written, outside or within. And rhythm is what lies in between night and day and makes possible their process of alternation in alterity. Thanks to the rhythm of the heart, mind, body and soul can be poetically tuned. The effect of music is to solicit a situation of perpetual inter-tuning, in which the rhythm of another person is constantly adopted and transformed while the person untunes him/herself to vibrate *into* the music that is being performed. What attracts a listener to a music is, above all, rhythm and resonance in the making. How it comes and goes, leaving its marks, changing the course of things, and resonating intensely in the listener at times when it is least expected. Rhythm is then always vital, for it always departs from metre and measure to link those critical moments of passage when things unfold while in metamorphosis, and when the process of tuning oneself consists in finding not only the transitional pitch necessitated at a given moment – *motion* – but also one's own (many-and/in-one-) pitch – *rest*. The struggle of positionalities may in the end be said to depend upon the accurate tuning of one's many selves. *Where is the love?*

A finale. Although he dressed, behaved and lived like a Buddhist priest, the Japanese poet Matsuo Basho likened himself to something best named 'bat', being, as he put it, 'neither priest nor layman, bird nor rat, but something in between'.[27]

Notes

1. Jean Genet, *Prisoner of Love*, trans. B. Bray (Hanover and London: Wesleyan University Press, 1992), p. 12.
2. This is a comment on the Vietnamese camps by Chuman, RAFU Shimpo, 21 May, 1975. Quoted William T. Liu, Marganne Lamanna, Alice Muratain *Transition to Nowhere: Vietnamese Refugees in America* (Nashville, TN: Charter House P, 1979), p. 102.
3. Barry Wain, *The Refused: The Agony of the Indochina Refugees* (New York: Simon & Schuster, 1981), p. 10 (my emphasis).
4. See E.F. Kunz, 'The Refugee in Flight: Kinetic Models and Forms of Displacement', *International Migration Review*, no. 7 (1973), pp. 125–46.
5. Nguyen Thi Trau, quoted in Liu *et al.*, *Transition to Nowhere*, p. 170.
6. Gloria Anzaldua, *Borderlands/La Frontera: The New Mestiza* (San Francisco: Aunt Lute, 1987), pp. 194–5.
7. Stuart Hall, 'New Ethnicities', *ICA Documents*, no. 7 (on Black Film British Cinema), London, 1988, p. 28.

8. Henry Louis Gates, Jr, *Loose Canons* (New York: Oxford University Press, 1992), p. 183.
9. Ibid, p. 185.
10. Jean Genet, *Prisoner of Love*, pp. 47, 83–4, 86.
11. Ibid, p. 218.
12. See Martin Luther King, Jr, *Where Do We Go From Here: Chaos or Community?* (New York: Bantam, 1968).
13. Genet, *Prisoner of Love*, p. 42.
14. Ibid, pp. 258, 148.
15. Ibid, p. 149 (my emphasis).
16. Ibid, p. 7.
17. King, *Where Do We Go From Here?*, p. 43.
18. Genet, *Prisoner of Love*, pp. 318–19.
19. In Gloria Anzaldua (ed.), *Making Faces, Making Soul: Haciendo Caras* (San Francisco: Aunt Lute F, 1990), pp. 300–1.
20. Anzaldua, *Borderlands/La Frontera*, p. 20.
21. Ibid, p. 21.
22. Ibid, pp. 83, 77.
23. June Jordan, 'Where Is The Love?' in Anzaldua, *Making Faces*, p. 174.
24. Audre Lorde, 'I Am Your Sister: Black Women Organizing Across Sexualities', in ibid, pp. 321, 325.
25. Herbert Marcuse, *Counter-revolution and Revolt* (Boston, MA: Beacon Press, 1972), p. 74.
26. John Cage, *Silence* (Middletown, CT: Wesleyan University Press), p. x.
27. Matsuo Basho, quoted in Ryusaku Tsunoda *et al.* (eds), *Sources of Japanese Tradition* (New York: Columbia University Press, 1958; reprinted 1965), p. 456.

Books
415 826-1300

2

The Bleed: Where Body Meets Image

Brian Massumi

Scenario

PASSAGE PRECEDES POSITION

The Bleed

It is 1937. The future president of the USA is beginning his first acting job. 'There I was', confesses Ronald Reagan,

> faced with my nemesis, reading. It isn't that I flubbed the words, or stumbled and mispronounced; I even placed the emphasis on the right syllable. I just lack personality when I read . . . The second day I was introduced to the rushes. This is the custom of going at the end of each day's work and seeing on the screen what you shot the previous day. What a shock it was!

Fast-forward, mid-paragraph, to 1965, the writing present of the now experienced actor on the cusp of a spectacularly improbable political career. Poised for the campaign for the governorship of California that was to set him on the road to the White House, and apparently no more comfortable with writing than reading, he is co-authoring his first autobiography. One of its primary functions is to explain how half a lifetime as a bad actor actually qualified him for high office, contrary to the misguided public perception that the roles of entertainer and governor were fundamentally incompatible. He couches his explanation in terms of a shocking deficiency in movie acting that can only be overcome in the public arena.

> It has taken me many years to get used to seeing myself as others see me, and also seeing myself instead of my mental picture of

18

the character I'm playing. First of all, very few of us ever see ourselves except as we look directly at ourselves in a mirror. Thus we don't know how we look from behind, from the side, walking, standing, moving normally through a room. It's quite a jolt. Second is the fact that when you read a story you create a mental picture of each character. For the first few years this is true even in reading a script. You don't see yourself because you haven't had much experience in seeing yourself. Thus as you act the part, in your mind you envision your mental picture of the author's character. You go to the rushes and somebody has stolen that heroic figure, and there you are – just plain old everyday you – up on the screen. It's one hell of a letdown. (pp. 78–9)

This deceptively complex statement does not condemn acting wholesale, for example, on the familiar religious or realist-humanist grounds that it traffics in fakery, substituting appearance for reality. In fact, it implies that there is power in acting, which is faulted not for the kind of process it sets in motion but rather for its inability to take that process far enough to realize the power inherent in it. The process in question is seeing: a seeing of *oneself*, specifically, a seeing of oneself *as others see one*. The problem with acting isn't that it carries the actor out of himself, out of his character into another, out of his real self into a false double; it is that it doesn't take the actor *far enough* outside himself. The movie actor's success hinges on his ability to see himself as others see him, but this is circumvented by what Reagan calls 'mental pictures.' These are private images the actor forms of the character he is portraying, developed from the script. The actor makes words into images, visualizes text, then renders that visualization public by embodying it before the camera. Watching the rushes is a jolt for Reagan *precisely because he recognizes himself* on the screen. 'There you are – just plain old everyday you'.

That Reagan should be jolted by this is jolting. As he sits in the screening room watching the day's shoot, he is seeing himself exactly as the director and his fellow actors simultaneously see him, and as the public will later see him. He is indeed seeing himself as others see him. So what's the problem? And who did he expect to see on the screen, if not himself? And if seeing a film of himself embodying a visualized text is seeing his plain old everyday self, does that mean that in everyday life he is an actor following a script (See fig. 4)?

What is clear is that Reagan is not concerned with the difference between reality and appearance. He seems to be speaking of two orders of reality, both of which are composed of appearance, understood more in a performative than epistemological sense. The relevant distinction is not between reality and appearance, true and false, acting and not acting, seeing and not seeing oneself as others see one. The pertinent criterion of evaluation is ontological, and cuts across those registers. It bears on the completeness of an appearance, which it locates on a scale of intensity, as a higher- or lower-degree reality.

The plain old everyday self is an actor playing an ordinary role in the ordinary way. Reagan defines that as mirror-like. Mirror-vision is by definition partial. There is a single axis of sight. You see yourself from one angle at a time, and never effectively in movement. If you keep your head motionless and your eyes level, you can see parts of yourself move, for example your arms, from one perspective. You can change perspective by immobilizing your body and moving your head. But if you try to move your body and your head together in an attempt to catch yourself in motion, you only succeed in jumping from one frozen pose to another. The movement between is a blur, barely glimpsed. You can never see yourself 'moving normally' as another sees you. Either you see movement, but the movement is partial, riveted to a stationary visual axis, stiffened by the effort of maintaining that line of vision, made wooden, deadened, turned into a caricature of itself; or you make a live movement at the price of losing sight of yourself for the duration. Every time you really see yourself, well, there you are. The single axis of vision stretches you between two surfaces recapitulating the same. On that axis, you resemble yourself perfectly. Stilted, static, a perfect picture. Change is excluded. Change is movement. It is rendered invisible.

This specular structure of doubled identity can be transposed into an intersubjective structure with only slight adjustment. In the everyday intersubjective world there are of course multiple axes of vision, but they are still strung out along a single line that subordinates them to resemblance and self-sameness. This line is itself nonvisual, it is a narrative line. In the family or at work, you perform your assigned social role. You interpret the script, you visualize what it means for you to be what your are, parent or child, mother or father, boss or employee, cop or criminal, and embody that visualization for the benefit of others occupying the contrasting but complementary roles. For each role there is a privileged other,

in whose recognition of you, you recognize yourself. You mirror yourself in your supporting actor's eyes, and they in yours. A reciprocal difference stretches between paired retinal surfaces. Between them runs a narrative line carrying both social players across a series of regulated thresholds. You resemble each other more fundamentally than you differ, by virtue of your shared participation in the same narrative. The difference between you and your specular complement is the minimal difference allowing movement. The axes of vision are at slightly skewed angles, so that the mutually self-defining recognition always imperceptibly misses. This perspectival disjunction creates just enough of an imbalance to prevent fusion. Saved from stasis, life goes on. There is change, but only minimal change, a skew-induced dynamic distortion generally consistent with sameness. You grow up, grow old, even reverse certain roles, perhaps becoming a parent, in any case turning into an adult after spending your entire life as a child. But you never outgrow yourself, however distorted your aging body and increasingly unfocused mind become. Privileged moments stand out clearly, perfect as pictures in a family album: birthday, graduation, marriage, anniversary, celebrating a pay rise, retirement. Plain old everyday you progresses through a sequence of life passages photographically preserved as stilted poses. Your life passes before you in succeeding tableaux, continuity shots punctuating a banal script just bad enough to systematically but modestly miss the mark. There is progression, but no real transformation, the movement barely glimpsed. Wherever you go, there you are again. Unavoidably you. Then you die. This is utopia, 1950s style.

Reagan is not content with that. He wants to transcend, to be someone else. He wants to be extraordinary, a hero. It jolts him that when he strikes the pose he sees himself. Acting keeps him him, in spite of the fame, because it only allows him to cross a minimal distance, between himself and his complement, in this case the movie goer. Sitting in the screening room, he anticipates his fans crossing that same distance in the opposite direction. He sees them seeing themselves in their recognition of him. He sees himself seen, as privileged other. He wants out of that mirror-vision, but the film stock fixes him in it by objectifying the partial mental picture he embodied. As long as he is in the movies, he is condemned to be what he is, a second-rate actor in a bad 1950s film, complementing, compensating small lives, on a larger-than-life screen. He is destined for greater things.

Complementarity is not completeness. Completeness is to be found

in a way of appearing that goes beyond text and visualization, script and picture, beyond the dual structuring of specular identity in which one compensates for a lack in the other. Reagan invokes a kind of vision that grasps exactly and exclusively what mirror-vision misses: the movement, only the movement ('walking, standing, moving normally through a room'). Reagan wants to see the lack in specular identity, and in the process transform it into a peculiar kind of fullness. The movement-vision he looks to is also perspectival ('from behind, from the side'). But its perspectives lie on the far side of a maximum distance, one that can be crossed but not bridged. Occupying one of these perspectives would render Reagan instantly unrecognizable to himself. In that instant, he would have *become* other, in a way unassimilable to reflective identity. Mirror-vision and movement-vision are discontinuous; between them there is no mediation. The first is relative (ongoing reciprocal determination of I–me/I–you), the second is absolute (self-distancing).

Movement-vision is not only discontinuous with mirror-vision. It is discontinuous with itself. To see oneself standing as others see one is not the same as seeing oneself walking as others see one. Maintaining any kind of continuity across standing and walking entails positing a commonality between moving and not moving, a generality in which their difference is resolved. It would miss, again, precisely what is being sought: movement as such, in its difference from stasis. The same goes for seeing oneself walking from behind and seeing oneself walking from the side. Movement is relational. Its specificity is compromised if any aspects of the relation are lost to generality, even if it is the generality *of* the terms in the relation, their self-sameness across time or in different coordinates in space.

Only as a generality can there be said to be a continuity between states (a body standing then walking) guaranteed by a unity of the observer (a subject that remains the same across changes of state in the object). The elementary unit of the space of movement-vision is not a generalizing subject coupled with an object in general, a self-identical observer who recognizes the object as the same, as what is common to different movements and to movement and stasis. Its elementary unit is the singularity of a movement that includes a perspective which occludes the actual functioning of both the subject and the object. The objectness of the object is attenuated as the subject, seeing itself as others see it, comes to occupy the object's place as well as its own. Simultaneously occupying its place and

the object's, the subject departs from itself. The subject-object symmetry of mirror-vision is broken. The subject overlays itself on the object, in a superposition of reciprocal functions. The gap left by the subject's self-departure is filled not by a new subject or object, but by a process encompassing their disjunction in a tide of change. Movement-vision is an *included disjunction*. It is a displacement of the subject, the object, and their general relation, the empirical perspective uniting them in an act of recognition. It is an opening onto a space of transformation in which a de-objectified movement fuses with a desubjectified observer. This larger processuality, this *real movement*, includes the perspective from which it is seen; but the perspective is that of a *virtual observer* that is one only with the movement (of the subject's self-departure). Not: I see you Standing then Walking. But: I (other than) sees me (now you) standing(-from-the-side), standing(-from-behind), walking(-from-the-side), walking(-from-behind) . . . The elementary unit of the space of movement-vision is a multiply partial other-perspective included in a fractured movement-in-itself (change).

When Reagan enters the space of movement-vision, he is leaving behind the empirical world as he knew it. He is coinciding with a perspective that is neither that of his plain old self *vis-à-vis* the others and objects populating his everyday world, nor that of the others in that world *vis-à-vis* him as an object in their sight. He leaves the intersubjective world of the other-in-the-self, self and other identity bound in mutual missed-recognition, for a space of dislocation, the space of movement-as-such, sheer transformation. There, movement is fractured, unhinged from subject and object, and they from each as other. The eye is out of its socket, hovering on an exorbital axis of vision, seeing elsewhere as a kind of other without other, actually *seeing distance*, the in-itself of distance, the as-such of difference-from. Seeing oneself as others see one in fact means occupying an axis of vision on a tangent to self and other, both as actual entities and as conditions of identity. It is to enter a space that opens an outside perspective on the self-other, subject-object axis. The tangent point at which movement-vision meets mirror-vision and diverges from it is the space between the subject-object poles, superposed, fractured, multiplied. It is relationality freed from its terms.

How can this be construed as completeness? Clues can be found in Reagan's recounting of the one time as an actor that he achieved this vision. It happened when he was called upon 'to portray a

scene of total shock' (Reagan and Hubler, p. 4). It was in *King's Row*, and he had to play a young, handsome 'blade' who has an accident and wakes up to find that the bottom half of his body has been amputated. 'Coming from unconsciousness to full realization of what had happened in a few seconds, it presented me with the most challenging acting problem in my career.' Reagan continues:

A whole actor would find such a scene difficult; giving it the necessary dramatic impact as half an actor was murderous. I felt I had neither the experience nor the talent to fake it. I had to find out how it really felt, short of actual amputation. I rehearsed the scene before mirrors, in corners of the studio, while driving home, in the men's room of restaurants, before selected friends. At night I would wake up staring at the ceiling and automatically mutter the line before I went back to sleep. I consulted physicians and psychologists; I even talked to people who were so disabled, trying to brew in myself the cauldron of emotions a man must feel who wakes up one sunny morning to find half of himself gone. I got a lot of answers. I supplied some more for myself. None of mine agreed with any of theirs. Theirs did not agree with each other. I was stumped. (pp. 4–5)

'Wan and worn' from a sleepless night, a despairing Reagan stumbles into the studio for the shoot.

I found the prop men had arranged a neat deception. Under the gay patchwork quilt, they had cut a hole in the mattress and put a supporting box beneath. I stared at it for a minute. Then, obeying an overpowering impulse, I climbed into the rig. I spent almost that whole hour in stiff confinement, contemplating my torso and the smooth undisturbed flat of the covers where my legs should have been. Gradually, the affair began to terrify me. In some weird way, I felt something horrible had happened to my body. Then gradually I became aware that the crew had quietly assembled, the camera was in position, and the set all lighted ... There were cries of 'Lights!' and 'Quiet, please!' I lay back and closed my eyes, as tense as a fiddlestring. I heard [the director's] low voice call, 'Action!' There was as sharp *clack* which signaled the beginning of the scene. I opened my eyes dazedly, looked around, slowly let my gaze travel downward. I can't describe even now my feeling as I tried to reach for where my legs should

be . . . I asked the question – the words that had been haunting me for so many weeks – 'Where's the rest of me?' There was no retake. It was a good scene and it came out that way in the picture. Perhaps I never did quite as well again in a single shot. The reason was that I had put myself, as best I could, in the body of another fellow . . . No single line in my career has been as effective in explaining to me what an actor's life must be . . . Seeing the rushes, I could barely believe the colored shadow on the screen was myself. (pp. 5–6)

Reagan was so touched by his truncated self that he organized not just the opening chapter but his entire autobiography around this bed scene, and took that fateful line for its title: *Where's the Rest of Me?*[1] The passage is so rich that a close reading, especially in connection with Reagan's later presidential performances, would prove inexhaustible.[2] The discussion here will be limited to retracing and retranslating the process he relives in it.

Reagan begins by saying that he was called upon to 'portray' not a character but a *'scene'*. What he has to embody as an actor is more fundamentally an *event* than a personality. It is something that can't be faked. He needs to know 'how it really felt, short of actual amputation': his challenge is to produce and coincide with a *reality 'short of' the actual*. The event at issue is the culmination, in a verbalized coming to consciousness, of a transformation from one bodily state (characterized by mobility, the ability to walk) to a radically different one (characterized by stasis, being bedridden). Reagan must embody the scene of a man *recognizing himself as irretrievably changed*, as having been transported in total darkness and unbeknown to himself from one perspective on life to another that is irreconcilably different from it. The actor's labour is not one of the intellect: the act of recognition is the end-result, not the means by which the scene's reality is produced. Acting is a labour of feeling, but not only that: the feeling is inseparable from motility. Reagan becomes a travelling rehearsal. He moves from one place to another, and from one kind of observer to another, repeating the culminating phrase, 'Where's the rest of me?' He starts from a difference between two unbridgeable perspectives which in their disjunction encompass an entire life, as telescoped into the absolute distance between being able to walk and being a cripple. Then he tries to learn how to cross from one of these perspectives to the other, by multiplying relative perspectives on the event they delimit but do

not contain: the accident, by which the self becomes other than it was. The phrase marking the culmination of the event in an act of instantaneous recognition of self-as-other is dragged by his body through his everyday world. It functions through repetition as a trace of the transformation, a spectre of an ungraspable, unthinkable event haunting the flesh. He recites the phrase to different people from different angles: to himself in mirrors, alone in the car, in front of friends, physicians, psychologists, and amputees. He repeats it so often it becomes automatic. The event, still a trace, begins to circulate freely through all of the interlocking visual fields composing Reagan's empirical world. Finally, Reagan's realm, that of the ordinary, and the realm of the extraordinary, the realm of the ungraspable event, begin to contaminate one another in a gradual contagion. Reagan's entire world becomes coloured by amputation. He is stumped, repeatedly referring to himself as a cripple. But he isn't, actually, and he hasn't yet produced the short-of actual reality of amputation. He only embodies its anticipation. The problem is that the perspectives he has connected to the event remain relative. They do not 'agree'. They now communicate across their difference, but cannot be superposed. It takes an artifice to jolt them into a synthesis. One that Reagan is incapable of constructing. His compulsive rehearsing has only exhausted him and driven him into a panic. He can no longer act, in any sense of the word. His manic activity has only succeeded in working him into a state of heightened excitability that is at the same time the pitch of passivity: he has become a peripatetic panic autonomically repeating a line.

This marks the end of the first phase of the process. The second begins with a 'deception' prepared without Reagan's knowledge and to which he is passively subjected. He is loaded into a 'rig', a bed with a hole in it to conceal his legs. His activity in the real world is now suspended by artifice; his anticipation of the event is turned into dramatic suspense as he sinks, quilted, into the scene. Will it happen? For a painful hour, he contemplates his torso. A feeling slowly wells within him. The time of contemplation is like an infolding of his previous activity. As if all of the relative perspectives he placed into communication were overlaying themselves on one another and on the disjunct but encompassing perspectives of the before and after between which he now lies suspended. In this state of suspended animation, he is more than himself, but less than whole. His eyes close. 'Action!' His eyes re-open.

Phase three. The suspension of the suspense by the director's

signal transports him across a blackout of vision into the space of transformation. The feeling that was welling inside his body bursts forth in a gesture and a phrase. He bolts up, crying his line. At that moment, he enters the body of another fellow. It's for real (short of actual). This time, he cannot recognize himself in the rushes.

In a way, it is both real and actual. Reagan has been changed by the experience. An actual event really did occur. He feels afterwards that as an actor he is 'only half a man' (p. 6). He is cut to the quick by his moment of triumph. The event he recreated has bled into his everyday life, colouring it forever. Reagan laments that he has 'become a semi-automaton' (p. 6), and will remain one as long as he is just an actor. The autonomic repetition into which he collapses during the preparatory phase leading up to the event has carried over into his everyday life. He can't go on that way. He resolves to find the rest of him. He will look for it in conservative politics.

If the event was in a sense real, and if it made him a semi-automaton, does that mean that finding the rest of him entails becoming a *complete* automaton? The answer is obvious to anyone familiar with his subsequent career.

The reason Reagan gives for his determination to complete his transformation is he felt like 'a shut-in invalid, nursed by publicity. I have always liked space', he writes, 'the feeling of freedom, a broad range of friends, and variety (not excluding the publication [of the same name])' (p. 6). Again, it is not the fakeness of acting, nor the media hype, that he is objecting to. Hollywood is simply not big enough for him. He needs more space, more friends and observers, a greater variety of relative perspectives through which to circulate as he repeats his lines. Politics will allow him to multiply incalculably the contexts through which he drags his founding event of reality-producing acted amputation, extending the trajectory of its trace, widening the space it colours. If accompanied by adequate artifice, this will allow Reagan to enter innumerable bodies of other 'fellows'. These bodies, in their eagerness (or at least willingness) to play their social roles, will have worked themselves into a state of heightened receptivity, a kind of panicked passivity marked by autonomic repetition of assigned lines and a susceptibility to becoming-other, on cue. All the world will be a stage, with Reagan in the leading role, as carrier of a dehumanizing contagion.

To recapitulate: Reagan invents a technology of the event that is also a technology of the self, and a technologizing of the self. He

starts from the need to portray a scene culminating in an event that can be taken as exemplary. The accident, in the suddenness of its transformation not only of the shape of a body but of an entire life, can be seen as a figure of the event in general. The generic or exemplary event is short of actual. It need only be acted. But its acting yields a reality of its own. Through his performance of the exemplary event, Reagan effects an actual change in his life. That change is expressed as a blend between the exemplary event and his ordinary world, a bleed between the two. The bleed occurs in a moment of prolonged suspense. Reagan's activity both as screen actor and as actor in the everyday world is artificially suspended. Reagan's line of sight is trained on his own body. It moves down his torso toward his waist, his centre of gravity, then disappears, as if moving through his body's centre into another space, experienced as one of affect. A feeling wells. Reagan's vision and body collapse into an intensity that increases in pitch the longer it lasts. The way for the welling of that intensity was prepared by extensive means. Reagan had spent his time leading up to the bleed moving between empirical contexts, each of which was characterized by a certain kind of relative perspective, in the sense defined above: an object (always Reagan) appeared before the eyes of various observers (sometimes Reagan), and was recognized as itself. In each context, Reagan repeated the same words. The words were treated as a kind of incantation, as if they enveloped something of the desired event, contained its trace. Their repetition deposited a trace of the event in each of the contexts, gradually colouring the everyday world. Conversely, each context left its own trace in the words. It is as if the words were absorbing the relative perspectives, absorbing traces of the movements accomplished within them, as well as the movement from one to the other, blending the motion of acting the exemplary event with ordinary circulation through the world. The accumulation immobilizes Reagan under its weight. He enters a state of passivity marked by heightened excitability. When he is placed in the rig, he continues to move, but in place. He is reeling, overtaken by vertigo, as if his previous movements were repeating themselves in intensity. Unmoving, he circulates between empirical contexts and incantations of the exemplary event. He relives them sequentially *and* simultaneously, as if he can pass into each of those contexts and perform all of his rehearsals at the same time without moving his body or parting his lips. He is all eyes and emotion. When his eyes descend to the blankness at his waist, he is only

emotion. He is no one, nowhere, in darkness. He is in an in-between space composed of accumulated movements bled into one another and folding in upon the body. And he is in an in-between time after before but before after, in a gap of suspended animation following the preparation of the event but preceding its culmination. He is in the space of the duration of an ungraspable event. The feeling of the event washes through him (or that in-between of space and time), a wave or vibration that crests in the spoken lines. This time, the repetition of the lines effectively produces the event. But the event, as produced, is different. It has the reality of an acted event, a performance: short of actual. The 'short of actual' is expressed as a prolongation of the intensive in-betweenness of the event in the empirical world. It is a subsidence of the emotion, a flattening of the wave as it spreads out to fill a wider area. Reagan will now be extensively what he just was intensively. He will be an ambulant blend of the ordinary everyday and of the exemplary event: he will be a walking amputee. His flesh will carry the mark of the artifice that jolted him into the event, endowing it with a kind of half-life: he will be a semi-automaton. He will find a method that will take this new self, semi-technologized through acting, through a similar transformation, after which he will feel it to be complete.

Fleshing Out: Definitions

Call the closing of Reagan's eyes as he sees himself at the pitch of panic and exhaustion *movement-vision*. It is a vision that passes into the body, and through it to another space. Call that infra-empirical space, what the blind-sight of movement-vision sees, *the body without an image*. The body without an image is an accumulation of relative perspectives and the passages between them, an additive space of utter receptivity retaining and combining past movements, in intensity, extracted from their actual terms. It is less a space in the empirical sense than a gap in space that is also a suspension of the normal unfolding of time. Still, it can be understood as having a spatio-temporal order of its own.

In its spatial aspect, the body without an image is the involution of subject-object relations into the body of the observer, and of that body into itself. Call the spatiality proper to the body without an image *quasicorporeality*.[3] The quasicorporeal can be thought of as the

superposition of the sum total of the relative perspectives in which
the body has been implicated, as object or subject, plus the passages
between them: in other words, as an interlocking of overlaid per-
spectives that nevertheless remain distinct. The involution of space
renders these relative perspectives absolute: it registers movement
as included disjunction. Subject, object, and their successive
emplacements in empirical space are subtracted, leaving the pure
relationality of process. Quasicorporeality is an abstract *map* of trans-
formation. Its additive subtraction simultaneously constitutes the
spatiality of the body without an image and translates it into an-
other kind of time. For pure relationality extracted from its terms
can be understood at the extreme as a time out of space, a measure-
less gap in and between bodies and things, an incorporeal interval
of change.

Call that substanceless and durationless moment the pure *event*.
The time of the event does not belong per se to the body in move-
ment-vision, or even to the body without an image. They incur it.
It occurs to them. As time-form it belongs to the *virtual*, defined as
that which is maximally abstract yet real, whose reality is that of
potential: pure relationality, the interval of change, the in-itself of
transformation. It is a time that does not pass, that only comes to
pass. It cannot be suspended because, unlike empirical time, it does
not flow. The event is supra-empirical: it is the crystallization, out
the far side of quasicorporeality, of already actualized spatial per-
spectives and emplacements into a time-form from which the pass-
ing present is excluded, and which for that very reason is as future
as it is past, looping directly from one to the other. It is the imme-
diate proximity of before and after. It is non-linear, moving in two
directions at once: out from the actual (as past) into the actual (as
future). The actuality it leaves as past is the same actuality to which
it no sooner comes as future: from being to becoming.

Thus far the body without an image has been discussed exclu-
sively as an optical effect. But there are other modes of perception
involved. The spatiality of the body without an image can be
understood even more immediately as an effect of *proprioception*,
defined as the sensibility proper to the muscles and ligaments, as
opposed to tactile sensibility (which is 'exteroceptive') and visceral
sensibility (which is 'interoceptive') (*Petit Robert*). Tactility is the
sensibility of the skin as surface of contact between the perceiving
subject and the perceived object. Proprioception folds tactility into
the body, enveloping the skin's contact with the external world in

a dimension of medium depth: between exodermis and viscera. The muscles and ligaments register as conditions of movement what the skin internalizes as qualities: the hardness of the floor under foot as one looks into a mirror becomes a resistance enabling station and movement; the softness of the fur of a cat becomes a lubricant of hand motion. Proprioception translates the exertions and ease of the body's encounters with objects into a muscular memory of relationality. This is the cumulative memory of skill, habit, posture. At the same time as proprioception folds tactility in, it draws out the subject's reactions to the qualities of the objects it perceives through all five senses, bringing them into the motor realm of externalizable response. Proprioception effects a double translation of the subject and the object into the body, at a medium depth where the body is only body, having nothing of the putative profundity of the self nor of the superficiality of external encounter. This asubjective and non-objective medium depth is one of the strata proper to the corporeal; it is a dimension of the *flesh*. The memory it constitutes could be diagrammed as a superposition of vectorial fields composed of multiple points in varying relations of movement and rest, pressure and resistance, each field corresponding to an action. Since it is composed of interactions subtracted from their actual terms, it is abstract in the same sense as is the included disjunction of movement-vision. Proprioceptive memory is where the infolded limits of the body meet the mind's externalized responses, and where both rejoin the quasicorporeal and thence the event. As infolding, the faculty of proprioception operates as a corporeal transformer of tactility into quasicorporeality. It is to the skin what movement-vision is to the eyes. Its vectors are perspectives of the flesh. Although movement-vision opens on to the same space as proprioception, the latter can be said to be the mode of perception proper to the spatiality of the body without an image because it opens exclusively on to that space, whereas the eyes also see in the intersubjective space of mirror-vision, and because it registers qualities directly and continuously as movement, whereas the eyes do not register movement without also registering its arrest, in other words form (the visual image insofar as it is susceptible to geometric expression; movement as captured in a still, snapshot, or tableau giving it measure and proportion). It is because vision interrupts movement with formed images that it must interrupt itself to see movement as such. Movement-vision is sight turned proprioceptive, the eyes reabsorbed into the flesh through a black

hole in the geometry of empirical space and a gash in bodily form (the hole in Reagan's stage bed; amputation). Vision is a mixed mode of perception, registering both form and movement. For it to gain entry into the quasicorporeal, the realm of pure relationality, pure movement, it must throw aside form in favor of unmediated participation in the flesh. Movement-vision is retinal muscle, a visual strength flexed in the extremities of exhaustion.

The temporality of the body without an image coincides with the eclipse of the subject in emotion. It is a time of interruption, the moment vision plunges into the body's suspended animation. It is a gap, like the event, but one that is still attached to empirical time as a punctuation of its linear unfolding. It can be understood as the double, in the actual, of the event, whose reality as pure interval of transformation is virtual, on the order of potential, more energetic than bodily, incorporeal. Or, its attachment to empirical time can be understood as the durational equivalent of the edge of the hole in empirical space into which the eyes of movement-vision disappear, in which case it would be the rim of the virtual at the crossroads of the actual. Reserve the term *suspense* for the temporality proper to the body without an image.

Just as the spatiality of the body without an image opens out on to another time-form, its temporality opens out on to another space. This opening occurs in a second dimension of the flesh: one that is deeper than the stratum of proprioception, in the sense that it is farther removed from the surface of the skin; but it is still at a medium depth, in that it also intervenes between the subject and the object. It too involves a cellular memory, and has a mode of perception proper to it: *viscerality* ('interoception'). Visceral sensibility immediately registers excitations gathered by the five 'exteroceptive' senses, even before they are fully processed by the brain. Walking down a dark street at night in a dangerous part of town, your lungs throw a spasm before you consciously see and can recognize as human the shadow thrown across your path. As you cross a busy noonday street, your stomach turns somersaults before you consciously hear and can identify as brakes the screeching careering towards you. Having survived the danger, you enter your building. Your heart stops before you consciously feel the tap on your shoulder and identify it as the greeting of a friend. The immediacy of visceral perception is so radical that it can be said without exaggeration to precede the exteroceptive sense perception. It anticipates the translation of the sight or sound or touch

perception into something recognizable associated with an identifiable object. Call that 'something recognizable' a quality. Movement-vision as proprioception subtracts qualified form from movement; viscerality subtracts quality as such from excitation. It registers *intensity*. The dimension of viscerality is adjacent to that of proprioception, but they do not overlap. The dimension of proprioception lies midway between stimulus and response, in a region where infolded tactile encounter meets externalizing response to the qualities gathered by all five senses. It performs a synthesis of those intersecting pathways in the medium of the flesh, thus opened to its own quasicorporeality. Viscerality, though no less of the flesh, is a rupture in the stimulus-response paths, a leap in place into a space outside action-reaction circuits. Viscerality is the perception of suspense. The space into which it jolts the flesh is one of an inability to act or reflect, a spasmodic passivity, so taut a receptivity that the body is paralysed until it is jolted back into action-reaction by recognition. Call it the space of *passion*.[4] Its elementary units are neither the absolute perspectives of movement-vision, nor the vectorial fields of proprioception proper, but *degrees* of intensity. The space of passion constitutes a quasiqualitative realm adjacent to the quasicorporeal. Say that every absolute perspective/vectorial field composing the quasicorporeal is associated with a certain intensity, a higher or lower degree of spasmodic passivity. The intensity can be thought of as filling the interval of quasicorporeal space with a time-derivative, as bathing its relationality with spatialized suspense. If quasicorporeality is a maximally abstract spatial matrix, intensity is the non-qualified substance occupying it. Passion, then, is best understood less as an abstract space than as the time-stuff of spatial abstraction. Call the coupling of a unit of quasicorporeality with a unit of passion an *affect*: an ability to affect and a susceptibility to be affected. An *emotion* or *feeling* is a recognized affect, an identified intensity as re-injected into stimulus-response paths, into action-reaction circuits of infolding and externalization: in short, into subject-object relations. Emotion is a contamination of empirical space by affect, which belongs to the body without an image.

(The need to keep deriving time from space and space from time testifies to the inadequacy of the terms. The body without an image is a seamless spatio-temporal mix [as is empirical space as understood by physics]. Still, time and space concepts are necessary heuristic devices for thinking the specificity of the interlocking processes contributing to the construction of the body without an image.)

Call proprioception and viscerality taken together – as two complementary dimensions of the 'medium'-depth perception most directly implicated in the body's registration of the in-betweenness of the incorporeal event – *mesoperception*. Mesoperception is the synaesthetic sensibility: it is the medium where input from all five senses meet, across sub-sensate excitation, and become flesh together, tense and quivering. Mesoperceptive flesh functions as a corporeal transformer where one sense shades into another over the failure of each, their input translated into movement and affect.

Affect contaminates empirical space through language. Entranced in his trick bed, Reagan moves through quasicorporeal space, accumulating perspectives and passages, and with them affects. As regions of his quasicorporeality are superposed upon one another, their associated intensities mount. It is as if the body's abstract matrix and its nonqualified filling form a resonating vessel rising to an unbearable pitch, reaching the point where it can no longer contain itself. The virtual resonation overflows as actual sound. A voice, perhaps his own, speaking words charged with feeling but whose meaning Reagan will not fully understand until many years later: 'Where's the rest of me?'

Bedded in passivity, Reagan cannot jolt himself out of his condition. He is freed from the body without an image and returned to the everyday world, albeit a changed man, by the words of another called out as a cue: 'Action!' Call the cue-call an *order-word*. Call the question-response an *expression*, keeping in mind that the expression is preconceptual and even presubjective: more an existential *cry* than a communication. The expression is the unmeditated and unmediated speaking of the event by the flesh. It culminates Reagan's transformation into half a man. It gives him a demi-self. What it expresses is less an idea or an emotion formed by a signifying subject than an ontological *problem* posing as an open question the very possibility of constructing such a subject. Feelings and ideas will follow from the expression and, before solving the problem it poses, will develop its problematic nature even further. The line Reagan speaks makes him feel like a cripple, and gives rise to the idea that he has become a semi-automaton. He has found half of himself, but he happens to have found it in the 'body of another fellow'. He is on the road to completing himself, to identifying his body, but he got there by mouthing a pre-scripted line that made him into a foreshortened other. Many secondary questions arise. All of them can be condensed into one: how can exalted difference

be derived from banal repetition? Repeat: how can a difference born of becoming-other be self-identity? Again: how can higher being arise from abject becoming?

The cue-call or order-word that jolted Reagan into the body of another fellow had the force of a magic incantation. It induced a phenomena of *possession* verbally manifested in the automaton mouthing of pre-scripted words, that is to say as *ventriloquism*. Susceptibility to possession and ventriloquism are the requisite skills of the true actor Reagan now embodies. Together they define the actor's talent: *self-affectation*. That term should be understood in the double sense of the artificial construction of a self and of the suffusing of that self with affect.

Again, nothing would have happened without artifice. Reagan is extracted from the body without an image and delivered to the actuality of his becoming-actor by the good graces of a 'rig'. The order-word simply tripped the rig into operation. Call the rigging of becoming *induction*. The activation of the rig by the order-word culminated his passion by inducing his possession of his body. Although he may think of himself as having been possessed by the other fellow of the script, it is ultimately the body without an image that takes his body, endowing it with a measure of potential. Reagan is now in becoming; his being is 'short of actual'. That is to say, his actual perceptions are coloured by the virtual. Unable to recognize the virtual-in-the-actual, Reagan develops it into feelings and ideas whose combined effect is to transpose it into a future possibility: an ultimate actuality in which the potential that has seeped into his body has been fully realized; the complete man that he desperately wants to become but which, as an ideal of being, prefigures the end of becoming. Reagan's body re-enters linear time, although it still carries with it traces of the body without an image, transposed into a phantom amputation. Call the phantom amputation that comes to stand for the body without an image in Reagan's mind and emotions the *exemplary event* (or central phantasm) of his life. Call each threshold he passes on the road to his ideal of being, each movement culminated in an everyday context or between contexts, an *ordinary event* (also a *phantasm*; as used here, the word phantasm does not connote irreality, quite the contrary; it connotes the mode of reality proper to events, however exalted or ordinary: insistent ontological ungraspability).[5]

The exemplary event is a deferred completion. But the fact that it takes over his life indicates that Reagan has already attained a

completion of sorts. For the ideal implied by the exemplary event to have been produced, Reagan had to have rejoined the body without an image for a spasmodic moment. His empirical body was completed by its virtual double. The word 'completion' is misleading. In the case of the exemplary event, it is misleading because it is not attainable: it denotes an ideal being, and as such lies beyond the reach of becoming. Call the ideal of being-complete *unity*. The ideas, emotions, and mirror-vision images attached to unity keep the ideal alive as the object of a compulsion or tendency. Call them *whole attractors*. In the case of the body without an image, 'completion' is misleading because it is always already attained at every turn. Call that perpetual future-past doubling ordinary events *supplementarity*. The exemplary event is the transposition of supplementarity into the lure of unity. Transposed supplementarity is the mode of being of the pure event. Call the event, to the extent that it continues to call from across its transposition, defining a compulsion or tendency to fracture the integrity attributed to the body in everyday action-reaction circuits and to shatter the symmetry attributed to subject and object in their mirrored mutuality, a *fractal attractor*.

Call the seeing of the body without an image by the blind-sight of movement-vision *blank mimicry*. The activity of the actor is less to imitate a character in a script than to mimic in the flesh the incorporeality of the event. Blank mimicry is supplemented seeming (acting injected with real passion and yielding real change) and seeming supplemental (the attainment of real passion and real change through the staging of the body in suspended animation). The rig, the order-word, the question-response, induction, possession, ventriloquism, the development of an emotionally charged ideal of unity and the quest to reach that ideal; all of these are technologies for *making seeming being*,[6] for making a life of acting, for making something unified of supplementarity, something central of liminality, for filling the fractal rim to make a (w)hole.

Reagan could not recognize himself in the rushes of *King's Row*. In the screening room, he *mis*recognized himself as his new ideal. He looked back into the mirror, even as he was marked for ever by movement-vision. He saw himself as other without other that is the body without an image, then blinked and saw himself again as self-in-other, in a mirror image of his own future. His subsequent career would be characterized by a continual flicker between these two visions.

Reagan was a bad actor. This was not an accident. It was *the* accident, the accident of his career, his fate, his professional crippledom. If he had been a good actor, he would not have had to turn to politics in a quest to complete himself. He would have found passion in each new movie. Repetition of that rush would have been enough. He was a real actor only once. He became a politician for life. It is not that there is anything to prevent a good actor from going into politics. But it would be experienced as a career choice, not a compulsion. And the kind of political success a good actor could have would be very different, and undoubtedly lesser, than the success Reagan had. As a politician, Reagan did not stop acting, despite his tendency in his first autobiography to portray the two roles as mutually exclusive. He went about completing himself *as* a political actor.

'He once described to me how he got into politics by accident', says a former senior Administration official. 'He told me he told someone, "By God, what am I doing in politics? The kinds of things I've done so far are far away from this. But then I thought that a substantial part of the political thing is acting and role playing and I know how to do that. So I used to worry, but I don't anymore."'[7]

There he goes again. Repeating lines: 'he told me he told someone'. Ventriloquizing himself. Still at it after all those years. Reagan not only did not let go of the technologies of making seeming being; he did nothing to hide them. His spectacular political success in fact hinged on *making seeming being visible*. Reaganism is the regime of the visibility of seeming being. Reagan's professional crippledom, his entry into public life, was the exemplary event allowing the population of an entire nation to develop emotions and ideas along those same lines. As political actor, he catalysed processes already at work in society. He was the Great Inducer, the national actor-cum-stage director who called a country to action in pursuit of the lofty lure of post-war unity. The amputation written into the script was the 'wound' of Vietnam. The all-too-visible rig was television.

Scenario

Find a cultural-theoretical vocabulary specific to the body. Use it to express the unmediated participation of the flesh in the image (whether 'natural' or mass-mediated). Find a logic for the corporeal (body *and* image) that does not oppose it to the virtual, even as it distinguishes them, as dimensions of each other. Find a logic for the virtual (imagelessness *and* potential) that does not remove it from the real; for example, by equating it with the imaginary. Dissever, instead, the imageless from the Ideal.

For an incorporeal materialism.[8]

See the body get rigged. See the flesh suffused with artifice, making it as palpably political as it is physical. For the artifice is always cued, and the cueing is collective.

Consider that there is no 'raw' perception. That all perception is rehearsed. Even, especially, our most intense, most abject and inspiring, self-perceptions.

REPETITION PRECEDES RESEMBLANCE (even to oneself).[9]

Consider that although change is compatible with repetition, it is nonetheless ontologically prior to sameness. See stasis, see station, as a special case of movement (a special case of reiterative movement: that allowing recognition).

PASSAGE PRECEDES POSITION.[10]

Rethink body, subjectivity and social change in terms of movement, affect, force and violence before code, text and signification. These reiterate arrest (the Law: where bodies cease, only to mean, and where meaning carries a sentence).

Even an arch-conservative politician can see and reach beyond the law long enough to catalyse a movement. A special case of reiterative movement (that allowing misrecognition: of the fractured time of the virtual for future Unity). This is becoming: against itself, because subsumed under that Ideal. Against itself, because its self-assigned meaning ('our Unity!') contradicts its own senseless, eminently effective, rallying cry ('the rest of me?'). Remember the becoming-Reaganoid of America through the 1980s. And beyond? Remember how one bad actor shed his self-likeness to steer a nation sameward. This is becoming: at once highly virulent and self-arresting.

What is left of *us*, after 'our' unity has completed 'his' amputation?

Do we, cultural theorists, recognize ourselves in the rushes?

Rig writing, unarresting.

DISSEVER THE IMAGELESS FROM THE IDEAL.

Notes

1. Ronald Reagan with Richard G. Hubler, *Where's the Rest of Me?* (New York: Duell, Sloan & Pearce, 1965; reprinted by Karz, 1981).

2. For analyses of Reagan's amputational propensities, see Michael Rogin, *Ronald Reagan, the Movie and Other Episodes in Political Demonology*, pp. 1–43 (Berkeley: University of California Press, 1987); and Ken Dean and Brian Massumi, 'Postmortem on the Presidential Body, or Where the Rest of Him Went', *First and Last Emperors: The Absolute State and the Body of the Despot* (New York: Autonomedia, 1992), pp. 87–151.

3. The concept of quasicorporeality is akin to what José Gil calls the 'infra-linguistic' in *Métamorphoses du corps* (Paris: Ed. de la Différence, 1985). Gil's 'infra-linguistic' and the notion of 'the body without an image' advanced here are local appropriations, in the context of anthropology and media theory respectively, of the idea of 'the body without organs' developed by Gilles Deleuze and Félix Guattari in *Anti-Oedipus* (Minneapolis: University of Minnesota Press, 1983) and *A Thousand Plateaus* (Minneapolis: University of Minnesota Press, 1987).

4. Steven Shaviro develops a theory of film spectatorship revolving around concepts of 'passion', an axis of 'tactile' vision that is elsewhere than in identity, mimesis, and contagion, to which this account is deeply indebted. See *The Cinematic Body* (Minneapolis: University of Minnesota Press, 1993), in particular chapter 1, 'Film Theory and Fascination'. See also Shaviro, *Passion and Excess: Blanchot, Bataille and Literary Theory* (Tallahassee: Florida State University, 1990).

5. On the equation of phantasm (simulacrum) and event, see Gilles Deleuze, *Différence et répétition* (Paris: PUF, 1968), pp. 162–8 and *The Logic of Sense*, trans. Mark Lester with Charles Stivale, ed. Constantin V. Boundas (New York: Columbia University Press, 1990), series 21 and 30, and appendix 3 (on Klossowski).

6. This phrase was suggested by Meaghan Morris's analysis of the way in which another leader 'generates Being by Seeming'. See 'Ecstasy and Economics (A Portrait of Paul Keating)', *Ecstasy and Economics: American Essays for John Forbes* (Sydney: EMPress, 1992), p. 47. The present essay is written in tacit dialogue with Morris's beautiful and thought-provoking essay on Keating.

7. *New York Times Magazine*, 6 October 1985, p. 32.

8. Michel Foucault, 'The Discourse on Language,' trans. Rupert Sawyer in *The Archaeology of Knowledge* (New York: Pantheon, 1982), p. 231. Quoted in Shaviro, *The Cinematic Body*, p. 25.

9. The assertions that repetition is always of the different, and that 'only differences resemble', are developed at length in Gilles Deleuze, *Différence et répétition* (Paris: PUF, 1968). See in particular pp. 152–7.

10. The ideas that the world is an interrelation of movements; that stasis is a movement-effect; that there is no object or subject of movement separate from the movement; and that any subject-object relations (and thus positionality) are effective 'illusions' arising from 'arrests'

or 'gaps' in movement, form central theses of the philosophy of Henri Bergson. For a useful summary, see Bergson, 'The Perception of Change', in *The Creative Mind*, trans. Mabelle L. Andison (New York: Philosophical Library, 1946), pp. 153–86. For a neo-Bergsonian analysis of film, see Gilles Deleuze, *Cinema I: The Movement-Image*, trans. Hugh Tomlinson and Barbara Haberjam (Minneapolis: University of Minnesota Press, 1986), in particular chapters 1 ('Theses on Movement') and 2 ('The Movement-Image and its Three Varieties'), pp. 1–11, 56–70.

Response: Reagan and the Problem of the Actor

Paul Patton

The problem of the actor has troubled me for the longest time

(Nietzsche, *The Gay Science*)[1]

Brian Massumi's paper is timely. We in Australia have just been subjected to an intense bombardment of political imagery. The images of our would-be rulers have been ubiquitous, as photo-opportunities have been multiplied indefinitely on the nightly television news in the attempt to make them coincide with all the self-images of our culture: factory worker, jogger, sheep farmer, etc. The importance of such media representations cannot be over-stated: elections are won and lost on the basis of impressions formed by the images at the top of the news bulletins. In this sense, the image *is* the political reality and Baudrillard is right to insist upon the difficulty of making hard and fast distinctions between 'reality' and 'image'. He is also right to point to the combination of scenarios, the exchange of signifiers and the substitutability of signifieds as omnipresent features of this virtual political reality: Clinton images fade into those of Kennedy, John Hewson's images dissolve into Clinton's: playing the saxophone, meeting the people, jogging, jogging, jogging.[2] In the same fashion, during the Gulf War, images of environmental disaster were superimposed upon images of military conflict, notably in the recurrent single image of the oil-soaked sea bird. To the extent that modern electronic media have made elections, wars, environmental disasters and other such events inseparable from their representations, it is true to say that we live in an age of simulacra.

The fact that our politicians have become actors is completely accepted. We instinctively judge them on the quality of their performances, and only reject them when they are bad actors. Not long

41

after the last Federal election in 1990, Max Gillies, an actor who has made a career out of playing politicians, sometimes better than they play themselves, commented that Andrew Peacock, who lost that election, was 'just a bad actor'. Gillies does not say that Bob Hawke, who won that election, was a good actor, but rather that he was 'an actor who becomes the role totally'.[3] Part of the difficulty of making a choice in the 1993 election was that both party leaders were new in the role and neither was entirely comfortable playing his allotted part.

Ronald Reagan, by contrast, excelled in his role. No one better epitomizes the political technology of the image: Mr Smith goes to Washington, Hollywood goes to the White House, the actor becomes president. It is not surprising that Baudrillard should devote a section of his *America* to the Reagan phenomenon, which he takes to exemplify a fundamental shift in the nature of American power in particular and political power in general: 'Governing today means giving acceptable signs of credibility. It is like advertising and it is the same effect that is achieved – commitment to a scenario.'[4] Reagan's success as a politician turned precisely upon the fact that he was an actor. That is why he remained popular despite his obvious shortcomings (falling asleep, gaffes, confusions). His very lack of substance meant that his appeal lay elsewhere, not in his ability to act as statesman and diplomat but in his ability to appear to be seeming to do so, in his ability to make 'seeming being visible', as Massumi suggests: 'Reaganism is the regime of the visibility of seeming being' (see above, p. 37).

As such, the Reagan phenomenon raises in stark form a number of questions that Baudrillard formulates somewhat differently. These include, first, the nature of the American public's confidence in such an imaginary figure: does this imply a kind of hyper-realization of nationalism and political trust, such that, with Reagan 'a system of values that was formerly effective turns into something ideal and imaginary'?[5] Second, a related question concerning the fate of American power in a postmodern world: is this still a power grounded in economic and military supremacy or has it become 'simulacral', merely the image of power, or power as a special effect?[6] Thirdly, what is the relationship between the appearance of power (which is real and which itself produces effects of power) and the other technologies of government to which we are subject. This question is implied in Massumi's description of Reaganism as a 'regime of sovereignty' and it is, as he suggests, a major challenge facing contemporary political philosophy.

The focus of Massumi's paper, however, lies in the nature of the Reagan phenomenon itself. He turns to the actor's own representation of himself in order to shed light on the process by which the actor becomes politician. Reagan's autobiography was written in the context of his campaign for the governorship of California and was therefore a fabricated image of his life designed to assist his political career. It takes its title and its leading image from the scene in *King's Row* in which the actor has to play a man whose legs have been amputated: 'Where's the Rest of Me?' The conceit around which Reagan's biography is constructed is that this scene was both the apotheosis and the symbol of his life as an actor. He played the scene so well that, for a moment, he really became the man who wakes to the realisation that half his body is missing. But in doing so, Reagan himself is changed. The event he enacts 'bleeds' into his own life 'coloring it forever' (see above, p. 27). He becomes aware of himself as merely an actor, a 'semi-automaton, 'creating' a character another had written'.[7] At this point, the border between the actor's body and the image it creates is breached, the boundary of Reagan's identity collapses and the amputee's moment of self-awareness becomes his own. No single line in his career has been as effective in explaining to him 'what an actor's life must be': 'If he is only an actor, I feel, he is much like I was in *King's Row*, only half a man.'[8] Reagan resolves to find the rest of him. The rest is history.

This phenomenon of the 'bleed', the experience of role becoming character, has long been recognized as one of the side-effects of being an actor. Since philosophers have tended to see it as their duty to police the border between character and artifice, the bleed has for the most part been regarded as a danger. It provides one of the grounds for Plato's condemnation of the poets in *The Republic*. In Book Three, Socrates asks: 'have you not observed that imitations, if continued from youth far into life, settle down into habits and second nature in the body, the speech and the thought?'[9] For Plato, the problem of the actor arises in the context of discussing the appropriate education for the rulers of his republic. It gives rise to his view that the young guardians should not be allowed to play at characters less noble than they were expected to be, for fear of their being corrupted. They were, however, allowed to impersonate the deeds of 'good men', particularly when the latter are acting 'steadfastly and sensibly'.[10]

This concession suggests that Plato's problem is not with playing a role as such, but only with certain kinds of role playing. He is

clearly opposed to the kind of indiscriminate role play that the profession of acting entails, but not what he calls play 'in the best sense of the word', that is, playing with complete seriousness and devotion to the role the part that God has allotted us. The best sense of play, Derrida comments, 'is play that is supervised and contained within the safeguards of ethics and politics'.[11]

Nietzsche, too, was aware of the importance of the process by which seeming becomes being. Consider the passage from *Human, All Too Human*, entitled 'How appearance becomes being':

> Even when in the deepest distress, the actor ultimately cannot cease to think of the impression he and the whole scenic effect is making, even for example at the burial of his own child; he will weep over his own distress and the ways in which it expresses itself, as his own audience. The hypocrite who always plays one and the same role finally ceases to be a hypocrite; for example priests, who as young men are usually conscious or unconscious hypocrites, finally become natural and then really are priests without any affectation . . . If someone obstinately and for a long time wants to *appear* something it is in the end hard for him to *be* anything else. The profession of almost every man, even that of the artist, begins with hypocrisy, with an imitation from without, with a copying of what is most effective.[12]

In a passage from *The Gay Science*, entitled 'How things will become ever more 'artistic' in Europe', Nietzsche outlines a somewhat different actor problem to the one which troubled Plato. He contrasts periods of European history in terms of the different manner in which individuals live their adopted or allotted occupation: first, he points to those periods in which men believed with rigid confidence, even with piety, in their predestination for precisely this occupation, precisely this way of earning a living, and simply refused to acknowledge the element of accident, role and caprice.

Second, he contrasts the former ages with those periods of a more democratic temper in which 'the individual becomes convinced that he can do just about everything and *can manage almost any role*, and everybody experiments with himself, improvises, makes new experiments, enjoys his experiments; and all nature ceases and becomes art'.[13] The individual who can manage almost any role is of course an actor. What concerns Nietzsche is the fact that, given the tendency for role to become character, the experience of the self as

actor is unstable. People will tend to become nothing but actors. As he says, 'whenever a human being begins to discover how he is playing a role and how he *can* be an actor, he *becomes* an actor'.[14]

Here, the phenomenon of seeming becoming being is replayed in relation to the particular role or occupation that Nietzsche elsewhere calls being an 'actor of the spirit', that is, experiencing one's self as always playing a part, or one's life as a series of roles. This is a role unavailable to those who live their relations to their occupation as destiny. Moreover, it is a curious role: initially a kind of meta-role, a mode of relating to the variety of roles one might adopt or might have adopted, it becomes in effect a role like any other, albeit with a crucial difference. To the extent that the process described actually operates throughout a given society, role-playing becomes the universal role, the primary focus of the activity of individuals, rather in the way that, according to Marx, money passes from being the universal equivalent for other commodities to being the universal commodity, the production of which comes to dominate and drive the production of everything else. According to Nietzsche, this phenomenon first appeared among the Greeks, whom he describes in *Daybreak* as 'actors incarnate' who 'play-acted before themselves',[15] while it recurs with modern Europeans and Americans.

What is wrong with universal role-playing? For Nietzsche, the problem had to do with the value of acting as such. On the one hand, unlike Plato, he wanted to encourage the human capacity to play at roles, to invent oneself with style and generally to celebrate 'falseness with a good conscience'. In this connection, in the context of his diatribe against those exemplars of modern European civilization whom he called the small men, Zarathustra also railed at the fact that there were too many bad actors and too few genuine actors to be found. On the other hand, he worried that play acting was perhaps only a derivative role, an art born out of relative weakness rather than the creative strength of the true artist.[16] Nietzsche's problem with the actor subject derives from the fact that the occupation of actor is itself only one rather limited and specific role. While an individual may undoubtedly achieve greatness as an actor, the role itself is limited from the point of view of human moral or social development. For the task of an actor is to perform the roles he is assigned to play, in contrast to the playwright who creates those roles. In other words, acting is an art form that recreates but does not create particular types or forms of life.

In this respect, Nietzsche compares it unfavourably with those other arts practised by the 'architects' of human values: the strength to build, the courage to plan for the future, the genius for organization and so on. The problem of the actor is that he is not a creative artist, in the sense of creativity that Nietzsche's moral philosophy seeks to privilege.

Kazuo Ishiguro's novel, *The Remains of the Day*, pursues a related problem, namely the case of a genuine actor whose life is devoted to service. Stevens, the central character, is an anachronistic figure whose life has been spent completely and genuinely immersed in the role of butler. His desire was to become a truly great butler and to possess the kind of dignity which never allows him to abandon his professional persona. As he says to the housekeeper, 'A butler of any quality must be seen to inhabit his role, utterly and fully; he cannot be seen casting it aside one moment simply to don it again the next as though it were nothing more than a pantomime costume.'[17] At crucial moments in his life, such as the death of his father and the loss of a potential romance, Stevens displays such dignity. One question raised by the novel is whether such a life is a tragic story of lost affection and human warmth, or whether it is the heroic story of Stevens becoming what he is, namely a great butler.

Reagan's doubts about his life as an actor appear at first glance to run along similar lines to Nietzsche's doubts about the actor self: as an actor he was only half a man. Moreover, his biography develops this theme, apparently to suggest that it was the desire to complete himself as a man that led him into politics. At the end, however, no doubt to forestall any doubts about his suitability for public office, the text suggests that he is complete as a man by virtue of the fact that he has a family. The Reagan story ends with a quote from Clark Gable: '"The most important thing a man can know is that, as he approaches his own door, someone on the other side is listening for the sound of his footsteps". I have found the rest of me.'[18] As a candidate for office, Reagan must of course present himself as complete in the patriarchal sense, that is, as a real man with a wife and children. But this undercuts the presumed motive for his entry into politics. It cannot be to complete himself as a man that he moves out of acting. It can only be, as Massumi suggests, to complete himself as an actor, to become more than a semi-automaton. Reagan's desire for completeness would then be what leads him to become a consummate political actor.

Massumi's analysis of 'the bleed' in the case of Reagan serves to confirm this interpretation. For the contamination of Reagan's life by his experience of playing the scene in *King's Row* is a singular event. What he is called upon to play in this scene is the character's becoming conscious of his legless body. In other words, it is an incorporeal transformation: the limbs are already gone, the event re-enacted in the scene is the character's becoming conscious of this fact, and no doubt being changed forever as a result. As such, the scene is exemplary in the sense that it represents the structure of events as such in their pure form. All events, Deleuze argues, are incorporeal transformations. They belong not to the realm of being but to the border realm of becoming. While they are implicated in the differing configurations of bodies and states of affairs, they are also essentially related to language: 'Everything happens at the boundary between things and propositions.'[19] While they concern bodies, events are expressed in propositions: what is the event Reagan is called upon to play? Not a man waking up, or even a man opening his eyes to find that his legs are missing, but a man becoming a cripple. These are all descriptions compatible with the physical movements in the scene, but only the last identifies the event portrayed.

In Reagan's account, playing this scene takes on the dimensions of a tragedy. Like Hamlet's decision to avenge the death of his father, it is at first an event too big for him. Then it takes hold of him and propels him into a state of suspension so that he is removed from everyday life, located outside time itself. Finally, he acts: he assumes the event with which he has struggled and is transformed in the process. So it is with Reagan and the amputation scene. In order to play this scene, he writes, 'I had put myself, as best I could, in the body of another fellow.'[20] He manages to transcend his own body and attain for a moment the intensity of the body without image, the quasi-corporeality of the event as such. He becomes the amputee and realizes on screen the pure event which is the becoming aware of corporeal incompleteness. But in representing this event, Reagan himself undergoes an incorporeal transformation. In succeeding as an actor and becoming-other than himself, he becomes aware of his failure to attain this level of intensity throughout his acting career. His becoming aware of himself as incomplete is a matter of his becoming aware of his lack of completeness as an actor. That is why, Massumi suggests, it is not accidental that a bad actor should have gone into politics. The event

that governs his representation of his own life is his becoming-incomplete. The desire for completion is installed as the ruling desire of his subsequent career as a political actor. But, as Massumi comments, 'the fact that it takes over his life indicates that Reagan has already attained a completion of sorts. For the ideal implied by the exemplary event to have been produced, Reagan had to have re-joined the body without image for a spasmodic moment' (see above, p. 36).

Suppose this analysis is accepted, what conclusions does it enable us to draw? In the first place, it seems to me that the overwhelming importance and interest of Massumi's chapter is that it shows us how in the case of Reagan the phenomenon of seeming becoming being gives rise to a new version of the problem of the actor. For Plato, the problem was that of good as opposed to bad forms of acting, which themselves were related to acting the part of noble rather than base characters. For Nietzsche the problem was that of acting as opposed to more creative forms of artistry. For Ishiguro, the problem was that of acting well but in a role whose *raison d'être* is the service of others. For Reagan it was a matter of becoming complete, as opposed to incomplete, as an actor. The completeness envisaged is a new kind of transcendence, unthinkable in earlier periods and made possible by the modern technology of the image. It is a question of transcendence through the image, of attaining the body without image, the unimaginable intensity of the pure event. For Plato, there is only one role that guarantees transcendence of the everyday and that is the life of the philosopher. Nietzsche was prepared to extend the list to include artists, prophets and even statesmen. Ishiguro's novel raises the possibility of transcendence through a life of service. With Reagan, the coincidence of the Hollywood actor and the technology of the mass media adds a further role: the political actor.

Further questions arise, however, which Massumi's paper leaves unanswered (perhaps only because it is part of a larger work). Some of these questions were alluded to above as questions for contemporary political theory: are we dealing here with a new form of technological realisation of the virtual body that has always 'completed' the body politic? If so, what other forms does this virtual sovereignty assume in other countries? For if we accept that the Reagan image functioned as a kind of transcendental Idea for the viewer/voters, in which they could reinvest the trust and loyalty expected of a national leader, only this time in imaginary form,

then we must recognise the particularity of this peculiarly American Idea. The desire of those attracted to the Reagan image is also in play. It may be indeed that they sought completion or unity for a country that experienced itself as in some sense 'amputated' by the defeat in Vietnam, but if something like this is true then the Reagan phenomenon is not generalizable.

Similar questions arise with regard to the experience of incompleteness which was central to Reagan's experience of the 'bleed': if Reagan's subsequent career as a political actor is governed by his desire to find the rest of himself, what if anything does this tell us about other stars of the political screen? In Australia, we have not yet had an actor who has made it big in politics, although it is perhaps not irrelevant to this question that our most successful politician in recent times has tried unsuccessfully to pursue a post-political career in television. Can we suppose that at some point in Bob Hawke's career as a politician he became aware of himself as a bad actor? The remainder of Max Gillies' comment suggests that this might be so: 'If you think of Hawke as an actor, he's an actor who becomes the role totally. I would never question his sincerity. He believes absolutely in his integrity. I've always been fascinated at how thin-skinned he is – I don't think he has any capacity for self-reflection.'

Notes

1. F. Nietzsche, *The Gay Science*, translated by W. Kaufmann (New York: Vintage, 1974), para. 361.
2. John Hewson was the leader of the coalition of conservative parties during the March 1993 Federal election. The election was won, against all odds, by the Labour party led by Paul Keating.
3. See the reported comments by Gillies in the *Canberra Times* 25 April 1990, p. 5.
4. Jean Baudrillard, *America*, trans. Chris Turner (London: Verso, 1988) p. 109. (Originally published as *Amérique*, Paris: Editions Bernard Grasset, 1986.)
5. Baudrillard, *America*, p. 114.
6. Baudrillard, *America*, pp. 107, 115.
7. Ronald Reagan with (Richard G. Hubler) *Where's the Rest of Me?* (New York: Duell, Sloan & Pearce, 1965), p. 6.
8. Reagan, *Where's the Rest of Me?*, p. 6.
9. Plato, *The Republic*, 395d.
10. Plato, *The Republic*, 396d.

11. Jacques Derrida, 'Plato's Pharmacy' in *Dissemination*, trans. Barbara Johnston (Chicago: University of Chicago Press, 1981), p. 156.
12. F. Nietzsche, *Human, All Too Human*, trans. R.J. Hollingdale (Cambridge: Cambridge University Press, 1986), para. 51, p. 39.
13. Nietzsche, *The Gay Science*, para. 356, pp. 302–3.
14. Nietzsche, *The Gay Science*, p. 303.
15. Nietzsche, *Daybreak*, trans. R.J. Hollingdale (Cambridge: Cambridge University Press, 1982), p. 22.
16. Nietzsche *The Gay Science*, para. 361 ('The Problem of the Actor'), p. 316. For Zarathustra's comments concerning bad/genuine actors, see Nietzsche *Thus Spoke Zarathustra*, trans. R.J. Hollingdale (London: Penguin), p. 189.
17. Kazuo Ishiguro, *The Remains of the Day* (London: Faber & Faber, 1989). For a more detailed analysis of the novel from the point of view of Nietzsche's problem of the actor, see P. Patton, 'Postmodern Subjectivity: The Problem of the Actor (Zarathustra and the Butler)', *Social Analysis*, 30 (December 1991).
18. Reagan, *Where's the Rest of Me?*, p. 301.
19. Gilles Deleuze *The Logic of Sense* trans. Mark Lester, with Charles Stivale, ed. Constantin V. Boundas (New York: Columbia University Press, 1990), p. 8.
20. Reagan, *Where's the Rest of Me?*, p. 6.

3 *Beginning is good*

Battle Lines

Beatriz Colomina

What the word for space, *Raum, Rum*, designates is said by its ancient meaning. *Raum* means a place cleared or freed for settlement and lodging. A space is something that has been made room for, something that is cleared and free, namely within a boundary, Greek *peras*. A boundary is not that at which something stops but, as the Greeks recognized, the boundary is that from which something *begins its presencing*. That is why the concept is that of *horismos*, that is, the horizon, the boundary. Space is in essence that for which room has been made, that which is let into its bounds.

(Martin Heidegger, 'Building, Dwelling, Thinking', 1952)

The horizon is an interior. The horizon is 'not that at which something stops but, as the Greeks recognized, that from which something *begins its presencing*'. The horizon defines an enclosure. In its familiar sense, it marks a limit to the space of what can be seen, which is to say, it organizes this visual space into an interior. It makes the outside, the landscape, into an inside. How could that happen? Only if the 'walls' that enclose the space cease to be thought of (exclusively) as solid pieces of material, as stone walls, as brick walls. The horizon organizes the outside into a vertical plane, that of vision. Shelter is provided by the horizon's ability to turn the threatening world of the 'outside' into a reassuring picture. But Heidegger repeatedly opposed the transformation of the world into a picture, a 'world-picture'. In *The Metaphysical Foundations of Logic*, he makes even more explicit the idea that the horizon *is* an enclosure, but also quickly dismisses the primacy of vision implied in the familiar sense of horizon: 'We understand 'horizon' to be the circumference of the field of vision. But horizon, from ὁρίζειν, is not at all primarily related to looking and intuiting, but by itself means simply that which delimits, encloses, the *enclosure*.'[1] Before vision, the horizon is a boundary, an enclosure, an architecture.

The way we think about architecture is always organized by the

51

way we think about boundaries. Traditionally it is a matter of walls dividing inside from outside, public from private, and so on. With modernity there is a displacement of the traditional sense of an inside, as an enclosed space established in opposition to the outside. All boundaries are now shifting. This shifting becomes manifest everywhere: in the city, of course, but also in all the technologies that define the space of the city: the railway, newspapers, photography, electricity, advertisements, reinforced concrete, glass and steel architecture, the telephone, film, radio . . . or war. Each can be understood as a mechanism that disrupts the older boundaries between inside and outside, public and private, night and day, depth and surface, here and there, street and interior, and so on. Today, the boundaries which define space are first and foremost an effect of the media (and not exclusively visual media, think for example about the space of sound: radio, the telephone, the walkman). The status of the wall has changed.

Throughout this century, this disturbance of boundaries has often been understood as a threat to identity, a loss of self. In talking about horizons, and in condemning their displacement by modern technologies, Heidegger, for example, was elaborating Nietzsche's claim that 'a living thing can be healthy, strong and fruitful only when bounded by a horizon . . . A man . . . sickens and collapses [if] the lines of his horizon are always restlessly changing.'[2] Modern man, then, will indeed be sick. With every new technology new sicknesses are identified. The idea of modernity can never be separated from the idea of sickness. Even space itself, or more precisely the absence of boundaries, is seen to produce sickness. At the turn of the century, urban theorists like Camillo Sitte criticized modern town planning for its failure to institute boundaries. Without a clear horizon, he said, the modern dweller suffers from new nervous disorders such as agoraphobia.[3]

But these sicknesses are almost always phantasmatic. The identity of the supposedly unified self threatened by the displacement of the horizon is itself suspect and must be interrogated. This interrogation must address architectural discourse since the question of horizon is, from the beginning, an architectural question.

1952. The same year that Heidegger publishes 'Building, Dwelling, Thinking', the Spanish architect José Luis Sert, then president of CIAM (Congrès Internationaux d'Architecture Moderne), opens the 8th Congress, *The Heart of the City*, which was devoted to 'The Core',

with a long quotation from José Ortega y Gasset's *The Revolt of the Masses*:

> For in truth the most accurate definition of the *urbs* and the *polis* is very like the comic definition of a cannon. You take a hole, wrap some steel wire tightly round it, and that's your cannon. So the *urbs* or the *polis* starts by being an empty space, the *forum*, the *agora*, and all the rest are just means of fixing that empty space, of limiting its outlines. The *polis* is not primarily a collection of habitable dwellings, but a meeting place for citizens, a space set apart for public functions. The city is not built, as is the cottage or the *domus*, to shelter from the weather, and to propagate the species – these are personal, family concerns – but in order to discuss public affairs. Observe that this signifies nothing less than the invention of a new kind of space, much more new than the space of Einstein. Till then only one space existed, that of the open country, with all the consequences that this involves for the existence of man. The man of the fields is still a sort of vegetable. His existence, all that he feels, thinks, wishes for, preserves the listless drowsiness in which the plant lives. The great civilisations of Asia and Africa were, from this point of view, huge anthropomorphic vegetations. But the Greco-Roman decides to separate himself from the fields, from Nature, from the geo-botanic cosmos. How is this possible? How can man withdraw himself from the fields? Where will he go, since the earth is one huge, unbounded field? Quite simply; he will mark off a portion of this field by means of walls, which set up an enclosed finite space over against amorphous, limitless space. Here you have the public square. It is not like the house, an 'interior' shut in from above, as are the caves which exist in the fields, it is purely and simply the negation of the fields. The square, thanks to the walls which enclose it, is a portion of the countryside which turns its back on the rest, eliminates the rest, and sets up in opposition to it.[4]

The *urbs* is 'like' a cannon. The city is 'like' a military weapon. This was not a casual example. War was written all over this congress and its idea of public space. But what kind of war? Most literally, it was the Second World War. The end of the war found many CIAM architects involved in the task of replanning central areas of bombed-out cities. They saw themselves as heart surgeons, trying to reconstruct vital organs of the city. From there came their pre-

occupation with the city and with 'public space', which they understood as place of 'public gathering', both in the traditional sense of 'public squares, promenades, cafés', etc., and also in what they saw as its most modern counterparts: 'railroad stations, bus terminals, landing strips'. But also from there came their clear, almost phobic, opposition to the new means of communications, which were already redefining the sense of public: 'Radio, movies, television and printed information are today absorbing the whole field of communication. When these elements are directed by a few, the influence of these few over the many may become a menace to our freedom.'[5] The media were identified with war, which is not surprising given its crucial role during the Second World War. Underlying this, however, was the common assumption that the public domain is the domain of violence, whether overt or latent, an assumption that is still currency today. Domestic violence is silenced, unrepresented. But isn't this silencing, this lack of representation, itself violent?.

But CIAM 8 was not simply declaring war against the media. The architects insisted on bringing the media into the public square (movies, television screens, radios, loudspeakers . . .), and in so doing turning, in Sert's words, public space into 'balconies from where they [the public] could watch the whole world'.[6] Note that the balcony is an element from domestic architecture, a place for both looking and being looked at. To say that public space is a balcony is already to recognize that the public is not so much a negation of the interior, as in the quotation from Ortega y Gasset, but rather an occupation of its traditional boundary: the wall. To be in public is to be inscribed in the limit of the interior, inscribed in order to 'watch the whole world'. (A sense familiar to us today in the commonplace idea that to occupy public space is to be at home watching television.) Far from declaring war on the media, Sert was installing it.

The real war here is architectural. The very separation between public and private, inside and outside, is itself violent in Ortega y Gasset's passage. The public is established 'in opposition', 'against', 'as negation'; 'it turns its back' . . . All these terms mark a certain hostility. Public space is produced by a violent effacement of the private. But here, returning to Ortega y Gasset's cannon, what is wrapped around the hole that is public space is the interiors excluded from it. The cannon is therefore constructed out of domestic spaces. It is not that public space is violent and the 'interior' is safe. The 'interior' is the steel wire of the cannon. It is the very substance

of the weapon. The interior is therefore precisely the possibility of
the violence that becomes visible outside it.

E.1027. A modern white house is perched on the rocks, a hundred
feet above the Mediterranean sea, in a remote place, in Roquebrune
at Cap Martin. The site is 'inaccessible and not overlooked from
anywhere'.[7] No road leads to this house. It was designed and built
by Eileen Gray for Jean Badovici and herself between 1926 and
1929. She named the house *E.1027*: 'E' for Eileen, '10' for J (the tenth
letter of the alphabet), '2' for B and '7' for G. They both lived there
most of the summer months until Gray built her own house in
Castellar in 1934. After the death of Badovici in 1956, the house was
sold to the Swiss architect, Marie Louise Schelbert. She found the
walls riddled with bullet holes. The house had been clearly the site
of some considerable violence. In a 1969 letter, she comments on
the state of the house: 'Corbu did not want anything repaired and
urged me to leave it as it is as a reminder of war.'[8] But what kind
of war? Most obviously, it was the World War. The bullet holes are
wounds from the German occupation. But what violence is there to
the house before the bullets, and even before the inevitable relation-
ship of modern architecture to the military? And anyway, to start
with, what is Le Corbusier doing here? What brings him to this
isolated spot, this remote house that will eventually be the site of
his own death?

'As a young man he had traveled in the Balkans and the near
East and had made sketches of strange, inaccessible places and
scenes. It was perhaps through a natural, anti-romantic reaction of
maturity that later, as a Purist, he proposed to paint what was
duplicable and near-at-hand.'[9] We will have to go back to Le
Corbusier's earlier travels, to the 'strange, inaccessible places and
scenes' that he had 'conquered' through drawing. At the very least,
to Le Corbusier's trip to Algiers in the spring of 1931. This is the
first encounter in what will become a long relationship to the city:
in Le Corbusier's words, 'Twelve years of uninterrupted study of
Algiers.'[10] By all accounts, this study begun with his drawing of
Algerian women. He said later that he had been 'profoundly
seduced by a type of woman particularly well built' of which he
made many nude studies.[11] He also acquired a big collection of
colored postcards representing naked women surrounded by ac-
coutrements from the Oriental bazaar. Jean de Maisonseul (later the
director of the Musée National des Beaux Arts d'Alger), who as an

eighteen-year-old boy had guided Le Corbusier trough the Casbah later recalled their tour:

> Our wanderings through the side streets led us at the end of the day to the rue Kataroudji where he [Le Corbusier] was fascinated by the beauty of two young girls, one Spanish and the other Algerian. They brought us up a narrow stairway to their room; there he sketched some nudes on – to my amazement – some schoolbook graph paper with colored pencils; the sketches of the Spanish girl lying both alone on the bed and beautifully grouped together with the Algerian turned out accurate and realistic; but he said that they were very bad and refused to show them.[12]

Le Corbusier filled three notebooks of sketches in Algiers which he later claimed were stolen from his atelier in Paris. But Ozenfant denies it, saying that Le Corbusier himself either destroyed them or hid them, considering them a *'secret d'atelier'*.[13] The Algerian sketches and postcards appear to be a rather ordinary instance of the ingrained mode of a fetishistic appropriation of women, of the East, of 'the other'. But Le Corbusier, as Samir Rafi and Stanislaus von Moos have noted, turned this material into 'preparatory studies for and the basis of a projected monumental figure composition, the plans for which seem to have preoccupied Le Corbusier during many years, if not his entire life'.[14]

From the months immediately following his return from Algiers until his death, Le Corbusier seems to have made hundreds and hundreds of sketches on yellow tracing paper by laying it over the original sketches and retracing the contours of the figures. (Ozenfant believed that Le Corbusier had redrawn his own sketches with the help of photographs or postcards).[15] He also exhaustively studied Delacroix's famous painting *Les Femmes d'Alger*, producing a series of sketches of the outlines of the figures in this painting, divested of their 'exotic clothing' and the 'Oriental decor'.[16] Soon the two projects merged: he modified the gestures of Delacroix figures, gradually making them correspond to the figures in his own sketches. He said that he would have called the final composition 'Femmes de la Casbah'.[17] But, in fact, he never finished it. He kept redrawing it. That the drawing and redrawing of these images became a life time obsession already indicates that something was at stake. This becomes even more obvious when in 1963–4, shortly before his death, Le Corbusier, unhappy with the visible ageing of

the yellow tracing paper, copies a selection of twenty-six drawings on to transparent paper and symptomatically, for someone who kept everything, burns the rest.[18]

However, the process of drawing and redrawing the 'Femmes de la Casbah' reached its most intense, if not hysterical, moment when Le Corbusier's studies found their way into a mural that he completed in 1938 in E.1027. Le Corbusier referred to the mural as *Sous les pilotis* or *Graffite à Cap Martin* (See fig. 8; it is also sometimes labelled 'Three Women'). According to Schelbert, Le Corbusier 'explained to his friends that "Badou" was depicted on the right, his friend Eileen Gray on the left; the outline of the head and the hairpiece of the sitting figure in the middle, he claimed, was "the desired child, which was never born".'[19] This extraordinary scene, a defacement of Gray's architecture and perhaps even an effacement of her sexuality since, her relationship to Badovici notwithstanding, Gray was openly gay (but in so far as Badovici is here represented as one of the three women, the mural may reveal as much as it conceals), is clearly a 'theme for a psychiatrist', as Le Corbusier's *Vers une architecture* says of the nightmares with which people invest their houses.[20] Particularly if we also take into account Le Corbusier's obsessive relationship to this house as manifested – and this is only one example – in his quasi-occupation of the site after the Second World War, when he built a small wooden shack (the 'Cabanon', see fig. 5) for himself at the very limits of the adjacent property, right behind Eileen Gray's house. He occupied and controlled the site by overlooking it, the cabin being little more than an observation platform, a sort of watchdog house. The imposition of this appropriating gaze is even more brutal if we remember that Eileen Gray had chosen the site because it was, in Peter Adam's words, 'inaccessible and not overlooked from anywhere'. But the violence of this occupation had already been established when Le Corbusier painted the murals in this house (there were eight altogether) without the permission of Eileen Gray, who had already moved out. She considered it an act of vandalism; indeed, as Adam has put it, 'it was a rape. A fellow architect, a man she admired, had without her consent defaced her design.'[21]

The defacement of the house went hand in hand with the effacement of Gray as an architect. When Le Corbusier published the murals in his *Oeuvre complète* (1946) and in *L'Architecture d'aujourd'hui* (1948), Eileen Gray's house is referred to as 'a house in Cap-Martin', her name is not even mentioned.[22] Le Corbusier ended up,

later on, getting credit for the design of the house and even for some of its furniture.[23] Still today the confusion continues with many writers attributing the house to Badovici, or at best, to Badovici and Gray, and some still suggesting that Le Corbusier had collaborated on the project. Eileen Gray's name does not figure, even as a footnote, in most histories of modern architecture, including the most recent and ostensibly critical ones.

'What a narrow prison you have built for me over a number of years, and particularly this year through your vanity', Badovici wrote to Le Corbusier in 1949 about the whole episode (in a letter that Adam thinks may have been dictated by Gray herself).[24] Le Corbusier replied in a way that makes it clear that he is replying to Gray:

> You want a statement from me based on my worldwide author-
> ity to show – if I correctly understand your innermost thoughts
> – to demonstrate 'the quality of pure and functional architecture'
> which is manifested by you in the house at Cap Martin, and has
> been destroyed by my pictorial interventions. OK, you send me
> some photographic documents of this manipulation of pure
> functionalism . . . Also send some documents on Castellar, this U-
> boat of functionalism; then I will spread this debate in front of
> the whole world.[25]

Now Le Corbusier was threatening to carry the battle from the house into the newspapers and architectural periodicals. But his public position completely contradicted what he had expressed privately. In 1938, the same year he went on to paint the mural *Graffite à Cap Martin* (fig. 8), Le Corbusier had written a letter to Eileen Gray, after spending some days in E.1027 with Badovici, where not only does he acknowledge her sole authorship but also how much he likes the house: 'I am so happy to tell you how much those few days spent in your house have made me appreciate the rare spirit which dictates all the organization, inside and outside, and given to the modern furniture – the equipment – such dignified form, so charming, so full of spirit.'[26]

Why, then, did Le Corbusier vandalize the very house he loved? Did he think the murals would enhance it? Certainly not. Le Corbusier had repeatedly stated that the role of the mural in archi-tecture is to 'destroy' the wall, to dematerialize it. In a letter to Vladimir Nekrassov in 1932, he writes: 'I admit the mural not to enhance a wall, but on the contrary, as a means to violently destroy

the wall, to remove from it all sense of stability, of weight, etc.'[27] The mural for Le Corbusier is a weapon against architecture, a bomb. But 'why then to paint on the walls . . . at the risk of killing architecture?', he asks in the same letter, and then answers: 'It is when one is pursuing another task, that of telling stories.'[28] So what then is the story that he so urgently needs to tell with *Grafitte à Cap Martin*?

We will have to go back once more to Algiers. In fact, Le Corbusier's complimentary letter to Eileen Gray, sent from Cap Martin on 28 April 1938, wears the letter head *Hotel Aletti Alger*. Le Corbusier's violation of Eileen Gray's house and history is consistent with his fetishization of Algerian women. One might even argue that the child in this mural reconstitutes the missing (maternal) phallus, whose absence, Freud argues, organizes fetishism. In these terms, the endless drawing and redrawing is the scene of a violent substitution that in Le Corbusier would seem to require the house, domestic space, as prop. Violence is organized around or through the house. In both circumstances (Algiers or Cap Martin) the scene starts with an intrusion, the carefully orchestrated occupation of a house. But the house is in the end effaced (erased from the Algiers drawings, defaced at Cap Martin).

Significantly, Le Corbusier describes drawing itself as the occupation of a 'stranger's house'. In his last book, *Creation is a Patient Search*, he writes: 'By working with our hands, by drawing, we enter the house of a stranger, we are enriched by the experience, we learn.'[29] Drawing, as has often been noted, plays a crucial part in Le Corbusier's process of appropriation of the exterior world. He repeatedly opposes his technique of drawing to photography:

When one travels and works with visual things – architecture, painting or sculpture – one uses one's eyes and draws, so as to fix deep down in one's experience what is seen. Once the impression has been recorded by the pencil, it stays for good – entered, registered, inscribed. The camera is a tool for idlers, who use a machine to do their seeing for them.'[30]

Clearly, it is statements such as this that have gained Le Corbusier the reputation of having a phobia for the camera, despite the crucial role of photography in his work. But what is the specific relation between photography and drawing in Le Corbusier?

The sketches of the Algerian women were not only redrawings of live models but also redrawings of postcards. One could even

argue that the construction of the Algerian women in French post-cards (See fig. 6), widely diffused at the time,[31] would have informed Le Corbusier's live drawings, in the same way that, as Zeynep Çelik notes, Le Corbusier precisely reproduces in his physical entrance to foreign cities (Istanbul or Algiers, for example), the images of these cities constructed by postcards and tourist guides. In these terms, not only did he know 'what he wanted to see',[32] as Çelik says, but he saw what he had already seen (in pictures). He 'enters' those pictures. He inhabits the photographs. The redrawings of the *Femmes d'Alger* (See fig. 7) are also more likely to have been realized, as von Moos points out, from postcards and reproductions than from the original painting in the Louvre.[33] So what, then, will be the specific role of the photographic image as such in the fetishistic scene of the 'Femmes de la Casbah' project?

The fetish is *'pure presence'*, writes Victor Burgin, 'and how many times have I been told that photographs "lack presence", that paint-ings are to be valued *because of their presence!'*[34] Clearly this separation between painting and photography is what organizes the dominant understanding of Le Corbusier's relation to photography. What these accounts seem to ignore is that here the drawing, the hand-crafted artistic meditation, is done 'after' the photograph: the art reproduction, the postcard, the photograph.

In fact, the whole mentality of the 'Femmes de la Casbah' draw-ings is photographic. Not only are they made from photographs. They are developed according to a repetitive process where the images are systematically reproduced on transparent paper, the grid of the original graph paper allowing the image to be enlarged to any scale. This photographic sensibility becomes most obvious with the murals at Cap Martin. Traditionally, they have been understood as paradigm of Le Corbusier the painter, the craftsman detached from mechanical reproduction, an interpretation to which Le Cor-busier himself has contributed with the circulation of that famous photograph of him, naked, working at one of the murals. (Do you realize that this is the only nudist image of him that we know? That it had to be here, in this scene, is in itself telling). But what is normally omitted is that *Graffite à Cap Martin* was not conceived on the wall itself. Le Corbusier used an electric projector to enlarge the image of a small drawing onto the 2.50m × 4m white wall where he etched the mural in black.

[They say that, in using black, Le Corbusier was thinking about Picasso's *Guernica* of the year before, and that Picasso, in his turn,

was so impressed with the mural at Cap Martin that it prompted him to do his own versions of the *Femmes d'Alger*. Apparently, he drew Delacroix's painting from memory and was *'frappé'* to find out later that the figure he had painted in the middle, lying down, with her legs crossed, was not in Delacroix.[35] It was, of course, *Graffite à Cap Martin* that he remembered, the reclining crossed-legged women (inviting but inaccessible) being Le Corbusier's symptomatic representation of Eileen Gray. But if Le Corbusier's mural had so impressed him, how come Picasso chose not to see that a swastika was inscribed into the chest of the woman on the right? The swastika may be yet one more sign of Le Corbusier's political opportunism. (Remember that the mural was done in 1938.) But the German soldiers, who occupied the house during the Second World War, may not have seen the swastika either, for it was this very wall that was found riddled with bullet holes, as if it had been the site of some execution].

The mural is a black and white photograph. Le Corbusier's fetish is photographic. After all, photography too has been read in term of the fetish. Victor Burgin writes:

Fetishism thus accomplishes that separation of knowledge from belief characteristic of representation; its motive is the unity of the subject. The photograph stands to the subject-viewer as does the fetishized object . . . We know we see a two-dimensional surface, we believe we look through it into three-dimensional space, we cannot do both at the same time – there is a coming and going between knowledge and belief.'[36]

So if Le Corbusier 'enters the house of a stranger' by drawing, could 'the house' be standing in here for the photograph? By drawing he enters the photograph that is itself a stranger's house, occupying and reterritorializing the space, the city, the sexualities of the other by reworking the image. Drawing on and in photography is the instrument of colonization. The entry to the house of a stranger is always a breaking and entering, there being no entry without force no matter how many invitations. Le Corbusier's architecture depends in some way on specific techniques of occupying and yet gradually effacing the domestic space of the other.

Like all colonists, Le Corbusier does not think of it as an invasion but as a gift. When recapitulating his life work five years before his death, he symptomatically writes about Algiers and Cap Martin in

the same terms: 'From 1930 L-C devoted twelve years to an un-
interrupted study of Algiers and its future . . . Seven great schemes
(seven enormous studies) were prepared *free of charge* during those
years.' And later, '1938–39. Eight mural paintings (*free of charge*) in
the Badovici and Eileen Gray house at Cap Martin.'[37] No charge for
the discharge. Eileen Gray was outraged; now even her name had
been defaced. And renaming is, after all, the first act of coloniza-
tion. Such gifts can not be returned.

P.S. In 1944, the retreating German Army blew up Eileen Gray's
apartment in Menton (Saint-Tropez) having vandalized E.1027 and
Temple à Paiella (her house in Castellar). She lost everything. Her
drawings and plans were used to light fires.

P.P.S. On 26 August 1965, the endless redrawing of the 'Femmes
de la Casbah' still unfinished, Le Corbusier went down from E.1027
to the sea and swam to his death.

P.P.P.S. In 1977 a local mason in charge of some work in the house
'mistakenly' demolished the mural *Graffite*.[38] I like to think that he
did it on purpose. Eileen Gray had spent almost three years living
on the site in complete isolation, building the house with the ma-
sons, having lunch with them every day. Then again, she did the
same thing when building her own house at Castellar. The masons
knew her well; in fact, they loved her, and hated the arrogant
Badovici. They understood perfectly what the mural was about.
They destroyed it. In so doing, they showed more enlightenment
than most critics and historians of architecture.

P.P.P.P.S Since then, the mural has been reconstructed in the house
from the basis of photographs. It re-emerged from its original
medium. The occupation continues.

Notes

1. Martin Heidegger, *The Metaphysical Foundations of Logic*, trans. Michael
 Heim (Bloomington: Indiana University Press, 1984), p. 208.
2. Friedrich Nietzsche, 'On the uses and disadvantages of history for
 life' *Untimely Meditations*, trans. R.J. Hollingdale (Cambridge: Cam-
 bridge University Press, 1983), p. 63.
3. Camillo Sitte, *City Planning according to Artistic Principles*, trans. George

R. Collins and Christiane Crasemann Collins; included in their *Camillo Sitte: The Birth of Modern City Planning* (New York: Rizzoli International, 1986), p. 183.

4. José Ortega y Gasset, *The Revolt of the Masses* (New York: W.W. Norton & Company Inc., 1932), pp. 164–5. Cited by J.L. Sert in 'Centres of Community Life', *The Heart of the City, Towards Humanization of Urban Life*, ed. J. Tyrwhitt, J.L. Sert and E.N. Rogers. (New York: Pellegrini & Cudahy, 1952), p. 3.

5. Sert, 'Centres of Community Life', (8th. International Congress for Modern Architecture) *The Heart of the City*, p. 6.

6. Ibid, p. 8.

7. Peter Adam, *Eileen Gray: Architect/Designer* (New York: Harry N. Abrams, 1987), p. 174.

8. Letter of Marie Louise Schelbert to Stanislaus von Moos, 14 February 1969. Quoted in Von Moos, 'Le Corbusier as Painter', *Oppositions*, 19–20 (1980), p. 93.

9. James Thrall Soby, 'Le Corbusier, Muralist', *Interiors*, 1948, p. 100.

10. Le Corbusier, *My Work*, trans. James Palmes (London: The Architectural Press, 1960), p. 50.

11. Samir Rafi, 'Le Corbusier et 'Les Femmes d'Alger', *Revue d'histoire et de civilisation du Maghreb* (Algiers), January 1968, p. 51.

12. Letter of Jean de Maisonseul to Samir Rafi, 5 January 1968. Quoted in von Moos, 'Le Corbusier as Painter', p. 89.

13. From several conversations of both Le Corbusier and Ozenfant with Samir Rafi in 1964. Quoted in Samir Rafi, 'Le Corbusier', p. 51.

14. von Moos, 'Le Corbusier as Painter', p. 91.

15. Conversation of Ozenfant with Samir Rafi, 8 June, 1964, quoted in Rafi, 'Le Corbusier', p. 52.

16. von Moos, 'Le Corbusier as Painter', p. 93.

17. Rafi, 'Le Corbusier', pp. 54–5.

18. Ibid, p. 60.

19. Letter of Marie Louise Schelbert to Stanislaus von Moos, 14 February 1969. Quoted in von Moos, 'Le Corbusier as Painter', p. 93.

20. Le Corbusier *Vers une architecture* (Paris: Crès, 1923), p. 196. The passage referred to here is omitted in the English version of this book.

21. Adam, *Eileen Gray*, p. 311.

22. See ibid, pp. 334–5. None of the captions accompanying the photographs of the murals published in *L'Architecture d'aujourd'hui* mentions Eileen Gray. In subsequent publications the house is either simply described as 'Maison Badovici', or more directly attributed to him. The first recognition of Gray in architecture since the 1920s came from Joseph Rykwert, 'Eileen Gray: Pioneer of Design', *Architectural Review*, Dec. 1972, pp. 357–61.

23. In *Casa Vogue* (Milan) no. 119 (1981), the house is described as 'Firmata Eileen Gray e Le Corbusier' ('signed Eileen Gray and Le Corbusier'), and the sofa as 'pezzo unico di Le Corbusier' ('unique piece by'); quoted by Adam in *Eileen Gray*, p. 335.

24. Letter of Badovici to Le Corbusier, 13 December 1949; quoted in Adam, *Eileen Gray*, p. 335.

25. Letter of Le Corbusier to Badovici, quoted in ibid, pp. 335–6.
26. Letter of Le Corbusier to Eileen Gray, Cap Martin, 28 April 1938; quoted in ibid, pp. 309–10.
27. 'J'admets la fresque non pas pour mettre en valeur un mur, mais au contraire comme un moyen pour détruire tumultueusement le mur, lui enlever toute notion de stabilité, de poids, etc.': Le Corbusier, *Le passé à réaction poétique*, catalogue of an exhibition organized by the Caisse nationale des Monuments historiques et des Sites/Ministère de la Culture et de la Communication, Paris 1988, p. 75.
28. 'Mais pourquoi a-t-on peint les murs des chapelles au risque de tuer l'architecture? C'est qu'on poursuivait une autre tâche, qui était celle de raconter des histoires' (ibid).
29. Le Corbusier, *Creation is a patient Search* (New York: Frederick Praeger, 1960), p. 203.
30. Ibid, p. 37.
31. For a discussion of French postcards of Algerian women circulating between 1900 and 1930 see Malek Alloula, *The Colonial Harem* (Minneapolis: University of Minnesota Press, 1986).
32. Zeynep Çelik 'Le Corbusier, Orientalism, Colonialism', *Assemblage*, 17 (1992), p. 61.
33. von Moos, 'Le Corbusier as Painter', p. 93.
34. Victor Burgin, 'The Absence of Presence', in *The End of Art Theory: Criticism and Postmodernity* (Atlantic Highlands, NJ: Humanities Press International, 1986), p. 44.
35. Rafi, 'Le Corbusier', p. 61.
36. Victor Burgin, 'Modernism in the *Work* of Art', *20th Century Studies*, 15–16 (December 1976); reprinted in *The End of Art Theory*, p. 19. See also Stephen Heath, 'Lessons from Brecht', *Screen*, vol. 15, no. 2 (1974), pp. 106ff.
37. Le Corbusier, *My Work*, pp. 50–1 (my emphasis).
38. von Moos, 'Le Corbusier as Painter', p. 104.

'The Boundary Rider': Response to 'Battle Lines'

Sue Best

Tightly and carefully constructed, and presenting a very smooth, finished surface, Beatriz Colomina's 'Battle Lines' is a very difficult paper to respond to, as it is somewhat wall-like itself. In short, it is a well-defended argument and thus difficult to breach, to penetrate, to enter. I repeat Colomina's language of warfare and battle advisedly, as is not the position of the respondent also that of the trespasser, the insurgent, the combatant?

To respond to another's work is in some sense always tinged with violence as it entails not only entering the 'house of a stranger' but also making oneself at home: at the very least moving the furniture around and in extreme cases, as exemplified by Le Corbusier, destroying the walls. To cross the boundary is always to breach the boundary as Colomina indicates in her concluding pages: 'The entry to the house of a stranger is always a breaking and entering, there being no entry without force no matter how many invitations.'

If this condition is generalizable in this fashion, and, indeed, I firmly believe that it is, then violence is the basis, the condition of possibility of any work or construction, whether it is called creative or critical. To build something, to make something, to write something, all of these activities entail incorporation, appropriation and, in some cases, even destruction.

Part of this point is currently quite easy to accept. The way is paved by postmodern art which is consistently interpreted as having foregrounded some of these issues, particularly the rise of appropriation as a viable artistic strategy, and the concomitant fall or declared bankruptcy of the notion of originality. Or, to be more precise, originality has become a problematic not an aim; and perhaps as a corollary of this, productivity and the generative power of appropriation can be thoroughly explored. Indeed, few, in these postmodern times, would subscribe to the Modernist-manifesto,

immaculate-conception, version of originality: that is, a reproduction which escapes 'earthly' insemination and fertilization.

However, while we can currently accept appropriation, we seem less able to accept destruction and violence as a continuing and intrinsic part of all Western production. Maybe this was more palatable in the modern period when 'down-withs' routinely formed part of the vocabulary of any self-respecting avant-garde movement.

There is, perhaps, some value in this historicization, although the too-neat modern/postmodern dichotomy tends to loosen our grip on the problem of engagement and appropriation as forms of violence. Instead, violence and originality end up cordoned-off on one side of the great divide, while appropriation and incorporation are contained on the other. The more interesting bleed across this border is thus stemmed: that is, the continuation of violent 'down-withs' in postmodernity and the appropriation and incorporation which can now be seen to have made modernism possible.

Current versions of 'down-with' offer a particular kind of containment. They allow one to erect a border and from behind this secure wall to point to the 'error' or violence of others' thoughts, actions or constructions: critique is here a kind of casting-out of error, a new purification. In this scenario violence is, of course, on the other side of the wall. But is it? This discursive eugenics assumes that the subject who is able to speak of violence is, indeed, pure and blameless. But what if, as Colomina suggests, violence is not just on one side of the wall? What if it is not simply confined to public space, the space of official combat and debate?

In the image Colomina mobilizes of the city as a cannon, the private and the domestic are the steel wire around the hole, such that the supposedly safe domestic interior is the very substance of the weapon. As Colomina concludes: 'The interior is therefore precisely the possibility of the violence that becomes visible outside it.' The interior is thus totally enmeshed in this production of violence; it is not neatly separable from it.

Following these insights to the letter, means that I, as a feminist, am not separate from this violence. It would be far preferable for me to put myself on the other side of the wall, in the pure camp of those 'more sinned against than sinning' and thereby to become part of the solution, rather than the problem. However, despite the considerable temptation, I must resist and instead place myself on the side of violence, as I, like Le Corbusier, am an appropriator of

another's space. I certainly don't intend to vandalize this space but I do want to clear some space for my own interests.

This is a form of violence to the integrity of the original dwelling/thinking as built and furnished by Colomina. I want to emphasize the ineluctable violence of annexing and re-arranging another's dwelling/thinking, as it is precisely when the consequences of this kind of engagement are brought home, and indeed so close to home, that we are reminded of our profound commitment to boundaries. No one who puts their work 'in public' particularly wants anyone to rearrange it or extend it, in spite of the implicit public 'invitation' for readers or viewers to 'enter' it, or make of it what they will. We may all publicly declare that boundaries have, or should, come down, or have, or should be, blurred. We may think they are violent and divisive but when it comes down to it, we are all profoundly invested in their continuation.

Even feminism, which constantly highlights the destructive effects of boundaries, is also absolutely committed to the battle line for its own definition. Whilst representing enemy territory to be attacked, patriarchy also makes feminism possible. The battle line is thus crucial, enabling and productive; it marks the boundary line of the last encounter but it also undoes the claimed polarization as it also marks the shared boundary: that is, where the two camps join.

What would it mean to ride a boundary? It could mean policing the edges, or it could mean trying to inhabit the battle line. My interest here is in the latter form of boundary riding, and, in particular, in a form of feminist criticism which could be both critical of violence and yet also able to acknowledge its complicity with it. In other words, I am interested in what I will term 'critical complicity': that is, maintaining a critical edge in relation to extreme violence, such as Le Corbusier's, and yet also remembering to be included in the same critique.

Do I need to clear a space for this? In order to speak or to create we are all forced to clear a position for ourselves, we must *make* space for ourselves. There is no empty space reserved for us, calling for us to fill it; we can never assume there is a blank wall or slate awaiting our inscription. In spite of this profound 'lack of emptiness', there are many who subscribe to the idea of empty space. Indeed this notion of blank space awaiting or requiring some 'form' does seem to be a remarkably persistent idea. It certainly informs Plato's notion of space. For him, space is the mother receptacle, the

matrix awaiting the impress of the paternal form: a sexualization of space which may in no small way account for the continual assumption and association of space with emptiness, a hole waiting to be filled.[1]

Sartre also followed this line (of argument), this contour which defines the presence of an absence, that is the dreaded hole in being. According to him the In-itself, the 'given' state of affairs, is represented by a 'hole' which needs and desires the forming and transforming For-itself.[2] This tale of absence, a yawning and yearning gap, is repeated by innumerable colonizers, including the colonizers of Australia, all of whom, no doubt, had a considerable investment in seeing nothing.

Colomina's paper cites yet another example of this wilful or hysterical blindness. She refers an excerpt from José Ortega y Gasset's *The Revolt of the Masses* which José Louis Sert used to open the 1952 CIAM congress, *The Heart of the City*. In that somewhat fanciful reconstruction of the formation of the *polis* it was assumed that prior to the actions of the Greeks the 'earth was one unbounded field', an 'amorphous, limitless space' which is contrasted with the 'enclosed finite space' they produced. In other words, settlement or colonization assumed a blank, yet a blank which has potential, a sort of full plenitude, a lack of a lack – to use Lacan's terms – which is then subject to symbolization when it is given a boundary and divided into inside and outside.[3]

The reference to Lacan here is not accidental; this is how the subject's boundary is also mapped. Psychoanalysis also presumes a full plenitude which is only later divided up when the Child becomes aware of such spatial relations as here and there, which are again – and this is clearly no coincidence – closely allied with the mother: that is, the mother's absence and presence. This mapping, of course, presumes a blank or blankish child, a pure beginning.[4] But if space is always already settled and inscribed perhaps we might also argue that so too is the child. It is interesting to note, however, that this double production of discrete bounded subjects and discrete bounded spaces turns on the notion of a beginning, an origin when space or the subject were unformed, unformatted, in effect, like blank disks. Did Le Corbusier also 'see' nothing? Did he see a blank (a blank wall) awaiting him?

As part of a general strategy of critical complicity I want to oppose this desire to see nothing. However, I don't want to replace it

with the traditional role of the woman intellectual – the obverse of seeing nothing which is trying to see and be mindful of everything – the situation discussed by Michèle le Doeuff when she notes the preponderance of respectful female commentators amongst her students.[5] Moira Gatens has suggested as a corrective to this view that rather than women being merely good commentators who add nothing of their own, women could be argued to claim nothing as their own: they render their interpretative labour invisible, all in the cause of building and maintaining the house of the master.[6] So, even when there is supposed to be only respectful maintenance, there is a degree of meddling, shifting and unpacking of the household goods. In effect, even the attempt faithfully to repeat some one else's thought will involve a certain degree of violence to that thought. 'Distortion' and 'deformation' are inevitable.

From this we could argue that in order to construct a subject-slot, we must begin by entering the stranger's house and appropriating, deforming and maybe even defacing their thought, as we make it over into our own. This means that no one begins with an empty space, this fantasy that seems to function as a denial of our maternal origins.

Clearing space, as this paper should indicate, means drawing upon the work of others. Although we cannot really claim to have 'cleared' a space, complete erasure does not take place; rather we write over that already written space, such that our writing remains legible, for a time at least before it is covered over. Through this process we remain defined, tied and indebted to that from which we differentiate ourselves. We incorporate and are incorporated by what we draw upon in both senses of this phrase. It is in the ambiguity of 'draw upon', that the violence of this action can be seen. To draw upon the work of the other is to absorb it, use it, and become part of it; but it also means to efface it, to write over it, to attempt to obliterate it.

The boundary is very hard to discern in this co-mingling of inscriptions and substances. To ride the boundary may well mean pushing it to exhaustion, or at the very least loosening our too certain grip upon it, and the moral rightness it might confer on any particular position. It is a much more complicated and imbricated version of politics that would result from this ride right along the battle lines, but surely this is the only one in the field worth saddling up.

Notes

1. Plato, *Timaeus and Critias*, trans. Desmond Lee (Harmonsdworth: Penguin, 1965) p. 69. See also Ann Bergen's commentary on Plato's concept of *chôra* in 'Architecture Gender Philosophy' in *Strategies in Architectural Thinking*, ed. John Whiteman, Jeffrey Kipnis and Richard Burdett (Cambridge, MA: MIT Press, 1992), pp. 48–67.
2. See Toril Moi, 'Existentialism and Feminism', *Oxford Literary Review*, vol. 8, nos 1–2 (1986), pp. 88–95 for a discussion of the feminine 'nature' of Sartre's In-itself and the masculine 'nature' of the For-itself.
3. In the preface to the English-language edition of *The Four Fundamental Concepts of Psycho-analysis*, ed. Jacques-Alain Miller, trans. Alan Sheridan (Harmondsworth: Penguin, 1979), p. ix, Lacan refers to the Real as 'the lack of the lack'.
4. Julia Kristeva's re-reading/appropriation of Plato's notion of space/ *chôra* does, to some extent, question the idea of the neonate as a blank, or rather, a being without inscription. See *Revolution in Poetic Language*, trans. Margaret Waller (New York: Columbia University Press, 1984), pp. 25–30.
5. Michèle le Doeuff, 'Long Hair, Short Ideas', in *The Philosophical Imaginary*, trans. Colin Gordon (London: Athlone, 1989), p. 124.
6. Moira Gatens, 'Feminism, Philosophy and Riddles without Answers', in Carole Pateman and Elizabeth Grosz (eds), *Feminist Challenges: Social and Political Theory* (Sydney: Allen & Unwin, 1986), p. 21.

4

The Cultural Periphery and Postmodern Decentring: Latin America's Reconversion of Borders

Nelly Richard

Remembering that *maps* are one of the most common cultural metaphors in our conception of the world, it is significant that the history of cartography is also the history of a certain rationalization: of how an order that measures and cuts up surfaces to articulate territories of signification and representation is, itself, subject to order. Both the geometric models and the visual categories employed by map-makers to formulate specific images of spatiality reflect the structures of knowledge which define the philosophical and cultural thinking of a tradition. From time immemorial the concentric representation of space has drawn an image of finiteness and completeness which symbolizes that form of universal knowledge whose domain is enclosed – sealed – within the perimeter of the circle. This symbolization operates as an image of totality, establishing a fixed point which permits the measured evaluation of relationships of proximity and distance that either draw together or separate all other points distributed in space: 'Each historical period or cultural tradition selects a fixed point which functions as the centre of its current maps, a physical symbolic space to which a privileged position is attributed and from which all other spaces are distributed in an organized manner.'[1] The privileged position which this centre defends, and then translates into authoritarian roles – taking decisions, fixing rules, exercising control, etc. – stands out most forcefully in the opposition we can mark as centre/periphery.

71

The centre traditionally stands for the place of the symbolic concentration of values and power. Following the tradition of Western metaphysics, the centre symbolizes that *whole* in which the founding meaning of origin and truth is concentrated. The centre articulates the representation of space by delineating outlines (fixing limits) and simultaneously graduating the degrees of intensity between the *middle* (the point of greatest saturation and gravity of meaning) and the *borders* or *edges*: those zones in which the loss of clarity issues in a lack of definition.

The relationship staged between centre and periphery assumes paradigmatic dimensions in the case of a European-dominated Modernity which synthesized in the image of the centre its rationalizing ideals of dominion and control (light), while conceiving of the periphery (shade) as a zone of subordination to its civilizing hierarchy. The countries of Latin America, their imaginaries replete with the ethos of cultural colonization, have been tributaries of this geographical and symbolic polarization. It is one that sets the *centre* (modernity and progress; metropolitan advance) against the *periphery* (traditionalism and regionalism; provincial backwardness). Centre and periphery thus reproduce the model-copy opposition: the centre acts as a model (the metropolitan paradigm of a 'point of reference' to be comprehended, applied and enforced in questions of politics, in philosophical constructions and across the syntax of cultural styles), while the periphery is defined as a reflex extension condemned to the reproduction and imitation of a succession of 'original' moments. Model and copy are the categories of power and meaning that international Modernity dispenses in favour of an image of the centre that is consistently subordinate to the metropolitan – and cosmopolitan – concept of the new.

The transformations in train (those breakdowns in the grand narratives of universal modernity) within the postmodernist scene, shifted the authoritarian structure which validated the absolute hierarchy of the centre, and at the same time reasserted the role of the periphery (edge, border, margin), giving it the opportunity to emerge as a new 'protagonist', and in the process vindicating that which was previously censured as Other, as heterogeneous. In this sense, I understand the periphery not solely as a *place of operation* (a historico-cultural, or politico-social context) but also – and above all – as a *site of enunciation*: that is, as a discursive position/posture and a critical strategy of cultural negotiation.

CENTRED MODERNITY AND PERIPHERAL MODERNITY: THE HETEROGENEITY OF THE BORDERS

The pact signed between *modernity* and *centrality* is expressed in diverse ways. First, Western modernity transmits its ideals of historical and technical progress through the networks of the metropolitan circuit which draw together and interconnect with the central countries, those national formations that share the same logic of development, the same history of 'civilizing' advance. Secondly, modern(ist) epistemology converts reason and history into self-centred totalities which exercise their dominion by relegating to the margins of logocentric thinking all that which resists or opposes its meta-abstractions. Constrained by this dual centralizing tendency, the peripheral formations had the experience of their underdeveloped modernity foisted upon them as a lesser and deficient (incomplete, failed) version of the model of developed modernity imposed by the centre. Nevertheless, various re-readings of Modernity, responsive to all that was expressed within it by that (censured or repressed) language of the 'intemperate', managed to subvert what might appear as a rote dependence on the unitary, fixed, register of Modernity. These re-readings have various orientations. One of them – which emerged from within European Modernity itself – uses the folds of the Baroque to reveal contradictions in the unifying synthesis of classical rationalism, and to confront the 'great founding figures of modernity – Subject, representative stability, Centre and Totality'[2] – with the anti-linear torsions of the decentred, which is, in turn, made over as a metaphor of 'the feminine'.[3] A further orientation consists in exploring the map of universal modernity not from the self-fulfilling program of the glorious achievements announced in the epicentres of European civilization (Paris, London, Milan) but from the eccentric/ex-centric tracings whose capricious, dissonant, replicas confound the rectilinear logic of uniform progress and reason with their explosive figures of fragmentation:

> between the end of the century and the 1930s, Austrian culture submitted received ideas of the 'subject' and 'substance' to a radical critique. The subject is no longer revealed as a unitary centre around which contradictions are hierarchized and synthesized, but to the contrary, as a chaotic place, set apart, where contradictions confront each other, cross each other and mix without

ever arriving at a resolution . . . Viennese culture, which tended to look for the truth on the surface of things, was also a cradle of postmodernism, of those processes which amplified the strong categories of thought and dispersed life into a collection of atomised, weakly linked parts, thus provoking the annihilation of conceptual order and the exhaustion of all reality.[4]

However, if there is an arena in which the paradoxes and contradictions of central modernity are exacerbated, an arena in which modernity ceases to be One and instead conjugates multiple and heterogeneous inclinations (and declinations), then this is Latin America. Here is a truly peripheral zone in which 'the contradictory meaning of [Latin American] modernity: the time of development traversed by the untime of difference and cultural discontinuity',[5] is well established, understood and appreciated.

Latin America became part of modern experience through its subordinated incorporation within the tendencies of progress – development and consumption – set in motion by the flow of goods and messages from Northern markets. But such flows are irregular. They are simultaneously absorbed or rejected by regional proclivities as they respond to differentiated mechanisms of reception which depend on the encrustations of the New particular to each local stratum. Certain modernizing impulses derived from the metropolis combine in strange ways with stratified regional pasts to create a sedimentation of heterogeneous memories, while other international rhythms are blocked by times and spaces which are resistant to their logic of progress or penetration. Such fragmentary, counterpoised, pulsions turn Latin American modernity into a collage of processes locked within a field of disparate, unstable tendencies. This is why in Latin America modernity betrays the linear scheme of development of a simple historicity by promoting the intersection of multiple and complex temporalities which unite and disunite in irregular bursts: 'In the case of Latin America, the motor of modernity – the international market – promotes and then reinforces an incessant movement towards the heterogenization of culture, setting into motion, stimulating and reproducing a plurality of *logics* which all act simultaneously, overlapping one another.'[6] This plurality of simultaneous and contradictory logics logics underlines the sense of what J.J. Brunner calls the 'cultural heterogeneity' of Latin America:

cultural heterogeneity refers to a double phenomenon: 1. segmentation and segmented participation in the world market of messages and symbols whose underlying grammar is the North American hegemony over the imaginary of a large fraction of humanity. 2. Differential participations following local codes of reception, both group and individual, in the ceaseless movement of circuits of transmission ranging from publicity to pedagogy ... Cultural heterogeneity means something very different from diverse ethnic cultures (subcultures), classes, groups or regions, or from a mere overlaying of cultures – whether they have found a form of self-synthesis or not. It means, primarily, segmented and differential participation in an international market of messages that unexpectedly 'penetrate' the threshold of local cultures, leading to a real implosion of the senses of consumption/production/reproduction.[7]

'Cultural heterogeneity' (Brunner) or 'multi-temporal heterogeneity' (García Canclini) of Latin American time-space, are the characteristics which best describe the *discontinuous* state of a historico-social formation comprised of memories and segmented imaginaries, interwoven with tradition and progress, orality and telecommunication, folklore and commerce, myth and ideology, rite and simulacrum, etc. The incoherent expressions of this peripheral modernity with its implants, transplants and shifting references, make it 'a heteroclite configuration of elements drawn from virtually anywhere, but always removed from their original context'[8] and given a new function through the local dynamics of sign conversion.

Seen in this way, *borders* (especially Latin America as a border, a cultural periphery) are the places where models and references range beyond the networks of meaning ordered and controlled by the cultural hegemony of the centre, which obliges the signs to defend certain programs of representation aimed always at conserving the privileges accrued by centrality and totality. The ruptures in the universal design of central modernity liberate the meaning of those fractions of language and identity which are disseminated on the periphery of the universal-culture system, and which disturb the normative, official, control-codes of a 'superior' culture.

THE BORDER AS A FRONTIER OF IDENTITY AND
A TRANSCULTURAL CROSSROADS

The 'cultural heterogeneity' of Latin American space-time should
not be understood as a mere aggregation of layers which passively
lie over one another like the sediment of static pasts. Rather, it
should be seen as the irregular combination of an already uneven
series which has come to form part of an *active multiplicity* of con-
flictive temporalities.

Such a combination suggests a certain type of Latin American
modernity which emerges as the tensional product of an interaction
of forces that counterpose the international (metropolitan progress)
and the regional (indigenous and popular traditions) within multi-
layered formations. This concept of modernity stands in opposition
to that presented by another Latin American vision, which is firmly
anchored in the defence of a continental *ethos*: that is, of a Latin
American identity whose *purity of origin* might be threatened by the
interference of signs emanating from Northern modernity. Accord-
ing to this vision, the abstract universalism of the Western Logos
and the functionalist rationalism of European modernity have dis-
figured the particular identity of Latin America by submerging its
panoply of rites and beliefs beneath the mask Europeanizing
ideologisms and technologisms.[9]

The collision of these two images of modernity (one as a super-
imposed reference, and the other as an intermingled force) leads
us back to the question of Latin American identity itself, and its
divisions between the 'Own' and the 'Alien'. The entire history of
cultural colonization, between whose lines of domination and
subalternity Latin America has been forever ransomed, reflects the
disjunctions of *identity by imposition* (when the Westernized norm of
the Self enforces the reproduction of a monocultural pattern) or of
identity by opposition (when the essentialist radicalization of the Other
serves as a gesture of counter-identification). This interplay of be-
ing and seeming has been dramatized by Latin American cultural
thought which sets *substance* (the indigenous background as the
ontological reserve of a property-identity) against *appearance* (the
mask of metropolitan culture as the mark of a borrowed identity).
The entire continental – Latin Americanist – discourse of the quest
and definition of 'Latin American identity' remained for the most
part within the sway of this Manichean scheme which juxtaposes
the internal (deep) and the external (superficial), the authentic

(native) and the false (foreign), the pure (virgin nature) and the polluted (industry and commerce), etc. So many of the controversies that enlivened the history of ideas in Latin America bear the scars of this skirmish between regionalism and cosmopolitanism (the polemic of modernism and of vanguards); between nationalism and multinational capitalism (the anti-imperialist critique of the North Americanization of consumption); between the Third World and the First World (the myth of resistance to the expansion of capital from areas which romantically phantasize that they are still free of trade and the traffic of the market-place); and so on.

Various shifts and reformulations of the coordinates of power – and of the circulation of power – which set up the play of forces between domination (the centre) and resistance (the periphery) have modified the theories of cultural dependency which formed the basis of thinking about Latin American identity in the 1960s. Certain of the changes in coordinates are related to the transnationalization of the information and communication markets which now disperse cultural power by following miniaturized networks for the colonization of imaginaries (passive consumption), but also of *differential resignification* of the messages transmitted (active and transformative reception). These movements of transference and interchange recombine *identities* (belonging) and *frontiers* (delimitation, circulation) in ways that are much more complex and subtle – as well as perverse – than was previously the case. They are movements that *deterritorialize* the geographical course of the relationship between the 'popular' and the 'national': movements that demonstrate how Latin America has passed 'from the defence of the national and popular to the export of the international and popular',[10] as with Brazilian television soap-operas which are consumed all over the world with a similar degree of success.

This deterritorialization of the signs of cultural identity – exacerbated by the modernizing currents which disturb the boundaries of high culture and popular culture, of the national and the transnational, by combining hybrid registers of experience – makes it difficult to continue to defend metaphysical contemplation of that *being* which serves as the basis of Latin American substantialism concerning Origin. Such 'originary' thought mythologizes the past (roots, sources) and effortlessly converts it into folklore, a reservoir of guardians for a preset identity. The traditionalism and fundamentalism of the 'Own' is based on an archaic memory and a nostalgic return to origins. It takes no account of the fact that that

which is 'Ours' is the product of a dialogic interrelationship which crosses multiple and shifting registers of experience. Identity is not the ritual store of a founding (originating, transcendental) truth to which one must return in search of *one* sole sense of belonging. Identity is a moving construction which is formed and transformed according to the dynamics of those confrontations and alliances in which the cultural subject participates in ever-changing circumstances. From this point of view, 'authenticity' can only be the creative product of a mixture of pasts and presents selected with regard to alternative futures, assembling quotations in order to dialogize the Self (the Own, the Ours), and placing it in tension with a variety of Other repertoires with which it establishes relationships of borrowing and negotiation: 'metaphors of continuity and "survival" do not account for complex historical processes of appropriation, compromise, subversion, masking, invention, and revival'.[11] Once assembled, these repertoires give place to cross-cultural constructions in which the mixing up and confusion of signs takes the form either of *collage* (the unlikely coming together of pre-existing materials transposed contextually) or of *parody* ('an imitation which mocks the original',[12] by employing double meaning as a satirical device to challenge the authority of the model).

Mestizaje has been one of the formulations of the *impure* according to which Latin American culture has portrayed itself as a mixture. But *mestizaje* 'is not only that racial fact from which we come, but the current plot of modernity and cultural discontinuities, of social formations and structures of feeling, of memories, of imaginaries which mix together the indigenous and the rural, the rural and the urban, folklore and the popular and the popular with the massive'.[13] These present-day crosses and appropriations connect into the history of syncretism and hybridization that Latin America inherited from its colonial past: operations of cultural transvestism which today the aesthetics of *simulation* and of *fragmentation* rename as postmodernist operations.

CULTURAL POWER AND THE DISSEMINATION OF MEANING

Centre and periphery sealed their relationship of hierarchy and dependence through the original-copy pairing which transcribes the dogma of cultural colonization: the original as first meaning

and the only one legitimized by the supremacy of the centre (the model), and the copy as a mimetic reproduction which translates it into an inferior, subordinated tongue.

The tradition of Latin American cultural thought always reserved for the 'enlightened elites' the task of mediating the gulf between progress and backwardness, spreading the lessons of the translated model. This was the machine for the production of outlines-of-culture, and reference-guides to metropolitan signification. The role of these 'enlightened elites' which had 'since independence ... articulat[ed] foreign thought', has been to 'reproduce the international debate between European countries',[14] by serving as *translators* of the canonized significations of the centre. Alberto Moreiras writes of 'translation' as a key agency of mediation through which Latin America has always attempted to resolve the distance between metropolis and periphery, continually adapting the *text* (the first enunciation) to the *reading* conditions of the context of reception-appropriation.[15] Modernity imprinted the model with codes that absolutized its meaning as first, unique and total: a process that was legitimized universally through the canonic weight of the Western tradition.

In light of such formidable constructions, a key question (and its implications) comes to the fore: how is the transculturizing operation of the Latin American periphery to be redefined, especially when the 'text' to be translated is no longer the unique and foundational (vertical) text of the modernity of the centre, but rather the plural and disseminative (horizontal) text of a postmodernity which speaks to us of decentrings?

The postmodern scene contemplates various processes by which the 'strong' categories of rationality and the absolutization of truth – which modernity had elevated to 'master' status – can effectively be 'weakened'. As a register of 'a crisis of cultural authority, specifically of the authority vested in European culture and its institutions',[16] postmodernity entails a questioning of various of the notions on which the supremacy of a fixed pattern of meaning was founded. These include: notions of *totality* (the disintegrated fragment replaces the completeness of the whole); of *centrality* (there is no longer any fixed point to justify the superior domain of an absolute reference); and of *uniqueness* (the monologic thought of the Self has been challenged by the dispersed heterogeneity of the multiple). One result of these challenges is the precipitation of a profound crisis of cultural identity.

We are now witnessing the pluralization of meaning, the fragmentation of identity, and new disseminations of power. Meaning systems have been pluralized and relativized: languages, history and society are rendered as texts, and no longer respond to forms of transcendental signification which subordinated the understanding of the real to its unique code of hierarchized reading. Instead, the new relativism permits signs to disperse horizontally as the plots (counter-narratives) of provisional and transitory interpretations. Identities are fragmented: the – homogenous and transparent – subject of metaphysical rationalism in command of her/himself has disintegrated into various Selves which combine multiple, unstable, traces of sexual, social and cultural identification. Power is disseminated: there is no longer some fixed polarity which localizes power in one centre, but diffuse networks which multiply and subdivide their points of antagonism and lines of confrontation. This postmodern ramification of power, which misaligns the topography of a centralized referent, giving rise to a fluctuating, multilineal network, supposes that 'centres' and 'peripheries' are now redrafted as multi-sited functions. These (and other) Postmodern redefinitions of meaning, identity and power necessarily inflect the whole notion of the *centre* in important ways.

The mass-mediated landscape of contemporary technoculture promotes the belief that the 'satellization of the real' precipitates the effects of planetary interconnection of a myriad of times-spaces scattered across the centre and periphery of 'the news'. It does so by giving an impression of *ubiquity* which solicits an understanding that 'the multiple images, interpretations and reconstitutions' of reality (which the news media distribute) function without any 'central coordination'.[17] The apparent suppression of distance between the *event* as centre (production of reality) and the *news* as periphery (transmission-reception of information) comes about in two ways. First, because the news is consumed *simultaneously* in any part of the world, the sensation of a homogenization of content is created, leveling out the historico-social unevennesses caused by asymmetries of context. Secondly, the news itself erases the distance between event and information, through the hyper-mediation of the real as an image of an image which is overexposed and recycled to the point of hyper-realist saturation. This way of confusing the distances which mediate and separate the different points spread throughout the network of information production and communication gives the impression that the conditions for the reception of

news in separate (distinct and distant) contexts have finally been equalled out, and contributes to the perceived dysfunctionality of the opposition centre/periphery. Such a dissolution is assisted by the simultaneity of consumption – transnationalized by the information market – which serves to reduce and annul the *out-of-time* that is constitutive of peripheral backwardness.

It is not only the everyday influence of the mass media that blurs the traditional relations between centre and periphery: there are also important philosophical reconceptualizations of identity and difference. These include the postmetaphysical critiques of the philosophies of 'difference', which also seek to dissolve the opposition, governing the logocentric tradition, between centres as points of origination and foundation, and peripheries as derivative and subaltern. Text and writing are understood as pure webs of spacing and differings. The conceptual privilege of a primal trace which retains the transcendental meaning of a unique truth, and the value of the original as a model residing in the supremacy of origin, in its foundational hierarchy, are canceled out. These postmodern shifts reveal the contra-canonical features of a new fragmentation of meaning, now indeterminate and multivalent. They necessarily raise the question as to whether (and how) such changes modify the production and reception of the authority which had previously defined – and occluded – the periphery.

If the postmodern text is characterized by its 'discontinuity', we might also suppose that the postmetaphysical economy of the fragmentation and dissemination of meaning could be useful to the periphery as an anti-fundamentalist device in its rebellion against the dogma of the centre. It is in this sense that we should understand the affirmation that 'postmodernity, for postcolonial societies, is an instrument of decolonization'.[18] Given that 'totalization threatens the possibility of emancipation for postcolonial societies because it has the ideological prestige of the lost original',[19] the postmodern critique of totalization effected from the dispersed fragment that emphasizes the breaking-up of the whole should become an instrument of anti-colonialist rebellion and liberation. We should not forget, however, that 'totalization' – which 'is produced by the factic discourse of socioeconomic power and its ideological projections',[20] – leaves its trace behind each time an enunciation transmits meaning, always capitalizing upon the value of a representation of authority. And, no matter how the dislocated rhetoric of postmodernism would draw it, we should also remember that the

centre continues to behave as a marker of prestige and authority. In fact, the centre, split up into multiple centre-functions, no longer carries out its role within the geographical realism of a metropolitan setting. The centre has dis-located itself into a series of centre-functions which exercise their power of authority by dictating usages, settling meanings, making rulings, decreeing currency, etc. The symbolic power of the centre derives from the privileged discursive spaces it occupies through its direction and control of an international network of metropolitan guarantees, comprising, for example, the most influential 'universities, journals, institutions, exhibitions, [and] editorial imprints' in the academic discussion of ideas.[21]

Furthermore, if we believe that the postmodernist theory of fragmentation – a rejection of the dogmatizing tyranny of the system or method – generates a disposition favourable to certain peripheral operations (such as the operations of quotation, of montage and collage, of parody, etc.) it must also be acknowledged that the practice of writing/rewriting the fragment (of any fragment, including a fragment of postmodernist theory) is not an undetermined practice. That is, the practice of the fragment is not a practice free from the determinants of power that rule the productions of culture. Neither the fragment, nor its rewriting, are immune to those givens which the 'word games' of cultural power exercise over devices and procedures, over-legitimizing or delegitimizing their use. This power leads to the fact that postmodernist theories of the fragment are received in the periphery as theories *mediated by* the signs of success which promote their status as theories forged in the discourse of 'American International[ism]' (Huyssen). These signs are mobilized so persuasively to demonstrate the irrefutability of enunciations generated in the centre that they reconstitute around the fragment an image of totality and systematization (that sanctioned by the efficiency switch of the metropolitan core) which removes all freeness and provisionality from the cuttings. Which is to say that the fragment, in spite of its desacralization of the matrix of authority of the whole, is resacralized by the periphery when the periphery applies it as material or procedure 'authorized' and legitimized by the 'superiority' of metropolitan theory.

As is well known, the hierarchy of the centre is based not only on the fact that it concentrates wealth and controls its material distribution. The superiority of the centre depends upon its being invested with sufficient authority to qualify it as a giver of meaning:

its symbolic advantage relies upon its monopolizing discursive and communicative devices to transact signs, values and powers, representing the area of the greatest condensation of signs, of the greatest circulatory and transactional density of current validated meanings. This is why in order to decentre the Centre, it is not sufficient to incorporate the rhetoric of the other (of the marginal, of the peripheral) within the progressive concerns of academic intellectuals. The pluralization and democratization of the mechanisms of cultural signification depend on the dehierarchization of the positions and functions of discourses which comprise the circuit of production and discursive and critical interchange.[22] This dehierarchization is impelled by two types of force:

1. those which move certain international theorists of 'alternative postmodernity'[23] to dare to 'use privilege to destroy privilege'[24]: that is, to break the exclusive, and excluding, monopoly of self-reference under the label of 'North American Academia,' calling on voices from other parts of the world to promote their strategies of socio-cultural intervention;

2. those which emerge from the border as a *site of enunciation* capable of mobilizing forces which traverse the limits of the systems of cultural distribution, thus revealing not only its arbitrariness (the fact that lines are drawn and redrawn by force) but also its *vulnerability*, given that new marginal pacts dealing with negotiations with signs constantly threaten to destabilize the legitimation of power.

(Translated by John Brotherton)

Notes

1. Bonaventura de Souza Santos, 'Una cartografia simbolica de las representaciones sociales', *Nueva Sociedad*, no. 116 (Caracas) (November–December 1991), p. 23.
2. Christine Buci-Glucksmann, *La raison baroque: De Baudelaire à Benjamin* (Paris: Editions Galilée, 1984), p. 34.
3. Ibid.
4. Claudio Magris, 'Esayo sobre el fin', cited in 'La remoción de lo moderno: Vienna del 1900' ed. Nicolas Casullo, (Buenos Aires: Nueva Visión, 1991), pp. 43–4. [trans. Graciela Ovejero]

5. Jesus Martin Barbero, *De los medios a las mediaciones* (Barcelona: Gustavo Gili, 1987), p. 165.

6. José Joaquin Brunner, *Un espejo trizado* (Santiago: Flacso, 1988), p. 219.

7. Ibid, pp. 217–18 [trans. Graciela Ovejero].

8. Ibid.

9. See Pedro Morandé, *Cultura y Modernizacion en America Latina* (Santiago: Universidad Católica, 1984); especially ch. 12.

10. Renato Ortiz cited by Nestor García Canclini, *Culturas hibridas* (Mexico: Grijalbo, 1990), p. 290.

11. James Clifford in *The Predicament of Culture* (Cambridge, MA: Harvard University Press, 1988), p. 338.

12. See Fredric Jameson 'Postmodernism and consumer society', in Hal Foster (ed), *The Anti-aesthetic: Essays in Postmodern Culture* (Port Townsend, WA: Bay Press, 1983), p. 113.

13. Barbero, 'De los medios', p. 10.

14. Bernardo Subercaseaux, 'La appropiación cultural en el pensamiento latinoamericano', *Estudios Públicos*, no. 31 (Santiago), p. 42.

15. Alberto Moreiras, 'Transculturacion y perdida del sentido', *Nuevo Texto Critico*, no. 6 (1991) (Stanford University), p. 108.

16. Craig Owens 'The Discourse of Others: Feminists and Postmodernism', in Hal Foster, *The Anti-aesthetic*, p. 57.

17. Gianni Vattimo, *La sociedad transparente* (Barcelona: Paidos, 1990), p. 81.

18. Moreiras, 'Transculturacion', p. 117.

19. Ibid, p. 116.

20. Ibid.

21. Gayatri Spivak cited by George Yúdice, 'El conflicto de postmodernidades', *Nuevo Texto Critico*, no. 7 (1991) (Stanford University), p. 29.

22. Following the argument developed by Edward Said in the interview 'In the Shadow of the West', in *Discourses: Conversations in Postmodern Art and Culture* (New York: The New Museum, 1990), p. 95.

23. Yúdice, 'El conflicto de postmodernidades', p. 34.

24. Jean Franco, 'Going Public: Reinhabiting the Private', in G. Yúdice, J. Franco and J. Flores (eds), *On Edge: The Crisis of Contemporary Culture* (Minneapolis: University of Minnesota Press, 1992), p. 80.

5

Vulture Culture*

Celeste Olalquiaga

Amidst the ruins of modernity's dream of progress and the glittering wastescape of technological debris, new cultural forms are emerging, simultaneously imitating and overthrowing the post-industrial grid through which they grow. Born as cultural marginalia, these are the practices of certain immigrants, homeless youth and other displaced urban peoples.

Trained by centuries of negotiation with both colonial/mainstream impositions and nationalist zeal, these peoples' fragmented identities are based on the eclectic appropriation of disparate foreign and alien elements, which they bring together in a unique melange that is at once a survival strategy and a lifestyle. In this process, the borrowed elements are decontextualized and made over into icons of themselves, often producing parodic or subversive effects.[1]

During the worst telecommunications crisis in Venezuela's recent history, women in Caracas took to carrying cellular phone look-alike handbags. Hi-tech systems were condensed in their state-of-the-art icons of the moment – cellular phones – only to be simultaneously discredited in a gesture that also disrupted gender and class hierarchies. Months before, every Venezuelan 'yuppie' worth the name had rushed to purchase the new gadget, possession of which not only provided a glamorous show-and-tell of power and efficiency, but also quickened the pulse of that one-uppedness so dear to men, in a context where nobody else in the city could make regular phone calls.

Yet all of this was exposed and turned around by the humourous degradation of these devices into that object of constant male derision, women's handbags. Lacking all meaningful connection to the apparatus of production and exchange, and therefore reduced to an electronically impotent carcass, cellular phone look-alike handbags rapidly became emblematic of the Third World's irregular adoption of the First's consumption systems. In the process, however, these mock handbags succeeded in symbolically demystifying

85

high technology by locating its fallibility in the realm of the mundane. They pronounced on the disparities of global telecommunications in a witty statement devoid of any traces of the cultural subservience often attributed to 'underdeveloped' countries. The fallen apparatus was forced, besides, to carry the weight of all its social implications by being placed in hands that would usually have limited access to it: lower-class women, the secretaries of those who own cellular phones.

This double mode of consumption is immediately indicative of the difficulty of presuming that the cultural market's reception of official and mainstream discourses is in any way uniform or harmonious. In Latin America, this assumption has been cast for centuries as an all-or-nothing dilemma. On the one hand, there is an indiscriminate acceptance of foreign goods and customs (originally from Europe and later referred almost exclusively to the 'American way of life'). On the other, there is either the fanatic waving of nationalistic banners that proclaim the essential goodness of native cultures, or various attempts to resist the thrusts of imperialism, in order to preserve a certain regional autonomy. Despite their apparent contradiction, both of these positions tend to disregard the fact that vernacular cultures consume what is alien to them in multiple and contrasting ways, ranging from uncritical (rote), adoption, to actively transformational processes of assimilation, appropriately dubbed 'anthropophagic' by the Brazilian Oswald de Andrade almost half a century ago.[2] This popular cannibalism digests the foreign body, so to speak, in order to render it more familiar to, and consonant with, the receiving culture.

In the First World, meanwhile, the cultural production of Third World countries is integrated into mainstream culture as a marker of difference and exoticism. Here, what is appropriated loses its original meaning, whatever it may have been. It is pre-emptively voided of any signification that could prove destabilizing to the receiving culture. This was what happened to the USA's 'melting pot' at the turn of the century, when the diversity of European and Asian immigrations was literally boiled away. It is also evident in the current multicultural fad in the USA, in which, rather than negotiating an organic integration of ethnic difference, both official and mainstream discourses treat ongoing syncretisms as if they were discardable, ornamental trinkets to be added and removed at will.

Until recently, therefore, there have been at least two quite distinct processes of cultural integration. By virtue of its attempt

meaningfully to adopt foreign discourses – notwithstanding the decontextualization to which these were subject in order to make them more palatable – that in process in colonized cultures might be considered inclusive. The other, by contrast, which was characteristic of mainstream metropolitan, or First World, cultures, was exclusive in that, despite the fact that it neutralized the absorbed discourse, the assimilating culture never ceased ultimately to treat it as something alien, even when boasting a formal heterogeneity. Now, however, a globalizing postmodernity that mixes and matches at will, taking little interest in historical, geographical or ethnic continuities, has produced a proliferating hybridity that necessitates a more specific elucidation of the elements at play in cultural integration. One of the problems with postmodernism is precisely due to its versatility, to which every melange under the sun is sometimes attributed, with little or no attention to whether these fusions can properly be called postmodern. This is the case with certain types of *bricolage*, like Dada and surrealism, which respond to entirely different cultural conditions, and have their own particular aesthetic and social agendas, but which are, nevertheless, confused with postmodern pastiche, or even considered its predecessors.[3] Differentiating between modes of cultural reception helps us to understand how postmodernism doesn't inherently reproduce a reactionary ideology – as is usually claimed in the arguments condemning it – but, rather, how it is a process whose constitutive elements (fragmentation, speed, eclecticism, ductility) are susceptible to different uses.[4]

THE RECYCLING OF ICONS

The main postmodern symptom is referential emptiness, the clearing-out of a sign's conventional meaning. This vacuuming of signification is constitutive both of the lack of historical and other continuities discussed above, but also of the exposure of hierarchical systems that relied on an obligatory interdependence between referent and sign to maintain their authority. All essentialist systems are affected by this process of referential emptiness, since their founding assumption is that there is a quasi-biological (as opposed to cultural) determinism between, say, ethnic origin and social behaviour, or gender and sexuality.

In the process of this clearing operation, signs are left as icons:

they present what may be conceived as a two-dimensional image of what they stood for before; they are the shell without the nut. In this condition, they are susceptible to being reinfused with meaning (any meaning). This is the condition that grants postmodernism its infinite malleability, and the process in which it is constantly engaged. The results vary extremely, and for the purpose of this essay I will distinguish three kinds of postmodern icon: in the first type, the icon is reinfused with its conventional signification; in the second, the icon unwillingly exposes the conventional meaning as a construct; and, in the third, the conventional meaning is used as a stepping stone for an alternative discourse.

The first kind of referential emptying can be illustrated by an advertisement that appeared in a trendy Venezuelan fashion magazine shortly after the Gulf War. It was for *Selemar*, a local, middle-class, department store (see fig. 9). In the advertisement, there are twenty-two physically similar young men and women (the women are tall and slim, their hair is dark and cut in a bob; the men have worked-out bodies, crewcuts and reddish hair) who are all wearing the motifs of the US flag: stripes, stars, the combination of red, white and blue. The flag itself is displayed at the centre of the advertisement by a young man in underwear who holds it behind his spreadeagled arms. The motifs are also repeated in handbags, an umbrella, and a T-shirt with the inscription 'America'. The advertisement's only other text, 'Selemar has got it . . .', heads up this peculiar group.

The political obviousness of the advertisement relies on the same bizarre, obsessive-compulsion for repetition and homogeneity that momentarily threatens to transform it into a parody of its own pretensions. To begin with, for all its endorsement of the most American of symbols, the advertisement's fragmentation of the flag into its constitutive elements (i.e., stars and stripes) that are then sported as body-wear (bras, men's shorts, socks), is a profanation of the symbol that clears it from its conventional meaning of a country's foremost civic emblem (in Venezuela, it would be unimaginable to do the same with the Venezuelan flag: such a desecration would probably be fined or even carry a jail term). The American flag becomes an icon the moment its primary meaning becomes secondary to its use value. Yet the emptiness left by this fragmentation and functional displacement is immediately recovered by the obsessive repetition of the flag's motifs, which are, in turn, semiotically reinforced by the homogeneity of the models.

This particular relation to the icon may be considered consonant with the audience that is represented and appealed to in the advertisement: the 'yuppies'. As such, it may be labelled 'international yuppyism', constituted as it is by relations that lack any direct emotional investment in the object: being shaped, instead, by a pragmatic stance proper to the most elementary kind of transaction. Overdetermined by exchange value, yuppies treat everything as icons, thereby easily appropriating and devaluing all eras, cultures and positions. However, because this action stems from an attitude of random consumption, and given the vertiginous interchangeability of these icons once they have no referent to fall back on, the traditional meaning with which they were formerly associated can easily slip back into them, leaving them intact as signs. Despite the emptiness of meaning that does in fact take place in this specific relation to the sign, such 'slippage' (which restores the conventional reference that the icon almost lost, for a moment at least) accounts for the reasons why 'international yuppyism' cannot achieve (nor does it seek) any ulterior subversion. What has taken place in this first kind of referential transformation is that the sign has successfully adapted itself to the new cultural demands of global capitalism, emerging like a Phoenix from the ashes of conventional representation.

Fashion and youth also meet in Santiago de Chile's 'weekend punks', as portrayed by Gonzalo Justiniano's video, *Guerreros Pacíficos* (Peaceful Warriors, 1985; see fig. 10 plates section). In contrast to the local punk underground that developed there, Chilean weekend punks live a relatively established life and don punk outfits as party costumes. Delighted at the local commotion they cause, the weekenders perform punk rituals such as wearing elaborate makeup, slam dancing, and ganging up. But, unlike 'real' punks, neither their aesthetics nor their attitudes are connected to the bleakness and violence that characterized the punk movement in the mid-1970s, when it grew out of the depressed British inner cities and was taken up soon after in New York City by middle-class youth.[5] Instead, Chilean weekend punks put on a show because 'es la onda' (it's cool), and their detachment from the local punk sub-culture, as well as their highly iconic experience of it, is perhaps best portrayed in their candid use of pins with the label 'PUNK'.

Originally, the punk aesthetics of deterioration conveyed a disillusionment with cultural progress or harmony. The use of black, torn, and hand-me-down clothing, of chains and spikes, of an

overlayering of fabrics and styles, produced a dysfunctional effect consistent with punk's aggressive cynicism towards society. As a sign, 'punk' conveyed destruction and anger; but, once it was dissociated from the lifestyle that produced it, this sign was emptied of all signification and left as an icon. The aesthetics of death and decay gave way to a decor, an urban style congenial to collective end-of-century scepticism.

What distinguishes this kind of referential emptiness from the previous one is that at this moment in the semiotic process the icon is not reinfused with meaning. Instead, it is borne as an empty signifier. As an emblem, punk does not have the consensual strength of the American flag, and therefore it dies when removed from its 'darkness' into the light. Consequently, punk's destructive power is still at play even when 'punk' disappears as an emblem and becomes an icon, refusing a clean cultural integration by circulating only as a caricature in the mainstream. In so doing, it disables a facile cooptation that would render its referential meaning ineffectual.

While the *Selemar* advertisement restores conventional meaning to the icon – however distorted – Chilean weekend punks unwittingly void it. By openly adopting punk as a fashion that in no way alters the rest of their life, these weekend punks shatter the illusion that adopting a certain type of clothing can automatically grant the corresponding experience. This is a founding illusion of consumer culture and its advertisement strategies, which equate aesthetics with style and style with fashion, implying that in buying fashion you are actually participating of a particular lifestyle. If this is true for the *Selemar* advertisement discussed above (insofar as the sign, here, conveys a meaning that remains intact despite its transitory suspension) it is not so with the appropriation of punk, where the sign's decontextualization cancels its primary signification.

A third and final example will illustrate an entirely different product of referential emptiness. Here, instead of reestablishing or displacing conventional meaning, the process infiltrates the icon with an alternative signification. This is the case of the cultural transvestism recently made public by Jennifer Livingston's documentary on Harlem drag balls, *Paris is Burning* (1990; see fig. 11 plates section). By simulating a straight 'realness', Black and Latino men in drag are able to participate in everyday life transactions without being detected, establishing, all the while, a sub-cultural code and a tacit network of alliances. In this process, mainstream

culture is used as a vehicle on which ethnic and sexual difference can ride.

In the drag balls mainstream culture itself is the sign whose meaning is emptied only to be transited by an alternative discourse. As an icon, the mainstream is converted into a scenario where daily practices are undertaken as so many roles, and thus subverted by their presentation as systemic cultural constructs. The alternative discourse that gallops on these established personae is characterized, on the contrary, by unbounded versatility and fluidity; it is animated by the ambiguous and hybrid aspects of a subculture that has learned to travel on the margins of traditional meaning to survive. In this sense, drag formalizes the implicit strategies of displaced populations which use camouflage as a way of adapting to hostile contexts. In a place like Manhattan, this can be appreciated everywhere, from Harlem's drag balls all the way to the Lower East Side Chinese teenagers' stylization of heavy metal, to the *bricolage* of retro paraphernalia worn by young East Village Japanese designers.

Far from remaining in a continuous state of isolation, or merging completely into the receiving culture, sub-cultural camouflage and transvestism become style in postmodernity. As such, they gain a previously unthinkable degree of cultural legitimacy. The conflation of mainstream codes (straightness, retro fashion, heavy metal gear) with sub-cultures whose access to hegemony is hindered by a cultural marginality (their lack of status as transvestites or immigrants) produces a border-like persona, which is 'made up' as the sum of the codes it chooses to use. These intertwined codes enable the establishment of a difference that pays little heed to conventional meaning, concerned as it is with reproducing surface. The icon, then, is desired precisely for its emptiness, an accessory value that renders it infinitely ductile.

Identity, in this universe, is not something inherent, homogeneous or fixed, but rather a transient, multiple condition that occurs at the intersections of ever-changing cultural crossroads. Foundational sameness is sacrificed for transformational difference. Ignoring the traditional hierarchy between appearance and essence, interior and exterior, reality and simulation, the postmodern persona gains a hitherto unknown mobility, free at last from the artificial strictures that traditional culture imposes on it in the name of essential purity: biological and social consistency, geographical delimitation and historical compulsion. Consequently, this third kind of referential

emptiness paves the way for one of the most exciting and potentially subversive cultural challenges of the moment.

SUBCULTURAL CROSSDRESSING

In this section, I discuss some of the issues underlying the postmodern recycling of icons: the collapse of cultural essentialisms, the hypercodification of style, and the displacement of referentiality by simulation.[6]

One of the main aspects of postmodern identity, as stated above, is its plurality and versatility: its complete divorce from any unitary notions that bind self-perception to an specific moment and place. Postmodernity stands directly against all kind of cultural essentialisms, disclaiming them not only as anachronistic, but mainly as rigid and hierarchical. Instead of a localized, or centred, ontological sense, postmodern identity is constituted in a continually shifting juxtaposition of multiple fragments, resulting in a bizarre personality surplus. Identities, in our time, are discardable, reusable, and modifiable, exactly like the consumer products through which they often manifest themselves.

What has taken place is that the market has replaced origin as a source of meaning. Given the vertiginous circulation of products in global capitalism, cultural artefacts, as well as their corresponding concepts and values, have ceased to be anchored in time and space, becoming icons or souvenirs of their referents. In this sense, whatever once seemed organically rooted to 'place' (of birth, era, gender, class and race), is now suspended in the black hole of postmodernity, ready to be worn or discarded at will. These categories have not ceased to operate meaningfully, but their articulation is taking place within the double paradigm of specific cultural practices on one hand, and of popular culture in general on the other. Popular culture (in either its mainstream or sub-cultural manifestations) has become a discursive practice of its own, a sort of parallel language in which social struggles operate at a commodified or iconic level, ignoring their referential ties in favour of discursive resolutions that would be otherwise unthinkable.

Take the recent 'Hasidic' fashion proposed by an Italian designer: long black jackets, white fringed scarf and a wide-brimmed black felt hat.[7] This appropriation of a very particular style is representative of the kind of discursive subversion that I am describing. The

Hasidic sub-culture is an extremely exclusive one, the Hasidim constituting a radical minority that has isolated itself from history by becoming a wilfully secluded pocket of long-gone conventions. Based on notions of patriarchal superiority and racial purity, Hasidic mores prescribe a rigid separation between body and spirit: any contact with the world is potentially tainting. This is manifested in closed community attitudes of solemn austerity and a marked refusal to engage in social transactions that are not distinctly functional (i.e., commerce). Given the Messianic overtones of Hasidic male privilege – each man is treated as the potential saviour of his people – women in this sub-culture are relegated to a secondary role of service and compliance, limited to procreative and domestic tasks, subordinated to male authority, and ultimately treated as an extension of a sinful and superfluous world, to the point where direct sexual contact, even among married partners, is strictly regulated.

In this context, the popularization of male Hasidic garb threatens the fundamental justification for these men's exclusivity: their uniqueness, represented in a style that is 'modest and distinguishably Jewish'.[8] By breaking a tacit agreement that allows Hasidic style to be worn only by Hasidic men, mainstream fashion is clearly disclaiming this singularity. In so doing, it is not only stating that style is for sale, that in a culture dominated by consumption everything is subject to the law of exchange value, but also, and more importantly, it is demystifying a code whose survival has so far depended on its untouchability. By coopting something as apparently mundane as clothing, fashion succeeds – however unintentionally – in unveiling what lies behind the emblem: ordinary men whose narcissism has been protected by a voluntary separation from those cultural transactions that would challenge their privilege. In this particular example, the stripping of symbolic value is exacerbated by making women the bearers of the inhibitory fad, thus completing the subversive circle.

Sub-cultures rely on the ritualistic sharing of their codes. Once these are infiltrated, the whole edifice on which their idiosyncratic practices are based often comes crashing down. Whatever the consequences of the 'Talmudic Scholar' look, mainstream fashion has presented it with a mirror that reflects its distortions, exposing, even deriding, the out-of-dateness of its singularizing attributes. Even if this results in a further enclosure of the Hasidic community (an enclosure which can only lead to certain death), this look has

succeeded in casting a shadow of doubt on the transcendental aura with which these men surround themselves in public, disavowing their self-proclaimed authority in the eyes of other communities which have to negotiate daily with Hasidim as fellow urban dwellers.

The extreme interchangeability of postmodern identities implies the valorization of surface, immediate gratification and highly iconographic codes over a tradition of depth, contemplation and symbolic abstraction. It may be compared to the dramatic transformation effected by the introduction of novelty in culture, a concept popularized by industrialization and its reshaping of the world according to the needs of mass production. The shift from a culture of maintenance, where value resided precisely in age and the ability of an object to survive use – therefore conveying a supernatural immanence – to a culture of replacement, where new objects are constantly taking the place of others which have broken or simply aged, marked the end of the aura of uniqueness which characterized Western culture up to the nineteenth century.[9]

Rather than lamenting the waning of use value and its quasi-organic connection to human production, the postmodern saturation of codes, and its ensuing referential suspension, opens up new modes of cultural validation through the once-despised operations of mimicry, camouflage and simulation. Instead of construing identity with reference to the fixed parameters of exclusivity and originality, these cultural strategies locate it in the hologrammatic attributes of overlap and repetition, which are much more consonant with massive reproduction. In so doing, the depuration of codes that led modernism to a barren minimalism is pushed aside by a chaotic, kitsch plurality that hyperstylizes codes to the point of absolute artificiality, presenting us with a cultural identity that rejoices in the synthetic quality of its many elements.

As part of this aesthetic pleasure lies in the mobility granted by such a degree of interchangeability, it should come as no surprise that it is precisely in those communities characterized by continuous migration and a desire for quick integration where the saturation and hyperstylization of codes prevails. The following examples are taken from the constellation of Chinese Hong Kong pop artists, who inhabit a universe so over-ridden by visual images that these popular illustrations are part of an innumerable, and unmarked, photographic series, sold like loose collectibles to Chinese-American children and teenagers, among others (see fig. 12). The artists in this series range from television sitcom actors to

rock singers and, although they are still imaged in carefully struck poses, they usually appear outside their professional context (the studio or stage).

The photos' main interest lies in the extraordinary stylistic contrast between three codes that are at odds with one another: the decor, the artists' clothes and their attitudes. On the one hand, the decor oscillates between the use of sophisticated scenarios with ultra-modern furniture, and the exact opposite: solid-colour backgrounds fronted by a suggestive icon, such as a chest lying on a heap of hay, or a studiedly casual setting, like the entrance to an office. On the other, the artists' clothing is either unassumedly 'sportif' or 'Sunday best', and their attitude varies from openly performative to simply natural. In sum, the codes convey either a baroque sophistication or a nonchalant easiness, but the problem is that they don't do so in a coherent manner, choosing instead to intersect in unpredictable ways: the simpler the scenario, the more affected the attitude and clothing; the more elaborate the backdrop, the more casual the pose.

This lack of semiotic balance confronts the viewer with an openly ambivalent representation that mixes a personalized discourse and a highly artificial one. The personalizing strategy begins with the 'family photo' format of the photographs, their low-budget quality, their collectability and a total absence of give-away text, all of which seem to suggest that these are not 'real' artists, but rather ordinary people playing at impersonation: something like the karaoke lipsynching that has become fashionable of late. At first sight, the artists' B-movie posturing exhibits a bogus quality that promotes spectatorial distance, making the artists into second-remove icons of themselves. Thus, an unforewarned viewer might easily confuse them with lovers or friends posing as artists, instead of seeing them as artists posing like lovers and friends.

Yet immediately superimposed on this initial impression is the unavoidable saturation of stylistic codes, which creates a unit of meaning through light, props and location, disavowing the relative spontaneity of 'personal' pictures. This overdetermination of meaning operates through the isolation of the icon from its signifying context, leaving it to produce meaning strictly from an intertextual position. The scenarios, garments and attitudes cease to be referential, becoming, instead, quotes from a collective storehouse of images: popular culture. In this way, we are left with a self-assured male orchestra singer, a coy cowgirl, or a passionate cabaret

performer, all of whom convey their personae in an exaggerated manner that underlines (rather than effaces) their referential lack.

It is precisely through the absence of context and the notable exaggeration that the impersonation is given away, thus slowly enabling the viewer's discovery of out-of-place details and of the scarcely veiled self-consciousness of the images. However, these characteristics are also part and parcel of a performance that desires iconicity and distance, rejoicing in the appropriation and simulation of popular cultural icons whose emblematic quality is uniquely foregrounded by this hyperstylization of the signifying codes. In other words, while flowers, bare shoulders and bright colours are a consistent choice for Latin artists, when recycled by another culture they gain an added layer of meaning, which is absent from their primary discourse. This meaning is that of 'tropicalism' and its cultural connotations of sexuality and fun. Worn as an icon, the ideological implications of the Latin outfit are exposed: both the ones it willingly reproduces and those through which it is interpreted. But its is still enjoyed for this very reason, as a cultural construct.

The main difference between the aesthetic fruition of high and low cultural artefacts, therefore, does not lie in their greater or lesser degree of complexity. As is clear from the previous examples, popular culture requires a shared cultural capital to enable decodification although, contrary to the exclusivity of high culture, this cultural capital is widely available to anyone exposed to the mass media. Yet what is so distinct about popular culture is that its main signifying operation is imitation. Articulating itself through an allegorical discourse based on accumulation and figurativity, as opposed to the condensation and abstraction proper of symbolism, popular culture produces pleasure through the recognition of the familiar, that is, through repetition.[10]

The operations of imitation, repetition and camouflage, so decried by modernism and the avant-garde, and therefore relegated to the backyard of artistic expression through most of the 20th century, have finally come out of the closet, so to speak, as valid modes of expression and pleasure. And, as I've been arguing here, these operations have the added value of showing the construed character of their referents: there is no such thing as a natural or raw cultural material, for culture is always an act of interpretation and transformation that introduces whatever it touches into one of

myriad social systems of meaning. Furthermore, these operations work as popular strategies for intercultural adaptation, enabling marginalized communities to integrate themselves in a participatory way into mainstream culture. This is done by a careful selection of those elements which have more resonance for the incoming community, elements that are then loaded with the particular values of that community, which then proceeds to elaborate a hybrid discourse.

In this sense the collectible photos of the Hong Kong pop artists are a perfect illustration of a dynamic, as opposed to a passive, Westernization, for while they enable Chinese teenagers and artists to negotiate with the West in a common language, they also exhibit a counterfeit quality that tacitly acknowledges the iconic aspect of their referents in a way that the West could not begin to discern on its own. As in the examples of the 'Talmudic Scholar look' and the 'realness' category performed in the drag-balls, the appropriation and recycling of a referent acts like a mirror through which that referent can gain a degree of self-consciousness. All of which leads me to believe that the claims of homogenization that are constantly hurled at postmodernity are only attempts at regaining a long-lost sense of transcendental uniqueness, a uniqueness that dissolves in the face of daily cultural practices, only to come out on the other side as an accessible and malleable product of mass culture's popular reception. To presume that such an effective democratization somehow vulgarizes or cheapens our cultural experience or understanding is, again, to privilege pre-industrial discursive operations such as authenticity and exclusivity over those postindustrial ones characterized by simulation and diffusion.

A contrasting example of the continually shifting boundaries between referentiality and simulation (or original and copy) in style may be found in the current 'fun fur' fad. As in the previous examples, what is striking about this fashion is the flexibility of representation to project desire, thereby discrediting the notion of a fixed referentiality in favour of a mobile one. We might think, for example, of how it used to be that people wore fake furs passing them as the real thing, and how now people wear fake furs that look intentionally fake, or even real furs that truly simulate fakeness. While a Claude Montana sheared mink, worth $11 000, is dyed turquoise, flaunting itself as a vinyl outfit straight out of Star Trek V, an Adrienne Vittadini 'sable' is, in fact, a polyester, rayon and

cotton blend that costs $990. If animal rights activists saw these two furs on the street their anger would be entirely misdirected at the simulated one.

However, what distinguishes the signifying processes of 'fun fur' from those of Westernized pop idols is that, no matter how intentionally political its market reasoning – environmental consciousness or consumer accessibility – fun fur doesn't disclaim or creatively recycle its immediate referent, but rather re-authorizes it by producing a replica. Both real and fake furs are caught up in a system of representation within which fur indicates beauty and social status. Intent as it is on eliminating the process of production, the fur battle doesn't acknowledge that doing away with the material means (the fur industry) is completely insufficient if the representation of the artefact is left untouched. This gross dismissal of representation accounts for the loss of a substantial number of political battles that simply refuse to attribute to representation its actual ideological weight. In a way similar to the 'smoking is not glamorous' campaign, whose message is more tangible to an image-obsessed culture than thousands of reminders about cancer, it is only through dismantling representation that a more effective struggle can be conducted.

What fun fur underlines, in respect of the arguments I am advancing here, however, is a demonstration of the oblique connection of representation to referentiality. The process of simulation does not automatically take on a life of its own, independent of its actual ties to the material reality that produces it and the ideological discourses in which it is inscribed. No matter how fake, fun fur still directly engages a system of value that appraises fur as a beautiful or prestigious cultural artefact. Yet in so doing, fun fur 'forgets' its artificial nature and calmly steps into a pretend referentiality that legitimizes representation as the foremost vehicle of meaning. Whether the fur is real or fake doesn't alter its social signification. Although fun fur doesn't subvert or expose its referent, as I argue for the sub-cultures discussed above, its equalizing of referent and simulation constitutes a dramatic departure from that belief in 'authenticity' to which I have already alluded: fun fur manifests a cultural discourse in which referentiality and simulation are undistinguishable. Rather than transforming the system of value on which fur relies, what the fun fur fad indicates is the exhaustion of a certain system of perception of reality.

It is this freedom from referentiality that ultimately grants

simulation and popular culture a new social dimension in which new meanings can be established, while never guaranteeing whether such operations will produce 'new' significations or simply reproduce 'old' ones. One thing, however, is certain: the introduction of simulation in the realm of representation has dethroned referentiality and its accompanying attributes of fixation and hierarchy from the court of reality. The cultural condition in which we now find ourselves treats referentiality as one mode of signification among others, allowing an unprecedented struggle between these different systems of meaning. Instead of simplifying and homogenizing the cultural panorama, as many argue, what postmodernity has done is to add new levels of complexity to a unitary, monological and essentialist culture by reclaiming, recycling, and irretrievably diffusing its signifying codes.

Notes

* This essay was originally commissioned by the Museum of Contemporary Art for the catalogue of the exhibition 'Art From Latin America: La cita transcultural', Museum of Contemporary Art, Sydney, 9 March to 13 June 1993, and later revised and expanded for The Biennale of Sydney.

1. By icons I mean signs that, as a consequence of their decontextualization, display their cultural load only at the level of the signifier. In this condition they become susceptible to the attribution of a disparate range of meanings, as I show below. This process is comparable to what Roland Barthes calls 'myth', or the second degree of meaning. See *Mythologies*, trans. Annette Lavers (London: Cape, 1972), first published by Editions du Seuil, 1957.

2. See Oswalde de Andrade, *Do Pau Brasil a Antropofagia e as Utopias* in *Obras Completas*, vol. 6 (Rio de Janeiro: Civilizacao Brasileira-Mec, 1970).

3. This was often the case in the symposium 'Vincente Huidobro y la Vanguardia', which took place in Santiago, Chile, in December 1991. The publication of this symposium is forthcoming (Universidad de Chile Press).

4. For a critical survey of the postmodern debate see Andreas Huyssen, 'Mapping the Postmodern', *New German Critique*, 33 (Autumn 1984), pp. 5–52.

5. See Dick Hebdige, *Subculture: The Meaning of Style* (London: Methuen, 1979).

6. For my view of postmodernity and some of its fundamental issues and theoretical texts see *Megalopolis: Contemporary Cultural Sensibilities* (Minnesota: University of Minnesota Press, 1992).

7. See 'Hasids on New Fashion Line: Case Clothed!' *New York Post*, 11 February 1993.
8. Ibid.
9. See Walter Benjamin, 'The Work of Art in the Age of Mechanical Reproduction', in Hannah Arendt (ed.), *Illuminations* (New York: Schocken Books, 1969), pp. 217–52.
10. See my discussion of kitsch in *Megalopolis*.

6

Zones of Marked Instability: Woman and the Space of Emergence

Charles Merewether

It is not enough to try to get back to the people in that past out of which they have already emerged; rather we must join them in that fluctuating movement which they are just giving shape to, and which, as soon as it has started, will be the signal for everything to be called into question. Let there be no mistake about it; it is to this zone of marked instability (*ce lieu de déséquilibre occulte*) where the people dwell that we must come.

(Franz Fanon *On National Culture*)

What is this zone of marked or 'occult' instability, of which Fanon writes, and how is it to be attained? One approach, after Fanon's own insistence, is to attend to the figures of emergence themselves rather than seeking 'a past out of which they have already emerged': a history, that is, of origins which fix identity in some distant vanishing point. By moving across this zone we shift from one condition to another, crossing borders from space to space. The zone of marked instability is a borderline in the sense that it is always a sequence of trans-positions, always engaged as a performative moment of translation.

In this discussion I explore the work of two artists whose productions function as an agency of change in re-inscribing the experience and memory of a non-consensual, marginalized or 'pre-figurative' subject active within this place of emergence. I aim to think through certain possibilities for a dis-located artwork, how it is able bear witness to the experience of social loss and political dysfunction experienced by women living along the edges of the urban centres of Colombia.

A key significance of recent work by two Colombian artists, Maria-Teresa Hincapie and Doris Salcedo, lies in its capacity to mimic the

'performance' of domestic labour, while at the same time creating metonymic objects for the experience of violence (Hincapie) and loss (Salcedo). By deploying the genres of autobiography/biography, on the one hand, and testimonial/witnessing on the other, each artist produces an interpretative account that shifts a traditional, narrative form of storytelling into what might be termed an insurgent form of modernism. The duration and spatial 'moment' of each work opens up a transformative 'in-between', capable of translating private experience into (shared) social knowledge. This work, then, participates in a politics of transfiguration, and in the expression of utopian aspirations which have almost no mode of shared articulation in the local culture.[1]

A THEORY OF EMERGENCE

Thirty years after the publication of his book *The Wretched of the Earth*, Fanon's concern to address cultures of emergence seems even more pressing. With culture no longer defined simply by place or nation, origin or identity, but rather by the conflictual experiences of displacement, exile and immigrant labour – both within and across the constituencies of the nation-state – global history has become a function of post-colonial identity and economic dissipation. As Edward Said puts it:

> Just beyond the perimeter of what nationalism constructs as the nation, at the frontiers separating 'us' from what is alien, is the perilous territory of not-belonging. This is where, in primitive times, people were banished, and where, in the modern era, immense aggregates of humanity loiter as refugees and displaced persons.[2]

It is in these terms that we must attend to the exclusions, silences and assimilations of disparate personal histories. We must ask about those who cannot move between places and cannot cross cultures, about those who, deprived of the rights of citizenship, operate (or are forced to) in the space of necessary illegality. What of the people who do not make it across the border, who are turned back as they traverse the 'middle passage'? While western critics rush to celebrate the new found 'freedoms' of postmodern syncretism, its latest hybrid imagining or synthetic simulation, other communities

are being silenced. They fall in-between. They are always arriving, always occupying a space between places. Caught between subject positions, they are mustered by a 'violent aporia between subject- and object-status'.[3] For Gayatri Spivak the ritual practice of Sati exemplifies this position for Third World women, caught as they are between patriarchy and imperialism, subject-constitution and object-formation, between resilient traditions and the advance of modernization.

Such peoples occupy a disjunctive space within the frame of the 'nation'. Unaccounted for by the ontologies of modernity, they remain trapped in a 'subimperial form of marginalisation' which binds them to the periphery yet renders them dependent on the interests of the nation-state and the operations of trans-national capital. Chatterjee puts it well in the conclusion to his study of nationalism:

> Much that has been suppressed in the historical creation of post-colonial nation-states, much that has been erased or glossed over when nationalist discourse has set down its own life-story, bears the marks of the people-nation struggling in an inchoate, undirected and unequal battle against forces that have sought to dominate it. The critique of nationalist discourse must find for itself the ideological means to connect the popular strength of these struggles with the consciousness of new universality.[4]

The marginality and disempowerment experienced by women who live in the shanty towns and peripheries of the metropolitan centres of Third World and post-colonial cultures demands that we reconsider the position of communities which are radically dislocated: communities which have a place neither within the construction of national identity, nor within the market-places of transnational capital, communities which remain unarticulated as social subjects of address. Such is the position of women and families who work as proletarian domestic labour in the cities, or who have been displaced from their homes and land by reason of political or economic violence, civil war or natural disaster. Such people constitute the 'dispersed sector' of the urban poor.[5]

Since the *Violencia* of the 1940s hundreds of thousands of Colombians have been displaced from their homes and country small-holdings. For much of the last half-century families who had once subsisted on small plots of land were exposed to almost daily threats of violence by paramilitary bands or vigilantes working for the

narcotraficantes. Accused of aiding one or other of the insurgent
guerilla armies their only options were to become agents against
others in the local community, see their family members abducted
or assassinated, or leave those members behind in the hope of a
future reunion. The results were massive dislocation.[6]

Resettling on the peripheries of the urban centres, especially
around Bogotá and Medellin, displaced women and children seek
work as servants and maids, or they attempt to survive in one or
other of the illegal economies of the street. The effect of displace-
ment from home, and/or of witnessing the death of a family mem-
ber, produces a traumatic condition, engenders fear and persecution,
and induces a sense of guilt, almost as if the victim had herself
perpetrated a crime. Those affected by these sensations often seek
complete anonymity, assume different identities by disguising them-
selves or by other means, and express only disinterest in public
affairs, social actions or any form of publicity.[7] Their past experi-
ence and the present conditions under which they live are felt
privately, often opaquely, and the victims assume a kind of 'non-
identity'.[8] Living on the boundaries of civil society and along
the margins of the law they also endure the consequences of the
unequal relations of gender and class to which they are also subject.
This is a world pitched between legality and illegality, visibility
and invisibility, the public and the private. In a sense the inhabit-
ants of this world have abandoned even their right to difference.
They live on the threshold of dispersal and dissolution. It is difficult
to give voice even to a residual sense of identity here; but if we can
find one at all it might be something like Blanchot's notion of a
'community of absence' or disavowal, one that is always positioned
as an aporia, one that is always already marginalized.[9]

Rather than recognizing these people, the Colombian state has
established a permanent *estado de excepcion,* a law that has hitherto
been used only in case of external threats to national security.[10] The
law has been used as a cover for declaring an *estado de sitio,* and
converted into a means for controlling the interior of the country,
where normal legal recourse has been suspended. Press censorship
has been introduced, strikes made illegal, and any public 'disorder'
or demonstration that appears in any way to disrupt the daily course
of civil life is subject to prosecution. Within this prohibitionary scene,
then, there is no effective public sphere.

The 'state of exception' allows military police to enter any house
or dwelling without a warrant and hold individuals if they are

suspected of aiding contra-government forces. Yet no real protection exists against paramilitary forces or the *narcotraficantes*.[11] This situation further aggravates the climate of fear and persecution under which these communities live.

While this prevailing situation clearly explodes the myth of an 'organic, unitary communality' in Colombia, the myth itself has an important function in its promotion of an 'imaginary reunification' and its imposition of an 'imaginary coherence' on the experience of dispersal and fragmentation. The circulation of this myth allows for the acknowledgement (indeed necessitates it) that its 'other side' is rupture, discontinuity and difference.[12]

> If the border is the site of infinite regression and if the border subject is the site on which the group defines its identity, then the ruptured body of that subject becomes the text on which the structure of group identity is written in inverted form – the information of the group is inscribed upon the body of the border subject.[13]

The question, then, is how to address and give voice to this 'inchoate' body which represents an emergent form of subjectivity experienced by marginalized individuals and communities in countries such as Colombia. Redefining themselves in relations to the centres, creating new circuits along which to gather a means of survival that is all but invisible to the public gaze, the experience of these communities demands that we redefine the relations of power that govern the 'public sphere'.[14]

AN AESTHETICS OF THE ORDINARY

In 1990 Maria-Teresa Hincapie performed for the first time at the Salon Nacional de Artistas a piece entitled 'Una cosa es una cosa' (One thing is one thing) (see fig. 13). The day following the opening the artist brought into the museum several bags stuffed with everything her apartment possessed, with the exception of the furniture. During the next eight hours she unpacked, laid out and repacked the contents of the bags. First she took everything out, unfolding, placing and arranging each item – onions, utensils, paper bags, nails, toiletries, potatoes, clothes – on the ground in a continuous rectangular configuration that gradually enclosed her in the middle

of the floor. This done, she proceeded to match certain objects. A fork which lay on her right side was brought together with others on her left; then the rolls of toilet paper, the potatoes, the clothes pegs, the plastic bags were each identified through their association with other items. One after another, categories of objects were created, according to their type, their form, their function, their number, their appearance, their size, and their colour (like units of language being ordered into a sentence). Then Hincapie gathered up, refolded and relocated all the items back into the original bags. When this process was completed, at the end of the day, she left. The museum space was empty and clean. The artist carried out these actions for eight hours every day for two weeks.

What we are made to witness here is a process in which the body and time/duration are caught up with the action of working alone with single objects in a 'space of accumulation'. Moreover, the emphasis given to each object as it is laid out in a manner that borders on the obsessive, dramatizes a kind of symbiotic relation of solitude between the object and women. In a passage from a short text about her performance, we can gain some measure of this:

> the cream alone and the brush with other brushes or also alone. All the flowers here. The clothes laid out. The black ones near me. The pink ones here. The handkerchiefs alone. The bedspread alone. The silverware alone. The broom alone. The carrots alone. The corn alone . . . The shoes alone. The stockings alone. The herbs alone. I alone. He alone. She alone. Us alone. Them alone. The space alone. The corner alone. A line alone. One way only. One shoe only.[15]

By performing the piece in a museum, Hincapie challenged the traditional boundaries and function of the institution. While her occupancy of the museum transforms it into the domestic sphere, on the one hand, her performance would also seem to bear out an intrinsic alienation from the space. The obsessive re-ordering and tidying up of the objects suggests the labour of a domestic servant outside her own house, while the final packing away of every article undoes any suggestion or possibility that rights might be claimed over this space, or even over the use-value of her labour. And the configuration she draws with the objects suggests a confining structure, where the environment not only symbolizes the museum and the house, but a psychological interior space.

The museum is transformed, then, into a site whose function is not to address universals, but to reveal a form of cultural expression symbolizing a marginal, communal, identity. As a 'performance', it gathers around what Jara has called a 'public intimacy' where the distinction between the public and private spheres of life is transgressed.[16]

Following from this, the performance acts as a testimony both to the domestic sphere and to the mundane, repetitious everyday world of women's domestic labour. The performance shifts between everyday language and the language of the everyday, such that that which is habitual, interiorized in the body as woman, speaks. Hincapie does not attempt to restore the concept of a centred, unitary self, a subject replete with either individual or collective agency.[17] Instead, she acts out the autobiography of a woman who is defined by the rituals of a domestic labour that have already etched the lineaments of a subjectivity. It is thus that *One thing is one thing* offers us a new way of confronting the complex, repressed, and fragile relations that circulate between domestic labour and the identity of women.[18]

As a consequence of its emphasis on the performative process and the staging of the 'event', the work never fetishizes the object(s) which centre it. Instead, it is absorbed by them, by their physical, almost quantifying power over the woman as she labours to bring them under control. This further undermines the institutional framing of points of view, and converts the viewing experience into a form of audience participation.

The audience is progressively estranged from the typical, normative, character of the objects on 'stage,' and from the repetitive, routine actions of domestic labour. Like Brechtian theatre, this estrangement produces an altered relation to the subject, transforming something experienced individually into a social process. For the work carries the necessary implication of a plural subject, which gives rise to a sense of sharing the experience, the process, the labour. By focusing on the process of labouring rather than the 'autonomy' of the subject, or an 'essentialized' identity, Hincapie brings to life the moments of inscription through which the subject is self-defined in relation to a community and its implicit social knowledge.[19] This contributes to the testimonial character of the work, assisting in its dialogic negotiation between collectivity and individuality, between the private and the public spheres. Crossing the divisions between autobiography and biography, the audience

is made witness to a form of storytelling that inscribes a space of inter-subjectivity and community.[20]

For both Benjamin and Fanon, the importance of the storyteller or artist was the part s/he played as part of an interpretative community. The storyteller was an agent of change and a translator of experience, who worked with the material of an oppressive past.[21] Through its redemption of the past, Benjamin believed, the work of art holds the promise of an utopian future. Such was the power of retelling in the storyteller:

> When the rhythm of work has seized him, he listens to the tales in such a way that the gift of retelling them comes to him all by itself. This, then, is the nature of the web in which the gift of storytelling is cradled. This is how today it is becoming unravelled at all its ends after being woven thousands of years ago in the ambience of the oldest forms of craftsmanship.[22]

Hincapie's movement of objects can be likened to the threads of a story, each element weaving memories together into new narratives. The work is a performative retelling. Rather than assuming that the oppressed must be either completely unrepresentable or possessed of an imaginary coherence (and therefore of a form of expressive subjectivity; the very form, in fact, which hegemonic power continues to threaten) the interpretative community creates a mobile arena of translation and alliance. Working across the frontier between private experience and public testimony, there are several contemporary artists who attempt to construct an 'in-between' or interstitial space of translation between communities.

As part of a larger interpretative community, artists produce 'open work': work that is 'open' to the place of the 'other', to minorities and post-colonial subjects, to those who have been marginalized. The movement enacted represents an engagement with hegemonic power as a process, and with difference as a necessary mobility, thus rendering visible certain sites of experience that would otherwise be invisible, inchoate, or repressed. It is not that this dimension of women's lives – the banal, daily, obsessive rituals of domestic labour – is unknown. It is that it tends to be unspoken, and unexamined. In this sense the performance 'bear(s) witness to this experience' and 'initiate(s) new sites of cultural difference', legitimizing its presence within the public sphere of a civil society.[23]

1. Still from *Surname Viet Given Name Nam*. Colour and black & white film, Trinh T. Minh-ha, 1989.

2. Stills from *Shoot for the Contents*. Colour film, Trinh T. Minh-ha, 1991.

3. Stills from *Shoot for the Contents*. Colour film, Trinh T. Minh-ha, 1991.

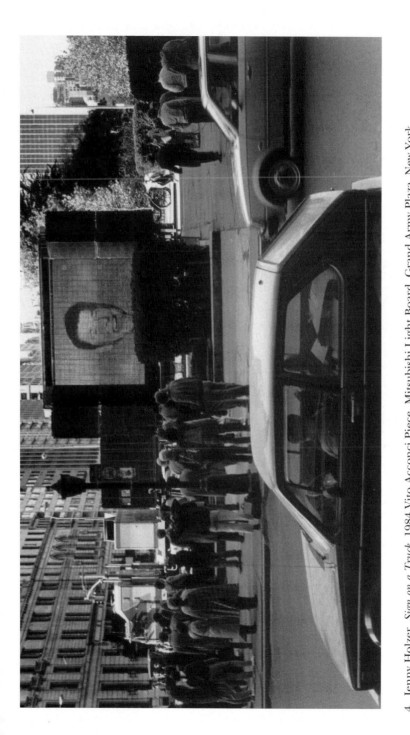

4. Jenny Holzer, *Sign on a Truck*, 1984 Vito Acconci Piece, Mitsubishi Light Board, Grand Army Plaza, New York. Courtesy Barbara Gladstone Gallery. Photo: Pelka Noble Photography.

5. Le Corbusier, *Cabanon*, 1952 (Cap Martin, France).

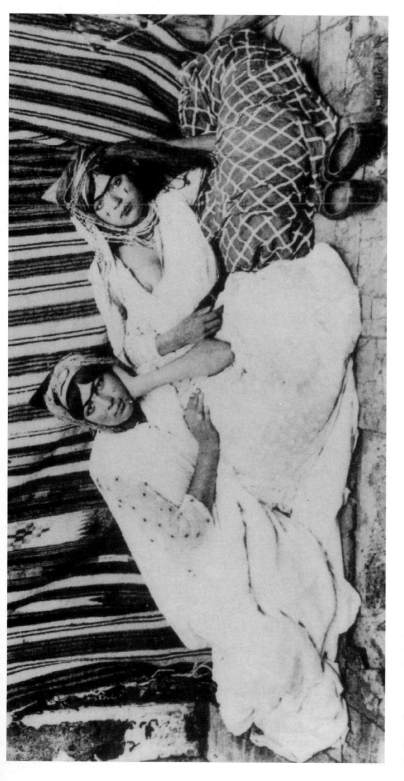

6. French postcard of Algerian women: *Scenes and Types – reclining Moorish women.*

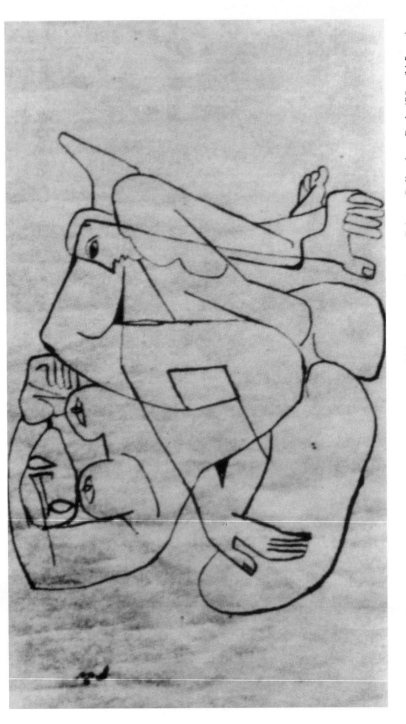

7. Le Corbusier, *Etude d'après les Femmes d'Alger de Delacroix*, ink and blue crayon on paper. Private Collection, Paris (50 x 64.5cms).

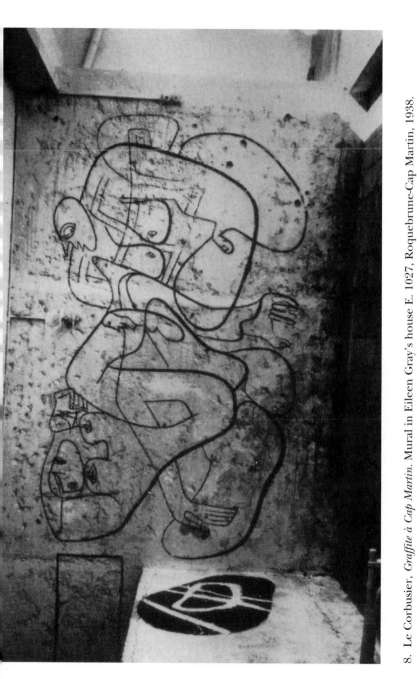

8. Le Corbusier, *Graffite à Cap Martin*. Mural in Eileen Gray's house E. 1027, Roquebrune-Cap Martin, 1938.

9. Advertisement circulated in Venezuelan magazines during 1991.

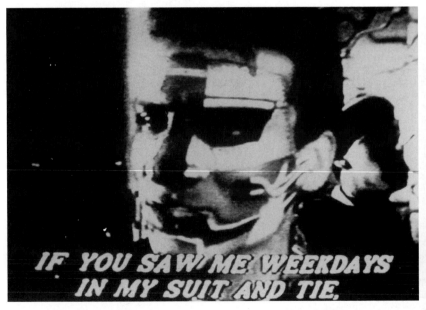

10. From *Guerreros Pacíficos* (dir. Gonzano Justiniano, 1985). Still by Celeste Olalquiaga/Third World Newsreel.

11. Dressed for success in the 'Executive Realness' category in *Paris is Burning* (dir. Jennie Livingston, 1990). Still released by Prestige, a division of Miramax Films, NYC.

12. Hong Kong pop collectible image.

13. Maria Terasa Hincapie, *Una Cosa es una cosa,* 1990.

14. Doris Salcedo, *Atrabiliarios,* 1991–92 (detail of shoes, cow bladder and surgical thread).

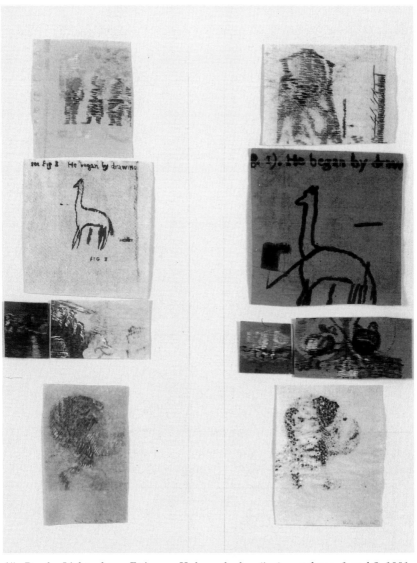

15. Bracha Lichtenberg- Ettinger, *He began by draw(ing),* panel nos. 1 and 2, 1991 (135 x 40 cms each).

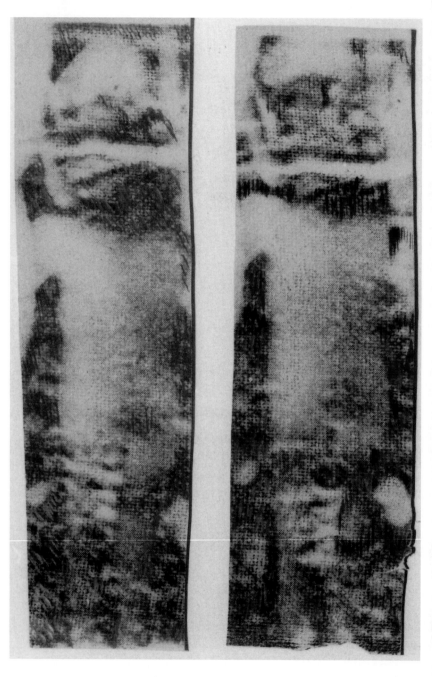

16. Bracha Lichtenberg- Ettinger, *Matrixial Borderline,* panel no. 3 (detail), 1990–91.

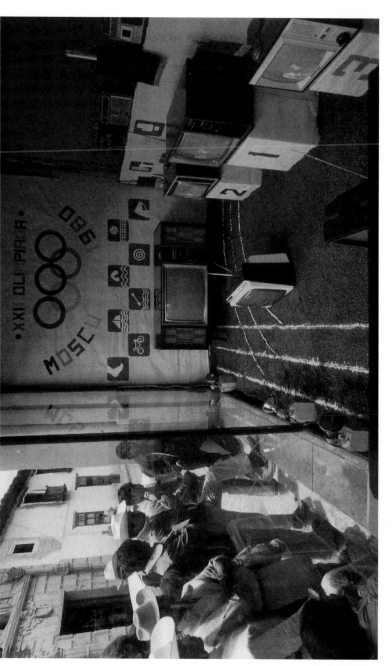

17. Elizabeth Sisco, *The 1980 Summer Olympics*, San Cristobel de las Casas, Chiapas, Mexico (1980).

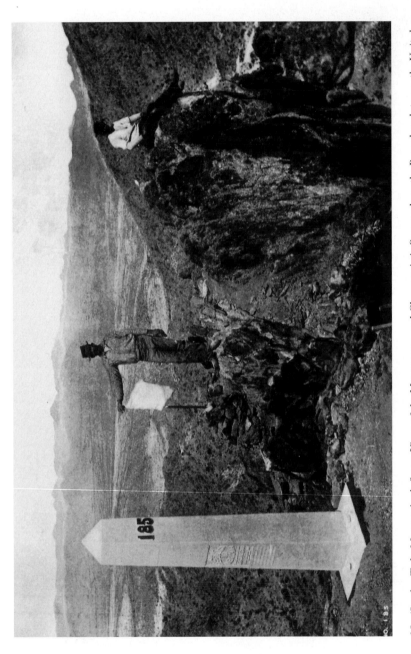

18. 'In the Tule Mountains', from *Views of the Monuments and Characteristic Scenes along the Boundary between the United States and Mexico*. Courtesy Arizona Historical Society.

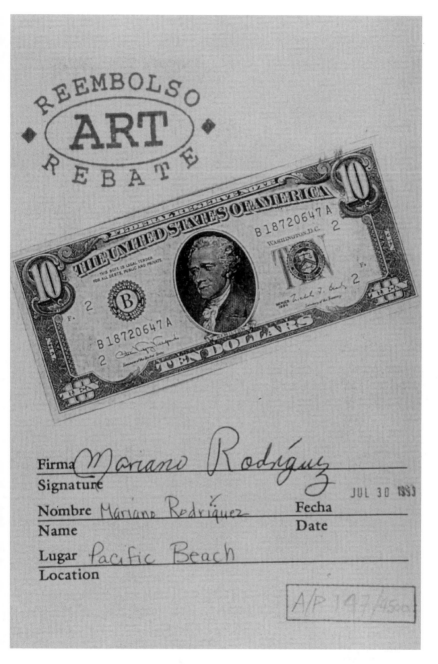

19. 'Rebate Receipt' from Mariano Rodríquez, dated 30 July 1993; from *Art Rebate/ Arte Reembolso,* David Avalos, Louis Hock, Elizabeth Sisco 1993. Photo: Elizabeth Sisco.

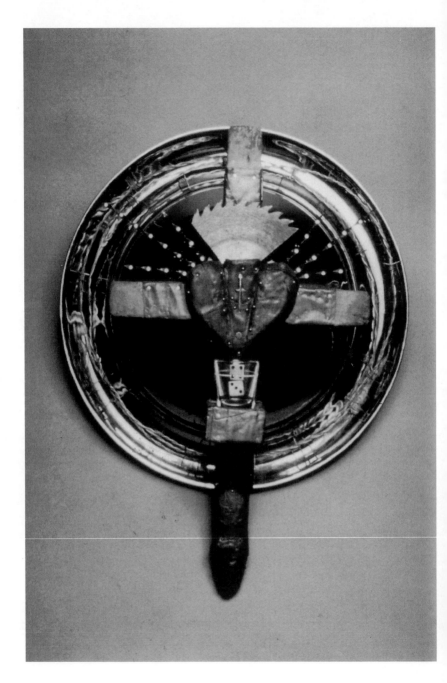

20. David Avalos, from the *Hubcap Milagro Series*, 1984–88, mixed media.

ART'S UTOPIA

In the wake of Auschwitz, Adorno wrote: Art's utopia . . . a recollection of the possible with a critical edge against the real; it is a kind of imaginary restitution of that catastrophe, which is world history.'[24]

For Adorno as for Horkheimer, the task of culture and the potential of the aesthetic sphere is to establish the identity of the self in relation to otherness, and offer an emancipated mode of interaction. To see art as offering the possibility of consciousness and transformation suggests not only a redemption of the real through the image, but its transfiguration.

In her book *Critique, Norm and Utopia*, Seyla Benhabib argues for a distinction between a politics of fulfillment and one of transfiguration.[25] A politics of fulfilment is based on a concept of normative content, and the notion that a future society will be able to realize the social and political promise that present society has left unaccomplished.

For Benhabib, a politics of transfiguration, on the other hand, represents the emergence of qualitatively new desires, social relations and modes of association. In his analysis of black popular music in Britain, Paul Gilroy draws upon this useful distinction, arguing that whereas a politics of fulfilment is 'immanent within modernity' and a 'valuable element of modernity's counter-discourse', a politics of transfiguration reveals the internal problems of modernity, while at the same time partially transcending its terms. By means of this deliberate opaqueness, the politics of transfiguration 'defiantly construct[s] its own critical, intellectual and moral genealogy anew in a partially hidden public sphere of its own'. Gilroy's suggestive argument offers a cultural form of insurgency that erupts from within the existing hegemonic discourse of modernity. The politics of transfiguration point to the 'formation of a community of needs and solidarity which is magically made audible in the music itself and palpable in the social relations of its cultural consumption and reproduction':[26]

The bounds of politics are extended precisely because this tradition of expression refuses to accept that the political is a readily separable domain. Its basic desire is to conjure up and enact the new modes of friendship, happiness and solidarity that are consequent on the overcoming of the racial oppression on which

modernity and the duality of rational Western progress as excessive barbarity relied.[27]

In the period of neocolonialism in the Caribbean and Latin America such counter-critiques redrew the boundaries of cultural difference through a mis/appropriation and displacement of paradigms (institutions and apparatuses) of Western modernism. The work of artists such as Wifredo Lam and the poet Aimé Césaire represent practices open to the otherness and alterity of the colonial and marginal subject. They produce a modernist discourse which is heterogeneous to itself, an 'outside in' reading, as Trinh T. Minh-ha calls it, permitting otherness to rupture and elude our logocentric conceptual grids. It is only at such moments that we can experience and reflect on the doubleness which is our constitutive experience in the modern world: 'in the West but not of it': 'It would not be only the structure hollowing itself out like that, but it would do so in its own way (itself almost untranslatable, like a proper name), and its idiom would have to be saved.'[28]

Not only does this challenge the binary opposition of colonizer/colonized, but it also suggests that knowledge is made possible and is sustained by irreducible difference, rather than by identity. For, as has been pointed out, there exists a 'chasm between the optimistic mobility of the intellectual and artist, between domains, forms and languages, and the mass dislocations endured by economic migrants, expelled refugees' or, for that matter, the marginal communities that subsist in and around metropolitan centres.[29] There exists, in other words, a powerful ambivalence between the cognitive recognition of cultural heterogeneity and the political need for solidarity. And there is a manifest danger in assuming that this position is 'co-terminous with the struggles of the dispossessed, feeding directly into them by making sense of them'.[30]

It is for these reasons, I would argue, that the concept of translation is of critical importance to any understanding of the relational possibilities operative among different communities, and to any concept of 'communicative utopia'. Far from being a matter of reproduction, translation, as Walter Benjamin noted, emerges from the 'afterlife' of an original rather than from the original itself.

Unlike a work of literature, translation does not find itself in the centre of the language forest but on the outside facing the wooded ridge; it calls into it without entering, aiming at that single spot

where the echo is able to give, in its own language, the reverbera-
tion of the work in the alien one.[31]

To translate is to negotiate with the double bind enmeshed in a
positivist objectification or a wholesale acceptance of the utter
unrepresentability of the other. To translate is thus to work within
the tensions, disruptions and ambivalences between the cognitive
recognition of cultural heterogeneity and the political need for
solidarity. It entails a double encounter of 'two contradictory
affirmations' that, on the one hand, 'affirm the existence of ruptures
in history', and, on the other, affirm that these ruptures 'produce
gaps or faults in which the most hidden and forgotten archives can
emerge and constantly recur and work through history'. These 'con-
flicting positions of historical discontinuity (rupture) and continu-
ity (repetition) . . . are neither pure break with the past nor a pure
unfolding or explication of it'.[32]

The interpretative power of a politics of transfiguration resides in
its ability to provide a bridge between 'residual' cultural forma-
tions, which 'continue cultural practices that no longer articulate
the social structure of the dominant class', and 'emergent' cultural
formations.[33] As Spivak suggests, the practice of the subaltern intel-
lectual is based on a theory of consciousness, agency and change,
that is 'pluralized and plotted as confrontations rather than tran-
sition' and 'signalled or marked by a functional change in sign-
systems'.[34] 'A theory of change as the site of displacement of function
between sign-systems', Spivak writes, 'is a theory of reading in the
strongest general sense. The site of displacement of the function of
signs is the name of reading as active transaction between past and
future.'[35]

TOWARDS A SUBALTERN PUBLIC SPHERE

How, then, is a social horizon of meaning given to these different
forms of experience and subjectivity? How does art recognize the
social self and contribute to its production against the hegemonic
power of the State and transnational media to atomize the indi-
vidual within society? How does art negotiate its apparent loss of
autonomy and the changing nature of experience underwritten by
modernity? And what role can art play in the expression of new

cultural formations within the sphere of public culture as against other media of production and reception?

In the 1920s and 1930s, the question of relations between high art and mass culture so haunted the historical avant-garde, including Brecht, and the Frankfurt School of Critical Theory (Adorno, Horkheimer, Bloch, Benjamin) that the two domains have been described as locked in a 'compulsive pas de deux'.[36] Driven by hopes of aesthetic and social revolution that would reconcile mass and high culture, the collective and the popular, both Brecht and Benjamin argued for a 'double-edgedness' to the phenomena of consumer culture, insisting that their ideological practice and their mobilizing, utopian potential are dynamically interrelated.[37]

Following Brecht's work on radio, Hans Enzensberger argued in the 1960s that the homogenizing, depoliticizing use of the media in advanced capitalism is not necessarily an innate product of the technical structures of the communications apparatus. On these grounds, he reintroduced the issue of consumption in the formation of a 'public', proposing that progressive cultural movements 'transform' the media 'from an apparatus of distribution into an apparatus of communication'.[38] Yet such a theory still left open the question of culture's power to mediate between the private and public spheres. Further, as Miriam Hansen has pointed out, Habermas also argued during the 1950s and 1960s that capitalism had produced a culture in which the 'webs of public communication unravelled into acts of individuated reception, however uniform in mode':[39] 'Culture could no longer function as the matrix of publicity (and therefore) as a discourse mediating between a subjectivity rooted in the intimate sphere (the bourgeois family) and the intersubjectivity of a self-constituting public sphere.'[40]

However, this position, in turn, was modified by Oskar Negt and Alexander Kluge. In *The Proletarian Public Sphere*, they argued for the introduction of class distinctions into the conception of the public sphere, pointing to emergent and 'multiple counterpublics' which were distinct from the bourgeoisie. Such 'counterpublics' were made up of peoples marked by specific terms of exclusion (i.e., gender, class, race, and so on). The notion of counterpublic was developed as means of indicating the emergence of new social movements and subjectivities.[41] More recently, the American cultural critic Nancy Fraser has suggested the term 'subaltern counterpublics' as a way of signalling those 'parallel discursive arenas where members of subordinated social groups invent and circulate counterdiscourses,

which in turn permit them to formulate oppositional interpreta-
tions of their identities, interests, and needs'.[42]

By naming the 'subaltern' we are forced to recognize in the sub-
ject of the public/cultural sphere a site of hegemonic power and
ongoing internal colonization. In such terms, the 'social' has neither
an essential structure, nor an imaginary coherence apportioned to
it by the vested interests of the politically and socially empowered.
Rather the 'social' forms a field or plenum of emergent, prefigura-
tive, differences that may engender non-consensual affiliations, and
forms of cultural dissensus and alterity.[43]

As mediated through radio broadcasts, newspaper circulation,
and university critique and counter-critique, the public sphere in
Colombia has played a significant role in generating public debate
around contemporary social issues. The present imposition of an
estado de excepcion by the State, however, has substantially dimin-
ished the effectiveness of this debate.[44] While it might be possible to
speak of a 'subaltern counterpublic' operative in this context, there
exist other forms which are filling in the spaces of an interpretative
community. In the case of Colombia, in particular, there are several
small but active branches of international and local human rights
organizations whose work has been to develop the skills, statistical
resources and infrastructure for developing cases of rights abuses
amongst the poorer and marginal sectors of the community.[45]

Working between private, unacknowledged, experience and public
testimony, the work of these organizations contests the exclusion of
such communities from the public sphere. They create sites where
dissent can be made known and the interests of the marginalized
can, in some measure, be voiced and met. They are an emergent
horizon for the shaping of post-colonial communities. They repre-
sent a 'terrain for elaborating strategies of selfhood and communal
representations that initiate new signs of cultural difference and
innovative sites of collaboration and contestation'.[46]

One notable significance of viewing the public sphere as a place
of difference, within which 'strategies of selfhood' are elaborated,
can be unfolded around the notion of subjectivity. The proposition
of a relation between 'subaltern counterpublics' and the question of
subjectivity will challenge the exclusionary consignment to women
of issues deemed 'apolitical' and 'private'. In recognizing a com-
monality of experience, the politics of difference is opened up in
relation to the dominant public sphere. The public sphere can thus
be reclaimed as a critical site for different communities, which have

previously been excluded from it. This leads to the creation of a new space in which to address experiences constituting the foundation for other forms of social affiliation and of rights to the difference and sharing of democracy.

THE POLITICS OF REMEMBRANCE

I have no wish to soften the saying that to write lyric poetry after Auschwitz is barbaric . . . But Enzensberger's retort also remains true, that literature must resist this verdict . . . It is now virtually in art alone that suffering can still find its own voice, consolation, without immediately being betrayed by it . . . it is to works of art that has fallen the burden of wordlessly asserting what is barred from politics. (Theodor Adorno, 1962)[47]

In countries that have endured long periods of military violence, it is precisely the idea of community or collectivity which is continually threatened and always at stake. This history reveals a pervasive vested interest in removing from consciousness the death of people in order to effect the displacement of popular memory as an active element of hope and a key impulse of collectivity.[48] Terror is anonymous. Mutilation and disappearance are strategies by which identification is erased. Human identity and death are desacralized. The practice of these regimes is to reduce individual loss through death to the anonymity of mass graves, thus rendering account of the 'disappeared' a matter of statistics. These practices generate palpable fear, and work as a method of social control. Death is placed under surveillance, and the dead repressed by the State or military police as a means of social repression. In this context, there can be no martyrs, no historical memory, no family shrines; nothing but anonymity.

The relations staged between violence and the law of the State have, in fact, driven collective memory from the public sphere into the private sphere of the individual and/or the family.[49] It is for this reason that the relation to the dead, and to death itself, is critical to the emergence of a popular counter-culture. Death is the contested site of identity that threatens military and state power.

In this context, forms of visual representation assume an important ideological function. They occupy a phantasmagoric space in relation to the real. Two forms of photographic practice negotiate

this position in ways that are worth noting. These are, first, photo-journalism, with its emphasis on images of conflict, violence and death; and secondly, the production and (re)circulation of photo-portraiture by the mothers and families of the disappeared. The difference between the two photographic activities is not simply a matter of genre or style, but is invested in the ways each photography transgresses and redefines the subject of the taboo; the ways, that is, they negotiate notions of the sacred, of intimacy and the private sphere. The significance of filling the streets with photo-graphic images of the disappeared, or those actually killed, is that they represent *the dead* rather than *death*. Their power originates from the form of resurrection achieved in the public demonstration of such intimate portraits, through their momentary fusion with the worlds of the living, and by their refusal to accept the anonymity of the public sphere. These gestures contest the assumptions of photojournalism, and therefore (by default) the practices of para-military death squads.

Photographs of mutilated bodies and cadavers are created for public circulation, not for the domestic or private sphere. In their own way they break taboos, as Benjamin points out, transporting the viewer to places where people cannot normally see, and show-ing things that can scarcely bear the gaze. Like a surgeon, they open up the body for display, revealing the secret scene of an anony-mous crime. Concealing the codes and apparatus of the technology which made them, such photography fetishizes the visual as evid-ence and testimony of the real. The photograph of the dead body becomes a fetish object which derives its power from its referent, yet also banishes it.[50] The image takes over the place of the real, producing a form of cathartic identification through the specta-cularization of death. There is something painfully adequate in work of this kind. As Pierre Nora has suggested 'the less memory is experienced from the inside ... the more it exists only through its exterior scaffolding and outward signs'.[51] This form of photography produces a kind of redemptive amnesia, as it structures remem-brance and forgetting. Yet it is in this space of memory, of interiority and the private sphere, that contemporary painting has assumed disturbing significance.

During the 1980s the 'new figuration' and 'neo-expressionist' painting movements achieved tremendous success, not only in Europe and North America but also in Latin America. This was accomplished both through North American and European art

magazines and international touring exhibitions. Private and state museums in Latin America welcomed exhibitions of contemporary Italian and German painting as signs of their active participation in relevant international contemporary culture. Artists such as Anselm Keifer, Georg Baselitz and A.R. Penck or Mimo Palladino, Sandro Chia and Francisco Clemente, then, had a great impact on local art scenes. One of the appeals of European neo-expressionism and the new figuration lay in its insistence on 'rhetorical and aesthetic vehemence', and the unmediated 'expression' of introspective sensations coupled with a supposed universality of subject-matter focusing on the mythological and allegorical.[52]

The museum and gallery systems provided immediate legitimation and support for such work, sanctifying certain forms of representation as locally relevant, yet claiming that they also function as discrete, autonomous objects that could be appreciated internationally. By providing a 'liberating potential . . . (through) a catharsis of the imagination' the question of violence in such paintings is transformed into a subject of apocalyptic, universal and timeless dimensions, which conform to the modernist privileging of visuality (and contemplation).[53] Such abstractions participate in the production of distinctions between the public and private spheres. In particular, the museum corresponds to the domestic interior, aligning autonomy with privacy.

Yet not only is the interior made over into the retreat of art, as Walter Benjamin points out, but art becomes a retreat into interiority.[54] In the context of cultures living under repressive regimes and everyday violence, as in Colombia, this kind of art, working as it does within the domains of memory and fantasy, fed directly into the sphere in which fear works. Fear is generated most effectively by the State not through communal ritualization but through privatized psychic internalization. In this way, death finds its home in repression in the same way that life might be defined as a survival determined by the power of death. Overwhelmed by the sensation of powerlessness, melancholy and despair before the return of the repressed, neo-expressionist art conformed to the redemptive power of history and its aspirations to form a coherent representational universe through mythic emblems of the historical past.

It is important to note that the kind of critical debates around the concept of public culture and the politics of images that occurs among institutions, artists and critics in North America is virtually

absent in countries such as Colombia. Instead, the few public cultural institutions that do exist do not really contribute towards the representation of public spaces. They have functioned, in fact, largely as a kind of silent agent of sanctioned national-building. Claiming aesthetic neutrality and disinterested perception, they sanctify certain kinds of art and foster respect for international culture as a way of constructing an aesthetic tradition and a language of anonymity sealed-off from the local; one that participates instead in the 'homogeneous empty time of modernity'.[55]

At stake, then, is the development of a practice of strategic interventions in the existing circuits and agencies of representation and their circulation through the public sphere. Such practices intervene not so much through the subject of address, but across its sitings and points of view. The challenge to contemporary art (and other forms of visual representation) in Colombia is not to reproduce violence, but to address the subject of these images, and the problems of everyday life through which people live. The culture of disappearance valorizes the separation of the subject from the body. Therefore, it is not just a question of re-sighting the body, but of reuniting the separation between people. It is in this sense that I want to examine the work of Doris Salcedo, who has contributed to an art of memory and consciousness conceived over against the practices of remembrance and forgetting enshrined in the painting and photography favoured by museums.

AN ABSENT BODY

From mid-1980s onwards, the sculpture of Doris Salcedo has explored the problem of how to address and articulate the subject of violence, displacement and loss. During the last few years her work has been based on the testimonials of women who, with their children, are continually subject to the violence of an ongoing civil war in Colombia. These women and children have been driven out of their houses and off their land to the peripheries of the urban centres, where they live in the shadow of their own private experience. In this condition they have little interest in, or recourse to, the public sphere and the rights of citizenship.

Defiant and *Atrabiliarios* (see fig. 14), works made in 1992 and 1993, comprise a row of wall niches filled with women's shoes, and a number of empty boxes made of transparent animal fibre, which

are placed on the floor. Each of the niches is small and discrete. Neither deep nor shallow, they function as careful display containers for the shoes, which are both singled and paired. Moving along the wall, one encounters more niches full of shoes; over and over again, shoes; nothing else, but abandoned shoes.

Covering each of the niches, the artist has then stitched pieces of rough and opaque material to the wall, using thick black thread. Using the skin of an animal bladder, the effect they create is like that of a membrane or a provisional gauze placed over a gaping wound. This masking of the niches not only makes it difficult to see the shoes inside, but the coarse, visceral quality of the skin alters the character of some of the shoes. At some moments they seem almost to disappear; at others, they appear like the bare bone of a foot.

As discussed above, over the past twenty years the experience of 'disappearance' has become a new tactic of State terror. It creates a death-space which diffuses fear through much of society. Far from erasing memory, this creates a new terror and new impossibilities, such as marking death with the ritual of burial.

Salcedo's construction of niches immediately recalls the site and support of a body's remains after cremation in the cemetery. Transposed into the museum space, her installation functions somewhere between a relic and a fetish. It both belongs to and is separate from its referent: the body. As a relic it stands in for the remains of someone deceased; and as fetish, it is a substitute object which simultaneously avows and disavows identification. It is intensely personal, yet exists as a discrete series of material objects outside of the individual. By acting as a material signifier of that which is absent it arrests death, yet as a metonymic displacement it also stands as a sign of the radical difference and separation death brings to the world of the living. The shoes appear to lack clear signs of identification, yet for their owners they are personal reliquaries and objects of remembrance: they draw together erasure and remembrance. Such an act of gathering together into one place is evidence of a common history and memory. It provides a bridge between the individual object and the collectivity of a community. It is the symbol for an alliance between the dead and the living. Durkheim's observations on totemism are relevant here. He writes: 'In a general way, a collective sentiment can become conscious of itself only by being fixed upon some material object; but by this fact, it participates in the nature of this object, and reciprocally, the object participates in its nature.'[56]

Salcedo's interventions are important in two senses. First, she is actively engaged in bringing to light what has been repressed, driven back into the private sphere, or completely erased by being made a spectacle. Yet she has also constructed a site of remembrance and a testimony to the collective experience of that which has remained hidden from view in the safekeeping of the home: that which is protected from the public eye, the objects of private mourning and love.

There is a difficulty in 'seeing' Salcedo's work. This does not arise out of a lack of immediacy, but rather from how she addresses the subject of loss and absence. Our understanding is informed by non-visual perceptions, by the tactility and viscerality of the skin, by the the coarseness of the thread or the sides of the empty shoe. These associations lead the spectator away from the spectacle of violence, creating a relation between tactility and memory that generates a crisis in witnessing. The work is made intelligible as an event that replays the experience of living in the presence of the absent body. It entails thinking through the impossibility of visual representation and the distance of translation between private experience and public testimony, between the non-site of absence and the sense that is made of it.

By using mundane domestic objects and organic materials, the work seeks to draw its audience closer to the locality and affective dimension of an experience which leaves its traces only within the community of those who have suffered loss. The sensuousness of the work offers something which is at once mundane, and every-day, and yet also an *aide-memoire*, provoking remembrance through the object of desire. This intimate, sensual space points to a hidden dimension which cannot be spoken, a secret place outside representation in which rituals of remembrance for the dead were performed. For those who live in terror with the memory of those who have disappeared, it is the space of the family and the 'feminine' which serves as a sanctuary of refuge and shelter from the State and from the public space.[57]

Laid out in the public sphere of the museum, certain tasks of translation become apparent. While testifying to private experience, the piece also makes its audience bear witness to the event or act of violence. To do so is to recognize the existence of a non-site, a place that is subject to erasure by dominant forms of representation and the apparatuses of circulation. By introducing the niche into the museum space, Salcedo disturbs its sanctified role according to which

the work of art serves to redeem death as irrevocable and the museum functions as its support: a mausoleum of forgetting.

In this way Salcedo's work undoes the separation of the public and private spheres. On the one hand, the work transforms the museum space into the private sphere of the house, while on the other, by speaking of death as a shared experience, the museum becomes 'a political space not only of commemoration but of an ethics based on collective memory and continuity'.[58] Thus, her art speaks of a community which lives in hope, and acts in defiance of the agencies of repression. Salcedo contributes to an art of memory and consciousness that is conceived against the practices of remembrance and forgetting of contemporary painting and photography enshrined by museums and celebrated in the mass media.

A HETEROGENEOUS SPACE

The work of artists such as Maria-Teresa Hincapie and Doris Salcedo produces a discourse that is outside in, heterogeneous to itself both in form and in circulation. In a manner reminiscent of certain Conceptual artists working in the USA in the 1980s, such work developed, as Benjamin Buchloh observed, a strategy of 'decentralizing the place of the author and subject by remaining within the dialectic of the appropriated objects of discourse and the authorial subject, which negates and constitutes itself simultaneously in the act of quotation'.[59]

Invaded by the spaces of marginality, Hincapie and Salcedo also invade the museum space, producing new 'zones of occult instability'. They challenge the museological function by denying that museums can (only) act as havens for art. As Walter Benjamin pointed out, museums, like bourgeois interiors, eventually become retreats. Not only does the work contest the museum from the point of view of gender and class, but it also, and equally, challenges a contemporary art that serves as a retreat into interiority and continues to promote a privatization of experience. The artists re-mark the museum as an arena for emergent subject positions within the public sphere. Using Benjamin's words once more, they are 'blasting a specific era out of the homogeneous course of history' with the goal of creating a differential history.[60]

Their assumption of this interpretative role, enables the intersubjective and collective experience of a nation-ness, community

interest, or cultural value, to be understood within the terms and processes of hegemony and change. Taking on and naming the histories of women and families who live on the borders of modern life, their practices bear witness to the silenced legacy endured by oppressed women and marginal communities. Based on a theory of aesthetics that is not only a communicative model of artistic production and reception, but an open system of enunciations and translations, such work forces audiences to bear witness to the local, multiple voices of emergent communities.

Notes

Since this essay was first drafted in 1993 the *estado de excepcion* has been lifted.

1. In proposing a 'politics of transfiguration' I am drawing on Seyla Benhabib's suggestions in her *Critique, Norm and Utopia* (New York: Columbia University Press, 1987); and Paul Gilroy's 'It ain't where you're from, it's where you're at: the dialectics of diasporic identification', *Third Text* (London), no. 13 (Winter 1991), p. 11.

2. Edward Said, 'Mind in winter: Reflections on life in exile' *Harper's*, no. 269 (September 1984), p. 51.

3. Gayatri Spivak, 'Can the Subaltern Speak?: Speculations on Widow Sacrifice', *Wedge*, 7/8 (1985), p. 128.

4. Partha Chatterjee *Nationalist Thought and the Colonial World* (London: Zed Books, 1986), p. 153.

5. Servants are such a common phenomenon in middle-class, Latin American households that little attention is paid to the conditions under which they work or to the class divisions their labour perpetuate. It is estimated that more than two million people were displaced in the 1940s *La Violencia*. See Paul Ouquist, *Violencia, Conflicto y Politica en Colombia* (Bogotá: Instituto de Estudios Colombianos, 1978), and Amanda Romero M. *Colombia: Conflicto Politico y Desplazamiento Interno* (Bogotá Colombia: Instituto Latinamericano de Servicios Legales Alternativos, or ILSA, 1992).

6. See *Informe: Mission de ICVA* [International Council of Voluntary Agencies] *a Colombia*, 11–19 April 1991.

7. Such experiences are recounted in the 'Testimonio de una Mujer Campesina del Magdalena Medio', a project carried out by Liga Internacional de Mujeres por la Paz y la Libertad (LIMPAL), 1990; and *Córdoba: No Todo Esta Perdido*, published by the Colectivo Periodistas por la Vida (undated, but *c.* 1990). See also Bertha Lucia Castaño, *Alteraciones Psicopatologicas Observades en Victimas de la Violencia Sociopolitica en Colombia* (Departamento de Psiquiatria, Facultad de Medicina, Universidad Nacional de Colombia, 1992).

8. The concept of 'non-identity' is used by Theodor Adorno to describe the experience of living with the legacy of the annihilation of one's own (German-Jewish) culture. Reference to this concept in the following discussion is indebted to Miriam Hansen's 'Unstable Mixtures, Dilated Spheres: Negt and Kluge's 'The Public Sphere and Experience, Twenty Years Later', *Public Culture*, no. 10 (vol. 5, no. 2, 1993), pp. 179–212.

9. See Maurice Blanchot *The Unavowable Community* (New York: Station Hall Press, 1988), p. 3.

10. Sections of this law, accompanied by an analysis, were published by 'Papeles para la Democracia' in *El Espectador* and *El Colombiano* in March 1993.

11. In certain cases, however, the military enforce families to abandon areas designated as conflict zones. They are resettled in makeshift concentration camps for unspecified periods of time, and have no rights to leave. See n. 6.

12. Stuart Hall cited in Benita Parry, 'Overlapping Territories, Intertwined Histories', in *Edward Said: A Critical Reader*, ed. Michael Sprinker (Oxford: Blackwell, 1992), p. 32.

13. Abdul JanMohamed, 'The Specular Border Intellectual', in *Edward Said: A Critical Reader*, p. 115.

14. The role of the church in responding to the experience of violence and displacement, and the development of small, regionally-based organizations of women and campesinos is discussed in the 'Informe' bulletin issued by ICVA (see n. 6).

15. Maria-Teresa Hincapie, unpublished manuscript, 1990.

16. René Jara, Prologo, in *Testimonio y Literatura* ed. René Jara and Hernan Vidal (Minneapolis: Institute for the Study of Ideologies and Literature, 1986), p. 3.

17. Parry, 'Overlapping Territories', p. 35.

18. This is suggested by the interviews held by various commentators with audiences after the performance: 'The performance is the representation of everyday life, of how one is, feels and lives'; 'It is a homage to women, and how they live and pass their lives.' See Martha Lucia Lozano, *El Espectador*, 8 April 1990, p. 8.

19. For a discussion of these issues, see Anne McClintock, 'The Very House of Difference', *Social Text* (New York), no. 25/26, (1990), p. 217.

20. Some writers suggest that this is a characteristic change in both the genre of the testimonial and the autobiography in postcolonial cultures and liberation struggles. See the special issue (ed. John Beverley and Hugo Achugar) of *Revisita critica literaria latinoamericana*, no. 36 (1992).

21. See Walter Benjamin's 'The Storyteller' in *Illuminations* (New York: Schocken, 1969), pp. 83–109; and Frantz Fanon, 'On National Culture', in *The Wretched of the Earth*, (Harmondsworth: Penguin, 1971) pp. 166–199.

22. Benjamin, 'The Storyteller', p. 91.

23. Homi Bhabha, *Critical Fictions*, ed. Philomena Mariani (Seattle: Bay Press, 1991), p. 63.

24. Theodor Adorno, *Aesthetic Theory*, ed. Gretel Adorno and Rolf Tiedemann (London and New York: Routledge & Kegan Paul, 1984), p. 196.
25. See S. Benhabib, *Critique, Norm and Utopia*.
26. P. Gilroy, 'It ain't where you're from', p. 12.
27. Ibid, pp. 12–13.
28. Jacques Derrida, 'Des Tours de Babel', in *Difference in Translation*, ed. Joseph F. Graham (Ithaca, NY: Cornell University Press, 1985), p. 165.
29. Benita Parry writes: 'We need to avoid the conceit of conflating the transactions with imperialism's structure effected by the elite post-colonial with the exigencies of the situation experienced by forcibly displaced populations or by unemancipated peoples': in 'Overlapping Territories', p. 20.
30. Rosalind O'Hanlon, 'Recovering the Subject: Subaltern Studies and Histories of Resistance in Colonial South Asia', *Modern Asian Studies*, vol. 22, part 1 (February 1988), p. 219 'if we ask ourselves why it is that we attack historiography's dominant discourses, why we seek to find a resistant presence which has not been completely emptied or extinguished by the hegemonic, our answer must surely be that it is in order to envisage a realm of freedom in which we ourselves might speak.'
31. Walter Benjamin, 'The Task of Translator' in *Illuminations*, p. 77.
32. Jacques Derrida, 'Dialogue with Jacques Derrida', in *Dialogue with Contemporary Continental Thinkers*, ed. Richard Kearney (Manchester: Manchester University Press, 1984), p. 133.
33. Peter Middleton, 'Language, Poetry and Linguistic Action', *Social Text*, nos 25/26 (vol. 8, no. 3; vol. 9, no. 1, 1990), p. 244.
34. Gayatri Spivak, 'Subaltern Studies: Deconstructing Historiography', in *Selected Subaltern Studies*, ed. Ranajit Guha and Gayatri Spivak (New York: Oxford University Press, 1988), p. 4.
35. Ibid, pp. 4–5.
36. Andreas Huyssen, *After the Great Divide: Modernism, Mass Culture, Postmodernism* (Bloomington: Indiana University Press, 1986), p. 24.
37. M. Hansen, 'Unstable Mixtures', p. 192.
38. Hans Enzensberger, 'Constituents of a Theory of the Media', *Critical Essays*, ed. Stuart Hood (New York: Continuum, 1982), pp. 46–76.
39. Jürgen Habermas, *The Structural Transformation of the Public Sphere* (Cambridge, MA: MIT Press, 1989), p. 161.
40. M. Hansen, 'Unstable Mixtures', p. 191.
41. See Oskar Negt and Alexander Kluge, *The Proletarian Public Sphere*, selections in *October*, no. 46 (Fall 1988); and *Social Text*, no. 25/26.
42. Nancy Fraser, 'Rethinking the Public Sphere', *Social Text*, no. 25/26, p. 67.
43. The emergence and role of 'new social movements' in the public sphere is also explored in Ernesto Laclau and Chantal Mouffe, *Hegemony and Socialist Strategy: Towards a Radical Democratic Politics* (New York: Verso, 1985).
44. This is aggravated by the continuing low level of literacy that exists among the poorer sectors of the population and their poor access to means and media of communication.

45. Such human rights organizations include Liga Internacional de Mujeres por la Paz y la Libertad (LIMPAL); Derechos Humanos de la Procuraduría General de la Nación (CONADHEGS); the Colombian-based Comisión Intercongregacional de Justicia y Pas; Instituto Latinoamericano de Servicios Legales Alternativos (ILSA); Asociación Latinoamericana para los Derechos Humanos (ALDHU); Conferencia Internacional sobre Refugiados Centroamericanos (CIREFCA); Fundación para la Investigación, la Cultura y la Educación Popular; the Geneva-based International Council for Voluntary Agencies (ICVA); and Amnesty International and Americas Watch.

46. Homi Bhabha, 'Beyond the Pale: Art in the Age of Multicultural Translation' in the catalogue to the 1993 *Whitney Biennial*, p. 63.

47. Theodor Adorno, 'Commitment' (1962) in *The Essential Frankfurt School Reader* (New York: Continuum, 1982), p. 313.

48. Jean Franco, 'Death Camp Confessions and Resistance to Violence in Latin America', *Socialism and Democracy* , no. 2 (Spring/Summer 1986), p. 3.

49. Michael Taussig, 'Terror as Usual: Walter Benjamin's Theory of History as a State of Siege', *Social Text* , no. 23 (Fall/Winter 1989), p. 15.

50. Annette Michelson, 'The Kinetic Icon in the Work of Mourning: Prolegomena to the Analysis of a Textual System', *October*, no. 52 (Spring 1990), p. 31.

51. Pierre Nora, 'Between Memory and History: Les Lieux de Memoire', *Representations*, no. 26 (Spring 1989), pp. 7–25.

52. Benjamin Buchloh, 'Figures of Authority, Ciphers of Regression', *October*, no. 16 (Spring 1981), p. 41.

53. Barbara Rose, cited in Douglas Crimp, 'The End of Painting', *October*, no. 16 (Spring 1981), p. 74.

54. Walter Benjamin 'Paris, Capital of the 19th Century', in *Reflections* (New York: Harcourt, Brace, Jovanovich, 1978), p. 155.

55. Walter Benjamin, 'Theses on the Philosophy of History' in *Illuminations* (New York: Schocken, 1969), p. 263.

56. Émile Durkheim, *Elementary Forms of Religious Life* (New York: The Free Press, 1965), p. 269.

57. Jean Franco, 'Killing Priests, Nuns, Women, Children', in *On Signs*, ed. Marshall Blonsky (Baltimore, MD: The John Hopkins University Press, 1985), p. 420.

58. Ibid, p. 14.

59. Benjamin Buchloh, 'Allegorical Procedures: Appropriation and Montage in Contemporary Art', *Artforum*, vol. XXI, no. 1 (September 1982), p. 52.

60. Walter Benjamin, 'Theses on the Philosophy of History', in *Illuminations*, p. 263.

7

Metramorphic Borderlinks and Matrixial Borderspace

Bracha Lichtenberg Ettinger

INTRODUCTION[1]

The notions of Matrix and Metramorphosis emerged in my artistic work.[2] Gradual clarification of these ideas in the field of psychoanalysis has led me to develop the concepts as follows: *matrix* I understand as a psychic borderspace of encounter; *metramorphosis*, as a psychic creative borderlink; and the *matrixial stratum of subjectivization* reveals subjectivity as an encounter of co-emerging elements through metramorphosis. I want to insist, however, that the theoretical elaboration of these terms does not control or even dominate the painting.

The Matrix is an unconscious space of the simultaneous co-emergence and co-fading of the *I* and the uncognized *non-I* which is neither fused, nor rejected. It is based on feminine/pre-natal[3] interrelations and exhibits a shared borderspace in which what I call *differentiation-in-co-emergence* and *distance-in-proximity* are continuously rehoned and re-organized by metramorphosis (accompanied by matrixial affects) created by – and further creating – *relations-without-relating* on the borders of presence and absence, object and subject, me and the stranger. In the unconscious mind, the dimension of matrixial borderline is linked to feminine desire: it co-exists and alternates with awareness of the phallic dimension. The *sub-symbolic* matrixial filter, torn out of foreclosure by *non-Oedipal sub-limation*, provides meaning to vague, blurred, slippery internal and external traces which are linked to non-Oedipal sexual difference. Passing through the matrixial filter, particular unconscious non-phallic states, processes and borderlinks concerning the co-emerging *I* and *non-I* become meaningful. The Matrix is not the opposite of the Phallus; it is, rather, a supplementary perspective. It grants a different meaning. It draws a different field of desire.[4] The intra-

uterine feminine/pre-natal encounter represents, and can serve as a model for, the *matrixial stratum of subjectivization* in which *partial subjects* composed of co-emerging *I(s)* and *non-I(s)* simultaneously inhabit a shared borderspace, discerning one another, yet in mutual ignorance, and sharing their impure *hybrid objet a.*

Metramorphosis is an archaic, blurred but nevertheless indelible conductable link-lane. Indefinite compositions of experience are exchanged; phantasies and affects are conducted through slippery borderlinks, transforming the co-emerging *I* and *non-I*, their borderspace and their *shared* objects beyond distinct representation, creating and redistributing an ontogenetic *becoming* memory. I will suggest that we use these concepts to revise the aesthetic object and re-view painting as a metramorphosis.

The matrixial prism transgresses and precedes the phallic/Oedipal notion of subjectivity, and of femininity and masculinity (indeed, of gender identifications). Metramorphosis transgresses the phallic processes of transformation and exchange, and of meaning donation and revelation. I will suggest that with these concepts we unravel *an-other*, a *beside* non-conscious dimension, and thereby enlarge our understanding of the creative process as well as the difference of woman's sexuality.

Within the general field of Lacanian and Freudian psychoanalysis I will trace the phallic network of relationships between the corporal *Thing*, the *Woman as Other* and as a phallic lacking 'objet', the present and the absent aesthetic (phallic) *objet a* and *Beauty*; and I will modify this network by deploying the notions of the Matrix (or *matrixial borderspace*) and metramorphosis (or *metramorphic borderlinks*). Stripping away the shrouds from the face of Freud's 'uncanny', I will deflect the Lacanian lost object's (*objet a*) aesthetic qualities from the phallus to the matrix, at the same time moving from the idea of beauty to that of the sublime. As a sub-symbolic (and not *pre*-symbolic) network, the feminine participates in the *symbolic* using other passageways from the *real* – passageways that do not conform to the mechanism and function of 'castration'. This perspective deconstructs the monopoly of the phallus and its accompanying mechanisms of imaginary and symbolic 'castration' in the field of desire.

In the realm of subjectivization through phantasy, sexual difference and artistic creation, I will draw a borderspace in several mental fields: the *real* (emphasizing links to *feminine bodily specificity*); the *imaginary* (exposing matrixial beyond phallic phantasies, for both men

and women); and the *symbolic* (displaying matrixial contributions to subjectivity, art and culture). Both matrix and metramorphosis seep into these three aspects of psychic reality from 'behind', from the realm of the slippery object which escapes, and shapes them all.

MATRIXIAL BORDERSPACE AS A SHARED STRATUM OF SUBJECTIVIZATION

The Matrix is an *extimate* zone, where the internal is becoming external and the external, internal by virtue of the transgressive potency of the margins. It is a zone of encounter between the intimate and the exterior, where the uncognized Other (as a *non-I*) and the *I* co-emerge and co-fade, are separate but together, in a continual attuning of distances in proximity. There is neither fusion nor repulsion, neither incorporation nor expulsion.

The Matrix empowers more-than-one and less-than-one partial subject, part-object, or element[5] and their joint borderlinks and borderspace, which are known and unknown, but also are discerned by and discerning one another. The plurality of the Matrix is made up of several elements (it is neither Nothing, nor One, nor Infinite), yet each matrix is a singular or unique ensemble.

In the Matrix, co-emerging *I(s)* and *non-I(s)* co-exist in difference; partial subjects discern one another as uncognized *non-I(s)* without absorbing mergence to abolish differences, and without attacking expulsion. My hypothesis is that such relations occur between internal psychic partial subjects and part-objects, and also between the subject, other subjects and external objects: in parallel to phallic relations, on an alternative track. In the very late pre-natal phase such relations occur on the level of the *real* between part-objects and partial becoming-subjects in the psychic-bodily feminine/infant borderspace. They are accompanied by some kind of mimimal awareness, refining traces which will be later brocaded into the tissue of subjectivity.

We can qualify classic definitions of the pre-Oedipal and Oedipal phases as phallic because the object – or the Other (to begin with, the oral object and the mother) – is approached through fusion, and the lack of the object – even the departure from the maternal breast – is always the result of rejection. The model of phallic castration is retroactively applied to all separations and weanings. To more recent, different perspectives concerning mother–child units and the

emerging self,[6] I suggest adding the co-emerging feminine/pre-natal *I* and *non-I*. A unique stratum of subjectivization is *shared* by several partners, and differentiation is primary. Elementary matrixial operations differ from elementary phallic operations attributed to pre-Oedipal phases in that the emphasis moves from elements to relations and links between them; from links of attraction and rejection to borderlinks of *distance-in-proximity*; and from symbols and representations to sub-symbolic transformations reaching borderline awareness of *relations-without-relating*. The object's and subject's intermediary state of *presence-in-absence* and *absence-in-presence* in early relations[7] highlights the functions of conductability by borderlinks between co-emerging *I(s)* and *non-I(s)*. The shared borderlines and borderlinks – more than each element – are sources of creation and transformation within *subjectivity as encounter* in the matrixial borderspace.

The idea of a *matrixial stratum of subjectivization* implies that late intra-uterine, pre-natal events already create meaning and somehow inscribe traces of their transformation, potentially producing discernible *pictograms*[8] on the level of the *real*, which filter through to ulterior developmental phases. It also implies that the invisible specificity of the female body creates discernible sub-symbolic transformations that inscribe mental traces and can reappear in later joint-psychological processes of exchange and transformation (e.g., projection-identification, transference-countertransference, acting out and aesthetic creation and experience). The real Matrix through which we pass (the womb) and from which we are separated, like the real Matrix which we possess (or not), leaves affected joint traces, and evokes conductable sensations, perceptions, and emotions. The borderlinks organize experience as they are accompanied by psychic-libidinal investments. A borderline discernibility of the uncognized *non-I* emerges for me and emerges with me, since the Other is indispensable for the matrixial stratum of subjectivization.

The *feminine/pre-natal* matrixial encounter with the external/ internal 'extimate' *non-I* is not to be confused with the *maternal/post-natal* relations of nurture and care for the known, beloved, intimate other. In the matrixial experience, a *non-I* is being cared/not cared for unconsciously by the same gesture: *I/non-I* cares for, or *I/non-I* does not care for my/your-self.

In the Matrix, the *Several*, the borderlinks and the borderspace between the several precede the One. From the moment we speak of the subject we can also speak of an enlarged subjectivity. The

archaic, sub-symbolic matrixal web can connect with imaginary and symbolic representations. Borderline inscriptions of shared experiences relating to the invisible specificity of the female body and to the pre-natal phase, emanate not only from a joint *bodily* surface contact or joint sensations of movement that create psychic borderspace, but also from the participation of the woman's (*non-I's*) unconscious apparatus in the formation of the *I's* (the infant's) phantasy and the re-tuning of the *non-I's* phantasy (the becoming-mother's) as a result of that passage to the other, as well as from the *non-I's* own receptivity to transformations in the other. From a matrixial perspective, the focus shifts from separate objects and subjects towards the borderlinks between part-object and partial subjects and towards processes of transformation which take place jointly in their borderspace. A feminine dimension emerges which consists of relations-without-relating between the co-emerging *I* and *non-I*.[9]

The particular external-internal borderlines between presence and absence in subjects (with objects) in differentiation in co-emergence, and the borderlinks to otherness in terms of transgression of margins and light oscillations of distance in proximity, have a creative function in subjectivization. The sub-symbolic matrix may be secondarily conceived conceptually and penetrate the discourse. The transformations in the co-emerging *I* and *non-I* through phantasy-transgressions of time-space-body instances via borderlinks suggest a creative process which I have called *metramorphosis*.

Relations-without-relating transmissions and transformations which conjointly concern the several in the matrix are metramorphic processes. Metramorphosis is an organizational mode, based on self-mutual-attunings of borderlinks, which creates and forms the matrixial subjectivity. Through metramorphosis, a continuous attuning goes on between the co-emerging *I(s)* and *non-I(s)*. Metramorphosis regulates asymmetrical libidinal investments in the joint space without aspiring to homogeneity. It participates in the concurrent emergence but also fading of the *I(s)* and *non-I(s)* via the borderlinks. Metramorphosis is the becoming-threshold of a borderline which allows for relations-without-relating between co-emerging *I(s)* and unknown Other(s). It is the transgression of a borderlink, its transmissability, its conductability. It is also the becoming-borderline of a threshold, without its freezing into a frontier.

Metramorphosis allows for the creation of new borderlinks, thresholds and margins. It allows for the redistribution of traces of affects,

sensations, emotions, libidinal energies and phantasies, and for exchanges of with-in-formation between co-emerging I(s) and *non-I(s)*.[10] A contingent borderspace of encounter emerges as a creative instance which is neither 'in the beginning' nor 'at the end', but somewhere along the road: as when several narratives with neither beginning nor end develop in a certain harmony which is not intended, and not directly represented, and yet changes them all.

In aesthetic terms, Metramorphosis is a creative potentiality, crystallized and realized in the artwork as a matrixial borderspace. During the 'paintorial' act, we can discern a minimal and diffused pleasure/displeasure affect which I call the *matrixial affect*, shared between the artist and the viewers – even if at different moments in time – through evocations like silent alertness, amazement and wonder, empathetic curiosity, compassion, awe, and uncanniness. The matrixial affect is not simply a lack of extreme pleasure and displeasure, and it does not 'aspire' to the quickest return to homeostasis; it is, in itself, a differentiated basic affect which does not slide towards pleasure or displeasure according to predetermined phallic channels. Matrixial affects slide towards one another without necessarily striving to disappear in perfect quietude.[11]

In the matrixial stratum of subjectivization, the psyche discerns the unknown Other, and is affected by the encounter and by the alternations in distance-in-proximity. The matrixial subjectivity is not entirely inaccessible since pre-natal processes (which seep into certain aspects of the post-natal, pre-Oedipal strata of subjectivization), as well as the repressed or forecluded difference connected to the female bodily specificity (which cannot be reduced to the absence of a penis) create unconscious phantasies and desire and unconscious objects of desire.

In the matrixial stratum of subjectivization, the Other's *difference-in-togetherness* is already discerned at the level of the affected space-time-body instances of each singular encounter. This gives rise to phantasy and influences subject's and object's relatedness, separation and sharing, lack and exchange, and, later on, social relations. The Matrix has ethical and political dimensions; it implies a permanent beside-awareness of a co-existence with a stranger which is neither the same nor the opposite. On the level of subjectivity-as-an-encounter, which hovers alongside the phallic subject, the Other always remains a borderline non-I, an extimate subject/object, an exterior in the interior or an interior in the exterior. The foreigner is a *non-I* who is not left alone to his/her own otherness in a state

of apathy or oblivion; the stranger is cared for without relinquish-
ing [its] difference. When the stranger is discerned in the matrixial
borderspace, s/he is invested libidinally and becomes a partner in
some of the *non-I*-zones of my-your self. The stranger might give
rise to curiosity and wonder, or apprehension and uncanny feeling.
S/he is neither hated nor loved, yet neither is s/he ignored. S/he
is with-in and with-out.

METRAMORPHIC CO-EMERGENCE IN DIFFERENCE

Traces of the unviewable, out-of-the-signified *Thing*, and of singular
instances of affected space-time-body or of archaic sensorial events
which ignore the *image of words*, cannot be repressed, yet they are
regarded as psychic events. Piera Aulagnier considers these events
as representations: as *pictograms*. The pictograms persist in a quiet
way throughout an individual's life. The process that produces them,
the *originary process*, uses the *image of things*. It appears in parallel,
or prior to two other psychic spaces and processes: the *primary
process* which uses the image of things and also, to a certain extent,
the *image of words* (represented by *phantasies*); and the *secondary
process* which uses the image of words already interwoven in a
cultural network, represented by *thoughts*. To say that the originary
archaic space produces psychic activity means that sensorial and
perceptive functions are not only used by the body for its survival
but are also invested with libido, or affected. Every experience,
whether its source is internal or external, produces representations
on several levels at once: in the *real*, in the *imaginary*, and in the
symbolic; pictograms, phantasies, and thoughts conjointly record any
given event. Aulagnier claims that the primary process 'trails be-
hind' the originary process, since the primary process only begins
functioning when the mind recognizes the separation of two corpor-
eal and mental spaces. Differentiation here is, then, secondary, even
though very early, and separation is considered to be imposed by
the experience of the absence and the return of the maternal breast.
It must be, therefore, post-natal, oral, and modelled on phallic
operations. Yet, the pictogram is already a relational representa-
tional schema; it represents encounters between zones of the *I* and
part-objects (belonging to the Other) or between the *I* and the
others-as-objects, and their accompanying affects.[12]
Indeed, there are several ideas permitting a conception of the

whole of the Unconscious and the *symbolic* as phallic: that 'devouring aggression', fusion and rejection are the only originary pictograms and the only possible relations towards the other and towards the outside; that these basic psychic inscriptions are affected either by *love* or by *hate*; that pictograms are always correlated *in the same way* to pleasure/displeasure and to the alternation between the presence/absence or appearance/disappearance (*fort/da*)[13] of an object, expressed in language as a yes/no opposition. This conception is also based on the idea that all instances of lacking can be traced to *one* phallic lack (Freud, Lacan), and that 'castration' is the only passageway between the *real* and the *symbolic*. According to this phallic paradigm, the pre-natal metaphor usually represents the extremities of the phallic position: it is both a total paradise and a state of annihilation.

The metramorphic borderlink between the *I* and the *non-I* offers a different kind of originary relational organization (from the pictogram), since it produces meaning *without* distinct representations, and in it differentiation is primary. In the matrixial model, the earliest stratum already has a dimension of relative distance in co-existence and of difference which is related to connectionistic modes of organization of experience in the infant/mother-to-be unit in terms of joint sensory surfaces, movements, time-intervals, rhythms and even voice and tangibility, to early phantasmatic passages between the co-emerging *I* and *non-I* reflecting an interior/ exterior borderspace and object/subject- (or other-) relatedness. The matrixial instances of differentiation through oscillations of distance-in-proximity alternates and co-exists with primary autistic and symbiotic moments in which the *I* is not differentiated with-in severality.

In the matrixial stratum of subjectivization, the awareness of difference recorded in the originary space can already be accompanied by pleasure and not merely by displeasure and anxiety, and can be related to the 'uncanny'. Thus, difference and the stranger are not *merely tolerated* by the subject.[14] Relative approaching in the co-emergence of the *I* and the *non-I* is not a loving incorporation; relative separating in their fading-away is not a hating expulsion. The partial subject, or the subject-to-be, invests libidinal energy in a borderspace without either invading or destroying it. At the same time, the co-emerging *I(s)* and *non-I(s)* are continually invested from the borderspace. Metramorphic borderlinks transmit and redistribute traces of – and for – the becoming and the fading-away encounters.

In the phallic stratum of subjectivization the subject vacillates

between fusion/assimilation/love and rejection/repulsion/hate which are seen as its 'normal' poles. If we conceive of the first encounters between partial subjects not as post-natal and oral but as intra-uterine and matrixial, two key theoretical equal signs of the psychoanalytical tradition are undone: the equal sign between approach, fusion and pleasure (positive libidinal investment), indicating an increase of Eros; and the equal sign between departure, repulsion/rejection and displeasure, indicating an increase of Thanatos. I propose the following non-phallic hypothesis: that the discernings of the uncognized *non-I* and the attunings of the experience of differentiation in co-emergence accompanied by a matrixial affect create, in addition to the two basic pictograms of *union-as-fusion* and *destructive rejection*, a third pictogram of *distance-in-proximity*. Distance-in-proximity should not be perceived as a combination, or a compromise, of the other two. It is a basic position in which a relative distance is not opened by loss, but is there from the start.

An enlarged subjectivity – *hybridized*, multiple or divided – shares a minimal, diffused libidinous investment in joint borderspaces, links and borderlines which are both exterior and interior. It is not to be understood as a simple *addition* of the *non-I* to the *I*. The borderspace, the borderlinks and the process of subjectivization are created together.

If we go on a return journey between body and language, I suggest that any relationship between the *I* and the *non-I* produces not only records in each psychic space, which can be formulated by metaphor and metonymy, but also a different kind of inscription: metramorphosis as a mental trace of a forth space of ontogenetic 'memory' of transmissions and transformations. To the co-existing idea (thought), the 'figurative mise-en-scène' (phantasy), and the pictogram, I add, then, a matrixial ontogenesis, understood in terms of the aesthetic: continual adjustments of *sub*-symbolic elements as *meaning-producing psychic events* which do not stay *pre*-symbolic. Sub-symbolic elements (as well as pre-symbolic representations manipulated by the originary processes) push their 'remains' towards the primary process to produce phantasies and towards elaboration by the secondary process. Alternatively we may say that at the same time that an experience is organized according to the logic of the discourse, it is both subjugated to the concealed or repressed 'logic' or 'aesthetic' of the phantasy, and echoes both its pictograms and its network of transforming inter-relations. The sub-symbolic

level is not only subversive in relation to culture but also trans-
forms it.

It seems to me that one obstacle to relativizing basic phallic as-
sumptions is the prevailing idea that a distinct representation should
correspond to each psychic event, and that the most archaic traces
are already representations. If I claim that originary matrixial – yet
not distinct – contingencies transform subjectivity, it means that the
matrixial corporeal survival is accompanied by libidinal investment
and is therefore a psychic event. In the matrixial borderspace, mean-
ing and memory emerge which are not based on a concrete inscrip-
tion of distinct experiences or on distinct representations. Thus,
matrixial experiences are not entirely foreclosed, since they trace
connectionist webs.

Nomination by symbols (Lacan), manipulation of distinct signs
(Lacan, Bion), and representations (Aulagnier) cannot serve as the
primary 'Payer' of matrixial meaning-revelation. Instead, a border-
line way of 'making sense' for 'feeling' and 'thought' elements is
suggested here. For F. Varela, connectivity is the dynamic network
of internal interactions within autonomous 'close' biological entities,
autopoietic systems,[15] which creates transformation and meaning.
Meaning is not carried *inside* symbols, and memory is not created
by registration and storage since it is the very history of structural
couplings.[16] Beyond the *symbolic* and beyond representation, living
systems 'make sense' which is inseparable from the history of their
transformation, and the transformation itself is inseparable from
this making sense.[17] The metramorphosis takes care of both self and
not-self together, and its borderlinks connect to both inside and out-
side, while autopoietic connectivity is conceived of as linkages of *I*-
elements within a closed system, at the service of a closed-system's
self. In order to think of the co-emerging *I* and *non-I* in terms of the
feminine/pre-natal encounter beyond homeostasis and the pleasure
principle, and of the other as neither rejected nor fused, we also need
to conceive of metramorphosis beyond the model of autopoiesis.

In his late 'phantasy theory' Lacan strives towards an aspect of
subjectivity which escapes the *symbolic*, and the absolute claim of
language over subjectivity is reduced and relativized. Yet even
though Lacan takes care to explain that, 'If the unconscious is struc-
tured like a language, I did not say: by . . .';[18] psychosis (like 'woman')
is still marked by a lack of signifiers: 'the speech of a schizophrenic
is specified by its being pronounced without the protection of any
established discourse'.[19] Lacan explains that an unconscious which

is structured like a language implies that it can allow for coding and being coded by signs.[20] If we think of psychological meaning-creation and memory also in terms of non-distinct traces of existential co-emergence beyond/before symbols, signs, and representations, then at the level of the *real*, continual readjustments accompanied by matrixial affects in the womb, on either side of its borders, are ontogenetic 'common sense', and memory is created even though distinct representations are not yet available. The matrixial encounter is a connectionist psychic event which has an emerging borderline sense. The feminine awareness (as an *I*) of the internal/external *non-I* by transmission of emotional tones and phantasies contributes to the *non-I*'s affects and phantasy world through metramorphic borderlinks.

The maternal discourse anticipates the infant's capacity to recognize internal and external phenomena and to use symbolic meanings.[21] It translates the archaic phantasy world to create 'cultural' meanings and organizes the subject's secondary space, just as, I would claim, the mother-to-be's function of meaning-revelation linked to her desire 'translates' the post-mature inborn infant's sense-impressions into phantasy.[22] The co-emerging *I* and *non-I*, when transforming together beyond the originary level through desire and discourse, will redistribute their recent and past traces according to their expansion in the symbolic world which opens up to each *I* and *non-I*, be it in their separate state or in togetherness.

The phallic and the matrixial states alternate, but also influence each other. These kinds of alteration relate to differences which are gradually perceived between several partial subjects, between several desires, several agents of desire or subjects, between parents, between the sexes as gender identifications, between us and the strangers. The phallic *I* (whether solitary or fused) and the matrixial *I(s)* – with their self-specific relations to the object – co-exist in each one of us, differently, regardless of sex and gender identification. Art may bring us into contact with possible actions of the shared matrixial 'sub'-originary borderspace and through this to some understanding of the feminine dimension of sexual non-Oedipal difference, giving room for the expression of the singularity of each encounter in terms of the borderline relations between the phantasies of one partner and the subjectivization of an-other partner.

There is no reason why matrixial phantasies cannot be partly recognized by the secondary process in the *après-coup*.[23] Metramorphic borderlinks are transferred from the 'sub'-originary to the

primary space and produce phantasies, but as an abstract concept they keep eluding our present *imaginary*, and the actual psychoanalytic *symbolic* is not enough suitable yet to account for it. In our culture, the female bodily specificity finds representation in vague phantasies but is reduced to a psychotic status since the appearance of phantasies that are not connected to images of words may produce a return of the *real* as delirious ideas and hallucinations. Such a difference cannot be recognized by the subject or by society as long as there are not enough (un)conscious non-phallic sub-symbols to attach it to and no non-phallic connectionist processes are assigned to the unconscious Other, for conceiving of an enlarged *symbolic*.

Yet, undigested matrixial instances manifest a unique power of resistance and protest, and expand the margins of culture through art, deflecting its scope from with-in. Whatever escapes the phallic symbolic text at the moment of the split between signifiers and signifieds – remnants, rubbish left out of the *symbolic*, unprocessed traces of real events, archaic fragments and 'lost' archaic remnants – all represent an ever-open possibility for passages of traces of otherness in an(Other) symbolic dimension, if we enlarge it to embrace the matrixial relational borderspace and if the *symbolic* is understood as comprising more than definite and distinct 'whole' entities of meanings or signs: with the sub-symbolic interwoven within it. Art allows for the incarnation of traces as relics, for the conception and the recognition of hidden elements which are otherwise approached through regression or psychotic hallucination.

I have suggested elsewhere that the symbolic network is broader than the phallic, that we must distinguish between phallic elements and those which are not phallic but which nevertheless infiltrate the *symbolic*, and that the passage to the *symbolic* must not be understood only in terms of Oedipal 'castration'.[24] As long as there is a lack of discourse, reflecting not-yet-conceived sub-symbolic zones, the secondary process treats matrixial phantasies as nonsense. These zones are revealed by the work of art, in terms of what is concealed in (and by) it, since painting is joining and creating a freely circulating metramorphic borderlink. Throughout the artwork as evocation of the invisible screen beyond appearance, theory can attempt to abstract matrixial meanings. In art, the invisible screen is theory-producing and not merely the product of theory.[25] If the 'remnants' of the Matrix can be found in art, they testify to the power of resistance of female difference which refuses time and time again to be

either psychotic or mystical, either entirely visible or completely erased. Art is a metramorphosis which, like the pictogram from the inside, triggers changes in the *symbolic* from with-in and with-out, sheds light on holes in its network, sits in its margins. It subverts and transgresses beauty and culture; it connects with their margins and triggers them into becoming thresholds. The creative artistic process is a metramorphosis.

THE MATRIXIAL OBJECT OF DESIRE ON THE BORDERS OF PRESENCE AND ABSENCE

In Jacques Lacan's early theory, unconscious subjectivity is exclusively structured by the symbolic network of signifiers (of language) in the Other: 'The unconscious is the sum of the effects of speech on a subject, at the level at which the subject constitutes itself out of the effects of the signifier.'[26] Unconscious meaning is created through knowledge supposedly dwelling in the Other and structured by linguistic-like signs. The masculine-paternal-phallic dimension – established as sexually neutral – is considered to be the only agent of culture. Women are considered equal in this neutral structure so long as no difference from the phallic dimension is maintained. Beyond the phallus, the feminine is the price which must be paid in order to belong to culture; the feminine is that which cannot belong to the signifying chain, and Woman, whether as personification, or as abstract abbreviation of the feminine as singularity, cannot be included in the symbolic Other. Yet she is – paradoxically, and for the same reason – the Other *par excellence*.

According to Lacan's early theory, if unconscious subjectivity is structured through the chains of the signifier in accordance with the Oedipal structure, the male or female subject cannot recognize the ephemeral part-objects, or the archaic pre-Oedipal object-relations that were established before he or she succeeded in perceiving him/herself as a united image in the 'mirror stage'. The ephemeral part-objects and the relations to the archaic object/Other (mother) belong to the *real* and to the 'dark continent' (Freud) of the feminine. Woman as Thing, linked to archaic affected sensorial impressions, is foreclosed from the Unconscious: She is not even repressed. She/Thing is the archaic body-thing associated with re-becoming fragmented part-objects, with partial drives and the

erogenous zones corresponding to them, which are omitted from the later unified, integrated imaginary-specular body, and with psychological disintegration. In Freudian terms, from the Oedipal stage onwards, Woman is associated with 'castration anxiety' as a visual model of the 'success' of castration. Otherwise, in Lacanian terms, She is either the archaic Thing, a pure pre-object of *jouissance*, or She is the radical Other, eternally escaping all conceptualization. She is either completely inaccessible to both men and women, or completely determined by the phallus. She is linked to psychotic disintegration and to the anxiety of ceasing to be differentiated and of becoming an amoebic entity. The psychotic male (Freud's Schreber) incarnates the woman.

For Lacan, *the Name of the Father* – the symbolic Other as a metaphor for the law of society, history, and culture and as the *locus* of revelation of the signifying chain, transmitted by discourse and represented by the father – replaces the real archaic Woman-Other-Thing who becomes the locus of the *action* of the phallus. Feminine sexuality is accounted for only by the phallic Oedipus Complex and the whatever of the feminine (referred to as Woman) which escapes the phallic definition therefore escapes the symbolic realm of culture and history, since the *symbolic* is entirely defined by the phallus. Where Woman as a radical Other is not determined by the phallus, her inaccessibility is like that of the two limits of human experience: procreation or death, close to psychosis and Thanatos, but also to the mysterious border between sublimation and art.

In Lacan's early theory, the *objet a* is created in the division into signifier and signified as what is dropped and slipped out of this division; it is, therefore, a psychic being without imaginary or symbolic representation in language.[27] In his later 'theory of phantasy', Lacan overturns some of his earlier postulates. In the inverted position, unconscious subjectivity is not constituted completely by the Other in terms of language. A group of elements closely related to the network of the *real* – the Thing, *jouissance*, and the *objet a* – become contributors to unconscious subjectivity revealed by phantasy, and thus, relativize the importance of the signifying chain of Lacan's early theory.

The area of the *real* is a psychic zone which is the nearest to bodily experience, to the level of sense-perception, instincts, drives and affects in which the first transformations from biological entity to psychological entity take place. The outcomes of these transformations are expressed by the phantasy.

The *thing* is distinguished from the object in that it participates in the elementary communication between sensing and moving (Erwin Straus, *Von Sinn der Sinne*): it is an aesthetic reality anté-predicative and pré-conceptual. The horizons of potentialities and marginality (cf. Husserl, Maldiney) in which the thing is discovered as the *Umwelt* or the background of the world which may be called reality (cf. Merleau-Ponty).[28]

The Lacanian *objet a* is no more such a 'thing', but already an object (organized along the guidelines of drives) created by a loss. In opposition to the part-object or the real *Other* in terms of *presence*, *objet a* is the part-object or the Other in terms of *absence*. It is not that which is present in phantasy but that which is omitted from it, even though phantasy leans on it and hints to it.

Psychic drive is an activity in the plane of the *real*, which 'cuts' off samplings of the body and carries their mark in its special modes. Only certain parts of the body are relevant for this activity. 'The common factor of *a* is that of being bound to the orifices of the body.'[29] The *objet a* is a mental product of the activity of the drive and is also its trace, as well as a trace of the part-object; it is the leftovers of the part-object after separation from it. The unconscious part-object to which the drive relates, which is different at every stage, can be considered as 'spare parts' of the erogenous zones. The original part-objects drop out from the body image of self and of others as visual complete 'wholes', and other objects can serve as their substitutes. The acquisition of language, and with it the passage to *secondary repression* and the formation of the Preconscious, cannot 'tame' or destroy these leftovers of the *real* in the form of the *objet a*.

In the early theory, entry into language creates the *objet a*. It is in the process of entry into language, in the division of words into signifiers (in the *symbolic*) and signified (in the *imaginary*) that the part-objects slip away and that traces of the split-off fragments become inaccessible. The Other subjugates the subject to the signifier while splitting and cutting it. In the later theory, the *objet a* eludes conjointly all three dimensions of experience: the *real*, the *imaginary* and the *symbolic*. The *lack* of the Lacanian object is based on the loss that is inherent in the fact that a corporal aspect of instincts and drives will never *be* a mental entity, that there will always remain a gap between mental representation of the body and corporal existence of the organism, and on the loss that is inherent to the

recognition of the separation and the split from the early relationships with the Other and from the archaic part-object.

The Other, for the late Lacan, has two faces, both unconsciously subjectivizing: the signifying chain and the lacking *objet a*. In phantasy, the subject comes to the fore 'first of all, uniquely and essentially' as the *'coupure* [cut] by the *objet a'*. Such relationships between the subject and the *objet a* allow Lacan to present *art* as an *'elevation of Woman to the level of Thing'*.

One should not assume that here, once again, Woman represents Object and Nature while man represents Subject and Culture. In light of the later theory and of the 'inverted' position, the psychological aspect directly connected to the body is no longer entirely subordinated to culture as it was in the earlier theory; *objet a* as a leftover of the *jouissance* participates in the constitution of the subject, and thus the *objet a* indirectly determines culture no less than does the signifying chain. Woman, rather than representing a failure in sublimation, as Freud insinuated (because of her 'inferior' Oedipal solution) may become its prototype. Her 'objective' status here is not that of an 'artistic' model; neither is She an object of representation in imaginary identification. Rather, she has the status of the lost archaic *objet a* as a subjectivizing agent.

Yet, being an *objet a*, Woman still remains that which has no place in the *symbolic*; moreover, the *objet a* is in itself phallic since it is established through a castration process, or through 'cuts' from the *real*. Thus, not only is each granting of meaning a phallic symbolization, but also all that is omitted from each of such grantings belongs to the phallic circle as well. Even the *objet a* that emerges at the stumbling point of the Other – at the signifier's abyss – depends on the phallus. Mostly, Lacan considers the phallus a neutral symbolic entity, but one which is dependent upon a sexual (not neutral) castration (which is formulated within the male perspective). While in relation to the inverse theory of the phantasy Lacan emphasizes not simply the presence or the absence of the *objet a*, but also the conjunction of the two in the coupure of which the subject comes to dwell, his *objet a*, still, always retains its phallic status.

In the later theory Lacan insists on what I call a *beyond-the-phallus dimension* of 'woman'. Yet, since for him language is entirely phallic and any passage to the *symbolic* happens by 'castration' and turns the object of this passage into a lacking phallic *objet a*, nothing can be said, therefore, about the beyond-the-phallus feminine in

'positive' terms. 'She is fully there [inside the phallic function] but there is something more.'[30] However, according to the earlier theory, if the *objet a* – which relates to the separation from bodily organs and from the archaic Other – could only be phallic, the later 'theory of phantasy' leaves, in my view, enough room for us to claim another kind of *almost*-absent object, a matrixial kind. In so doing, the paradigm itself rotates from 'within' and *desire* receives supplementary meaning. This different, almost-absent object also contributes to subjectivity, and so the feminine beyond-the-phallus enters subjectivity through the back door, escaping the castration imprint and yet *becoming symbolic*. I call such another emerging and trading joint object of phantasy and cause of desire (produced by the metramorphic processes) a *matrixial object (or objet a)*.[31] The metramorphosis creates an-other object, links and a field of desire.

The subject is not determined by discourse alone, but also by the object-cause of desire which 'cannot be imagined and thought of', even though 'everything which is thought of as a subject, the being one imagines as being, is determined by it'.[32] Archaic representations of the body as psychic events do not stem in a backward movement from symbolic discourse alone but emerge in a 'forward' movement from originary space toward primary space; metramorphic transformations and pictograms that become phantasies are already unconscious events without passing through the *symbolic*.

In the early theory the passage through language is also responsible for the transformation of the part-object into a lacking object. The drive is transformed into desire under the effect of this passage; it is modified by signifiers. But in the later theory, the object-cause of desire is exterior to this passage and remains *autonomous*, unmodified by the signifiers. It is neither formulated nor changed by language, it has no specular image and it cannot be communicated by discourse. For the angle of desire 'in this inverted point of view', the subject of the phantasy is 'the *coupure* of the *objet a*': the derivations of the body 'cut off' 'samples' from a continual existential noise and those take part in the process of subjectivization. We can say that singular events in the *real* attract meanings via *jouissance*, and thus the body as a psychic event participates indirectly in the construction of subjectivity even though a *one-to-one concordance between body and language is impossible*: 'There would never be any conjunction, any coupling, of One and *a* . . . There is nothing in the unconscious [as the effect of speech] which accords with the body'

and therefore the subject is also caused by that which cannot be said but only noted in writing the (*a*). 'In all this what is irreducible is not an effect of language'.[33]

Since the phallus covers the whole fields of the *symbolic* and the *imaginary*, the *objet a* which escapes discourse and visual specularity is compared to Woman. In Lacan's early theory, when Woman is either inside the phallus or constitutes whatever cannot be recognized or formulated by it, this is a hidden trap: escaping the phallus as an *objet a* does not mean being autonomous in relation to it. That which escapes it is still defined by it, since the *objet a* is omitted from the *symbolic* through its creation by 'castration'. But in phantasy, where the *objet a* is autonomous, the traces of the body re-enter the Unconscious through the back door and are undetermined by the phallus up to a certain point: independent to some degree of the structure imposed on it by the *symbolic*. Thus, the general theory of phantasy (beyond the variations between Freud, late Lacan, Winnicott and Bion) opens for us a way for conceiving of female bodily specificity and its *jouissance* as an independent contributor to subjectivity and as a potential source for an-other (sub)symbolic creation which neither forecloses the feminine nor turns it into an imaginary object of exchange, and for an-other desire.

The image covers the *objet a* and overpowers it, and the symbolic Other as the network of the signifiers takes its place in order to grant it meaning; but the *distance between perception and consciousness*[34] can originate only if the 'remnants' of the body, its traces as unattainable events, determine unconscious subjectivity. Through the *matrixial objet a*, feminine difference is subjectivizing too. The discourse is not only a testimony that castration has taken place – and therefore a testimony of the existence of the phallus – but also a testimony of the matrixial stratum on behalf of its metramorphic passages interlacing in-to webs and becoming-symbolic and of its sub-symbolic elements.

In the early theory of Lacan, subjectivity is structured in the passage into language by the Other *qua* network of signifiers, a source of desire for the lacking object that falls aside like debris. According to the late theory, to which I add the *matrixial objet* (and *link*) *a*, the *objet a* designates the locus of a basic human lack which can be hidden behind representations in phantasy emanating straight from the *real* and creating a zone of subjectivity. The phallic *objet a* and the matrixial *objet* (and *link*) *a* simultaneously reside on the borderlines of corporeal and mental zones. The matrixial ones elude

the *imaginary* and the *symbolic*, since they are psychic spaces opened by desire no more defined in symbolic terms, and yet, at the same time, they engender borderline images and forms which reverberate their singularity. Thus, each lacking object is not just any no-thing, but is a specific no-thing.

The *gaze* is the lost and desired *objet a* in the scopic (or visual) field which escapes us because of the split (schism) between gaze and vision.[35] For Lacan, the *gaze* is the model of the 'purest' *objet a* because it is the most elusive of all the objects upon which the subject depends at the level of desire. As soon as the subject tries to focus the gaze, the gaze becomes a point of dissolution and vanishes. In a painting there is an encounter *beyond appearance*, beyond the field of representation, with the separated, lost object, which, according to Lacan, always takes on the value of a phallic symbol of lack and is 'no more than the basic support for the game of presence and absence' (*fort/da*): that is, an object which can be replaced by anything and everything. 'It is the passage of the Phallus from a+ to a−, from being present to being absent, in which we see the relationship of identification.'[36] If identification deals with such a process of losing the object, then, according to this metaphor, all identifications are phallic. In Lacan's late writings the feminine not-all (*pas-tout*) is heterogeneity and the masculine (*tout homme, thomme, l'hommosexué*) is 'the prototype of the same (see my mirror stage)'.[37] Yet no genitality is possible other than that which is created in the 'passage to the major signifier – the phallus', and no symbolism is indicated other than the fields of signifiers and logic signs.[38]

> The gaze is presented to us only in the form of a strange contingency, symbolic of what we find on the horizon, as the result of our experience, namely, the lack that constitutes castration anxiety. The eye and the gaze – this is for us the split in which the drive is manifested at the level of the scopic field.[39]

Where the *objet a* is only phallic, there the subject – which is its 'coupure' – can only be phallic as well! (And with it any identity and any gaze.) But in light of the diffused quality of perception and satisfaction linked to objects like gaze or touch, and given the primacy of the search for relationships to the object which these registers reveal, we may question the validity of the phallic status of the gaze as an *objet a*. I have elsewhere criticized this position by reference to Freud's '*uncanny*'.

Lacan raises only one of the complexes mentioned by Freud concerning that particular aesthetic experience which testify to the approaching of the lost object. But Freud named two archaic infantile 'complexes of phantasy' that approach the subject in reality and are the source of the feeling of the *'uncanny'*: the *castration complex* and the *maternal womb [matrix] phantasy.* 'The "uncanny" proceeds from repressed infantile complexes, from the castration complexe, womb-phantasies, etc.'[40] In my reading of this text, for Freud, the phantasy of life in the womb – which is an experience related to the re-approaching within the *real* of one's most primitive contact to feminine invisible bodily specificity – is not subjugated to phallic genitality, nor is it replaced by Oedipal castration. These two kinds of phantasy – two different and repressed infantile complexes – co-exist, each sharing the experience of the uncanny 'equally', and both, we may assume, create different kinds of 'lost' objects and aesthetic objects. In my view, both can serve in a different way as basis for different kinds of passage to the symbolic (phallic and matrixial), at the service of both men and women.[41]

In a rare remark in his late theory, Lacan spoke of the infant's relating to the mother's body as an interior-exterior envelope and of a lost enveloping sphere of continuity between the interior and the exterior.[42] However, in Lacan's elaboration of the uncanny – which is particularly related to the work of art – the intra-uterine phantasy Freud speaks of disappeared, leaving on the surface only the castration phantasy.

From the matrixial angle, in the unconscious locus opened by desire, the *objet a* is not utterly lost because of its primary shareability and exchangeability. Between the separate but co-emerging and co-fading *I(s)* and *non-I(s)*, what is lost for one partial subject may have been otherwise processed by another partial subject. The sub-originary matrix does not rest on the level of connected traces of affected space-time-body instances; it participates in the underlying weavings of the *real*, the *imaginary*, and the *symbolic*. Its principle of absence is neither phallic (castration) as with the phallic *objet a*, nor androgenous (effacement of any sexual difference),[43] but 'border-liner', since in the matrix we share *objets* and conductible *links*.

The matrixial *objet a* is a 'feminine' *objet a*, based not on the loss of the object related to the organ by way of castration, but on a partial loss by way of the transformations of the relations-without-relating into others, or into either relations or non-relations. This loss is relativized by a diffraction of traces and by transformations that

occur in the sub-symbolic, relational partial dimension. The anxiety of the *uncanny* arises, says Freud, when the once-known object becomes estranged. In the matrixial stratum of subjectivization, the movement is also reversed, from the unknown to the known: something is lost when the unknown *non-I* becomes known, in the passage from subjectivity-as-encounter of the several to several separate subjectivities.

In the Matrix, being-together with the unknown precedes being alone or fused, and therefore, as sexual difference pertaining to the feminine, the matrixial object is a figure of *borderline* absence. During diffractions and further differentiations in co-emergence, the object, the Other, and the particular links are lost in different ways and to different degrees for all participants of the matrix. In the Matrix, borderlines between subjects become thresholds and matrixial objects are non-symetrically shared among several partial subjects; they are not equally lost for all partners.

A matrixial encounter affecting instances of space-time-body in a minimal, diffuse fashion engenders *joint* (even though not 'the same') traumas and phantasies which seep into higher psychic levels. Thus, expelled from the *symbolic*, a stain on the *imaginary* and a 'hole' in the *real*, the matrix, as well as the Woman, is not destined or doomed to foreclosure alone. *Non-Oedipal sublimation*[44] of the matrixial co-emergence and of (instances of) the feminine-becoming-maternal participate in 'becoming-woman', for both male and female subjects. Every becoming, say Deleuze and Guattari, is a becoming-woman.[45] Interconnecting to ulterior dimensions of subjectivity, the Matrix introduces the becoming-woman and the dynamic borderlinks with the Other into 'higher' structures of meaning production. Matrix and metramorphosis highlight certain relations between ontogenesis, originary, primary, and secondary spaces, processes and products. The symbolic world which opens up to us is suffused with sub-symbolic matrixial meanings which seep into it through intrinsic connections between drive, phantasy, desire and sublimation, in subjectivity-as-an-encounter.

BORDERLINE APPARITIONS OF THE WOMAN-OTHER-THING OR PAINTING AS METRAMORPHOSIS

Beyond the connections established by Lacan between the *objet a*, Woman and Beauty, we can point to a connection – by way of their

exclusion from representability – between the phallic and matrixial lacking objects and the (Kantian) sublime. In Freud's theory, we may differentiate two aspects of sublimation, which should be treated differently. One aspect, usually thought to be its major meaning, emphasizes social-cultural adaptation and satisfaction and neurotic outlet. It would appear to relate, therefore, to the concept of beauty, with its links to universal consensus (in principle) and to pre-established rules. Another aspect of sublimation is the object-idealization linked to drives, which might, in turn, be related to the concept of the sublime, where no imaginary representation can correspond to ideas, and visible presentation in art can only hint at the *un/pre*-representable.

I have pointed out elsewhere that *Woman* occupies several paradoxical positions in Lacan's theory.[46] She is the *Thing*, but she is also a hole in the *real*, an *objet a*. She is the Other ('The Other, in my language, can therefore only be the Other sex'),[47] but when by Other Lacan means a 'treasure of signifiers', she is also a hole in the Other: therefore 'Woman does not exist and does not signify anything.'[48] Furthermore, these positions cannot reach one another and She, as subject, cannot reach either of them since Woman is repressed, and foreclosed; and this is true for women as much as for men. Is Woman, asks Lacan, the Other: that locus of desire which, intact and impassable, slips under words; or is she the Thing (das Ding), the locus of *jouissance*? Woman is, 'to borrow an expression from Deleuze', this 'blank empty space', this lack in the chain of the signifier, along with its resultant wandering objects in the chain of the signified. The 'elusive woman' is the 'wandering object' *par excellence*. Since the Other is precisely a 'place' emptied of the 'intolerable immanence' of *jouissance*, all of these positions cannot meet in a woman as subject.

When Woman is equated with the Thing, she is like the maternal archaic body, fragmented by the unconscious drive attached to it; *jouissance* excludes her from the *symbolic*. The unconscious desire, that trace of the drive, persists and reappears even though the original objects which were attached to it disappear and leave behind them a reminiscence in the figure of the *objet a* (a lack in the realm of the *real* which is also a lack in the imaginary other and in the symbolic Other). Woman is equated with this lacking *objet a*, whose relations to the real body are emphasized more and more. But, alternatively, She is equated with radical symbolic Otherness. Then,

She is remote and inaccessible and dwells in the holes of the signifying chain of discourse.

Both the symbolic Other and Lacan's *objet a* are caught in a masculine prism which negotiates the feminine from the angle of the Phallus. 'The *objet a* is something from which the subject, in order to constitute itself, has separated itself off as organ. This serves as a symbol of the lack, that is to say, of the phallus, not as such, but in so far as it is lacking.'[49] In this conception, libidinal formative stages are organized retroactively around the fear of castration which is, like a thread, perforating every stage of development. It orients anterior relations to conform to its current appearance.[50] I suggest to view Oedipal castration as tracing the dividing line between the two sexes for both men and women *from a masculine perspective*, whereas we can view the matrixial passage to the *symbolic* as preceding it and/or transcending it, introducing an-other perspective and different feminine perspective of non-Oedipal sublimation.

Towards the 1970s, Lacan moves away from the understanding of the woman in mainly phallic terms. Not only in the unconscious are the sexes not complementary – neither symmetrical nor 'the same' with regard to the phallus – but also a special network of relations link the feminine with *jouissance* and with its remnants in terms of 'plus de jouir' which we may see as *objet a* deduced from the prism of the *real*. Lacan does not speak of the feminine dimension beyond-the-phallus in positive terms since everything expressed by discourse becomes, by virtue of this act, phallic. The *objet a*, presented early on as an imaginary loss, is a logical consistency, it is not in the *symbolic*. In an analogous way, *Woman is not*. Woman 'is not All'; Woman 'does not exist'. Woman 'does not signify anything' and 'there is no sexual rapport'. It seems that in his late theory, with the concept of *sinthôme*, Lacan hints that there exists more than only one possible sexual reference for the two sexes. Such a position is clearly stated by Lyotard: 'The truth of sex does not reside in the remark often made by Freud that there is really only one sexuality, which is masculine.'[51]

'So, on what level is the sexual relation situated?' asks Lacan in 1969. He claims that we do not know anything about sex and that it would be better to be careful before making any declarations about sexual rapport (relations); that sexual rapports have nothing to do with what they are exclusively substituted for in psychoanalysis, namely, the phenomenon of identification with a category

called either male or female. In other words, sexual rapports have nothing to do with gender identifications.

On a rare occasion, Lacan hints at the possibility of replacing the model of opposition between Man and Woman with a more 'microscopic' view that will include the intra-uterine. He suggests, however, that it is necessary to look for images involving sex that are not limited to 'two people sleeping together'. A choice of images from the cellular level would indicate that this may be a function whose essence eludes psychoanalysis. However, he has doubts as to the usefulness of images from such a fundamental level, more suitable for scientific research. Perhaps one of the reasons why Lacan did not develop this line of thought is that it immediately led him to mysticism and to traditional phallic notions relying on 'two poles': something organized like a spherically ordered web between two poles, a web spun from the forces of 'domination' or 'repulsion'. The more ambiguous term 'influence' is introduced here, but the 'two poles' dominates the picture.

What I consider as a first glimpse of a matrixial borderline – a lost enveloping sphere which can be read as a continuity between the interior and the exterior that Lacan discussed, just once, in his late teachings – immediately drifted away from a feminine beyond-the-phallus towards phallic ideas of 'totality' and 'incorporation': 'If anything allows us to understand a carrier of primary narcissistic totality', he says, 'it is the subject's [the baby's] relation to the maternal body, *not as a parasitic body* but as an *interior-exterior envelope*. But then these are relations of physical incorporation which risks a clarification from the father's side and not from the mother.' This argument would compel him to pass through the tradition of Jewish mysticism, which, he says, no doubt dominated Freud's thinking, but he has no time to do it. Nevertheless, Lacan indicates that psychoanalysis may investigate this external-internal continuity, even if this investigations leads us, 'as always', to give up the maternal for the paternal. Traditionally, mysticism, psychosis, and the feminine join together in western culture and in psychoanalysis within a psychic zone that is defined by the *phallic-symbolic* as that which escapes it. All three, to use Lacan's expression, are kinds of 'jouissance that go beyond'. Apart from being that *jouissance*, the feminine is dealt with only inside the phallic realm.

I interpret the concept *sinthôme* (in Lacan's 1976 seminar)[52] as a positive statement that there exists more than just one possible sexual reference for the two sexes. Lacan claims that Woman can be a

sinthôme for man; and it is in this way that he modifies his celebrated declaration that 'il n'y a pas de rapport sexual' ('there is no sexual rapport').[53] Given the structure of the *sinthôme* unveiled by artwork, we can describe a web of links between the *real*, the *imaginary* and the *symbolic* which allows us to assume that there is no *equivalence* between the sexes (as in the Phallus). Thus, beyond the phallic structure, there can be, under certain conditions, sexual *rapport*. From what I call the matrixial perspective, there is, and at the same time from the phallic perspective, there is no sexual rapport: at the level of sexual equivalence between the sexes, which is phallic, sexual difference disappears and sexual rapport is not possible; whereas at the level of non-equivalence which is matrixial, sexual difference reappears and sexual rapport is possible. When a primary principle of co-self-attuning and transformation-in-co-emergence is added, a shift in-side the *symbolic* occurs, to account for an-other Woman: an-other *jouissance* and an-other desire.

Only if there is a supplementary non-phallic zone can a feminine difference then appear, which makes sexual rapport possible. The *sinthôme*, as Lacan explains, is the sex 'to which I do not belong, that is, Woman'. He suggests that in the future we might find a different name, from the woman's perspective, that would correspond to the idea that Man is an absolute other for women in a similar way as Woman is an absolute Other for men. I would contend that in the idea of metramorphosis the conception of *Woman as Other* (in Lacan, or Levinas) turns into *Woman as other kinds of relations*, so that the shift from a masculine to a feminine perspective is not a symmetrical opposition.

From a phallic perspective, the *objet a* corresponds to the feminine on several levels. It corresponds to the lost primordial, symbiotic maternal object, to the lost symbiotic mother and autistic self, to feminine bodily sexual specificity as absence, to the lost primordial incestuous mother, and to the unattainable, fragmented body, all of which are foreclosed and replaced. Both Woman and the *objet a* lack a signifier, both constitute 'a hole' in the *symbolic* (where they are metaphorically replaced) and a hole in the *real* (where they are metonymically exchanged). Thus, if Woman is such an *objet a*, the subject is constituted at the price of Woman. She cannot participate in subjectivity. As a subject, she is determined by the Phallus and by castration; as a subject, She does not exist and does not signify anything. In this paradigm, both man and woman can only be in touch with the feminine as a phallic object of exchange. However,

it is the very possibility of being both feminine subject and object at the same time that the idea of the *matrix as borderspace* and the *metramorphosis as borderlink* brings about.

From the point of view of the phantasy's structure, the *objet a* determines subjectivity. But from the point of view of the *imaginary*, that aspect or element which is severed from the subject is a figure of loss; it is a reminiscence of the signified that cannot appear in representation, cannot become a visible object or receive specular recognition. In the invisible screen of phantasy, the *objet a* is a non-specular object situated at the borderline of the subject's mirror images which are created by the Other. Under certain conditions related to the structure of phantasy, the fragmented, non-symbol-ized archaic 'derivations' of the body in their alliance with uncon-scious desire have a borderline visibility. For Lacan, these borderline apparitions of what I call the Woman-Other-Thing, these revela-tions of the lacking object behind the image, even as a most horrible apparition, will always maintain a reflection of beauty. The lacking object incarnates as Woman that which is the beauty in art, even if its images are those of horror and death.

Conceiving a work of art (see fig. 15) as an incarnation of Woman as absent (*objet a*) is clearly different from the idea of the incarna-tion of Woman as a present, passive commercial object given for the viewer, conceived within the prism of gender identification, since art is not a product of the *imaginary* or the *symbolic*; rather, it creates representations that filter into these domains and transform them. The incarnation of the Woman as either a phallic *objet a* or a *matrixial objet a* is the effect of sublimation, if some aspects of sublimation can be understood as inscriptions of the non-Oedipal in the sub-symbolic sphere. In other words, the specular image has a border-line which is normally invisible but which may become visible as something else, as beauty in the work of art. Otherwise, the ap-proach of this borderline in reality and the proximity of the phallic *objet a* or the matrixial *objet a* in the *imaginary* (as when approaching castration, or the feminine archaic matrixial zone, through regres-sion) produces the anxiety of the *uncanny* and alerts the subject to the dangers of an archaic encounter or threat of castration.

If the *objet a* does not appear through sublimation in Art – for Lacan as the *beauty* within a work – then, according to the phallic paradigm, feminine difference can only appear at the cost of the disintegration of the subject, at the cost of a psychotic blurring of the borders which separate object and subject (hallucination or the

anxiety of becoming a woman). When the *objet a* does not present the danger of arising in an unexpected, regressive, savage manner in the imaginary field – or, alternatively, when it does not appear as beauty in the work of art – the *objet a* remains the lack behind the image, the hole, the emptiness, the absence, the blind spot onto which images are engraved and traces are inscribed. Moving to the second dimension of sublimation I have described, the matrixial perspective allows us to add to the dis-appearance/appearance of the lacking *objet a*, the diffraction of the shareable *objet a* and the conductable *a-link*, interlacing towards apparation as a *sublime* in the work of art.

In order to articulate sublimation as an idealization of the object operating together with the impulse, Lacan presents the Thing (das Ding) as a *vacuole* (like a concha). It is a real empty space, an invisible vacuity outside the signified, like the space in the inner ear without which sounds cannot be produced. The *objet a* which escapes the destiny of the *real* (to be covered by the *imaginary* and the *symbolic*) resists and reappears as a residual in several metonymic forms (oral, anal, the gaze and also kinaesthetic movement, voice, touch). It encounters the Thing and this encounter leads to *jouissance*, defined as what derives from the distribution of pain or enjoyment in the body.

In the zone of *jouissance* – in the vacuole – the Law is circumvented. There, the Other cannot impose his organizing system through language: it is a central zone in which the Law is prohibited. Against this, the subject is located in a different field which can be described as the other side of the encounter between the Thing and the lacking object; it is connected to the locus of the Other as emptied of *jouissance*. We can conceive of *jouissance*, the archaic Other, the Thing, and the vacuole as dwelling on one side, while the subject and the symbolic Other are lingering on the other side of human existence and experience. If the feminine is linked to the first web, the object here is not 'objective'. On the contrary, it carries the particularity and the singularity of each *becoming*-subject.

Sublimation, says Lacan, is related to *jouissance* through the 'anatomy' of the vacuole. The *objet a* is 'what tickles the Thing (das Ding) from within', and this is 'the essential quality of everything we call art', and it is also 'the incarnation of Woman as beauty'. Adding the matrixial angle to this incarnation, the realm of beauty moves aside and that of the sublime floats forward.

Like the *objet a*, the vacuole is 'extimate': an intimate exterior. The extimate is thought of, by Lacan, as that which is most intimate for us but which is not given to recognition unless it is outside, like a shout. Woman is also related, by analogy, to the work of art because of the topology of the Thing and of its relations to the lacking object. Lacan notes 'all the enigmas that appear, and we know not why' when we study feminine sexuality. 'The enigma of what vaginal sensitivity represents', and the fact that women's *jouissance* is *'limitrophe'* (borderline). But 'the Thing is not sexed (*sexuée*)', a fact which, Lacan says, enables a man to make love to a woman without having the slightest idea of what she is as sexed being. In as much as the Thing is not sexed but is also feminine, it seems to me that the feminine difference that Lacan hints at is beyond the Oedipal line of demarcation between the sexes, and that it may also correspond on the level of the *real* – beyond vaginal sensibility – to the uterus. I suggest that the feminine relates to the enigma of the particular matrixial relations between singular compositions of *I*(s) and *non-I*(s) and their shared Thing, experienced by both female and male infants with-in the woman/potential mother-to-be.

There is a *feminine extimate (exterior/interior) difference* that is perceived from the *with-in-side*. This difference is ignored by the Phallus (it is its *non-sens*) and revealed by the Matrix. The idea of the Matrix thus slightly shifts Lacan's late perspective on subjectivity. I suggest that the extimate matrixial *object a* can also induce traces recognizable from with-in, and the (matrixial) Thing and the Other (Woman) thus create and shape the transforming margins of the symbolic Other on the level of the sub-symbolic web shared by the *I* with the Other and with others.

In the phallic stratum, sublimation keeps Woman in a love relationship at the price of her constitution at the level of the Thing. But in a matrixial stratum, the passageway back and forth between exterior and interior, between the Thing and the Other, is open; matrixial subjectivity – situated at the borderlines – is a prisoner of neither one. The Woman is both subject and Other on the borderline of the Thing. Female non-equivalence marks the emergence of relations-without-relating (*'rapports sans rapport'*) between the sexes. Woman may also be 'incarnated' in the artwork as a metramorphosis.

The Matrix is not about women, but about a feminine dimension of plurality and difference of the several in joint subjectivity. The matrixial prism can alternate, in men and women, with the phallic prism of being either subject or Other, sometimes aware of the links

with the extimate *non-I* or ignorant of them, sometimes fused with or disconnected from the Thing or replacing it, to the extent that matrixial and phallic perspectives participate side by side in the *real*, in the *imaginary* and in the wider *symbolic*. A matrixial stratum of subjectivization allows for a network of relations-without-relating leading to an awareness-becoming-recognition of presence in absence, while the phallic stratum of subjectivization allows for distinct alternations between subject and Other, relations and non-relations, presence and absence. Several partial subjects are parts of the same stratum, sharing and shared by the same borderlinks. Traces belonging to the co-emerging *I* and *non-I* – recorded in joint borderspace – can be redistributed after their initial distribution. In addition, passages are made between the matrixial stratum and the phallic stratum of the same subject. We are at the same time both *one* and *several*, on different trajectories.

With the concept of the Matrix the loss of the archaic psychic fragments is not ignored, and nor are ignored the loss concerning drives or impulses and the lack concerning any desire related to them. But the matrixial lack, from trauma to phantasy, has a *border-line sharing*. Loss opens the space of desire; loss makes room for symbolic inscriptions. The emergence of the symbolic phallic *I* entails loss (that of the object), and so does the co-emergence of the sub-symbolic matrixial *I* and *non-I*. It entails a non-castrative loss of particular relations-without-relating and of relational *joint* objects. However, matrixial loss is not implemented by castration, since metramorphosis relates to the circulation of lacks in a way which is different from the metaphors or metonymies in the phallic system. Metramorphosis, allowing what is lost in one to be inscribed as traces in the other, thus allows for an after-passage of these traces back and forth between *non-I* and *I*. Borderline traces of re-tunings within the enlarged and shared stratum of subjectivization create a different transmissibility.[54] The lost matrixial *objet a* is therefore not completely lost for all the partial subjects and is not lost alone, and something of the sublime can have a borderline sharing in and through art. A partial subject can conserve what the unknown internal/external other has lost and it is possible to have a borderline contact with the loss that another has experienced, with the Other's trauma and phantasy.

In the matrix, an *I* may disappear in a traumatic way or in a subtle way, in what I have called *retirance* (withdrawal inside, or contracting) as in the cabalistic principle of creation: *tzimtzoum* [He-

brew]. Contraction and gradual disappearance create a void in which an other – or a world – will appear. Retirance is a possible metramorphosis; here, time enters subjectivizing instances where elements are partly created and partly abandoned within *being-together*. Contrary to that, 'total' introjection of the *non-I* in the matrix, no less than a 'total' rejection of the outside, wounds the matrix, or forces a retreat beyond its scope of shareability (see fig. 16).

Matrixial objects (*a*) are relational *hybridized* and shared, and their partial subjects are involved in unconscious transmitting, relating and sharing; that which is created or lost for one creates transformations within the other in such a manner that with each separation or retirance, subtractions and transformations take place. The differences between the relations one retains and those one has lost, between the subject and the object, between the Other and the Thing, become creative thresholds, on the edges of the matrixial borderspace.

In the Matrix a stranger sprouts, necessary to subjectivity and creativity; a stranger without whom the human matrixial stratum of subjectivization cannot be created or creative; a stranger without whom *I* will not co-emerge. If I attack, if I expel or swallow the stranger, it is me who will be reduced; it is me who will be impoverished in *our* unconscious matrixial borderspace; it is me who will freeze the becoming-threshold of borderlines, block their conductivity and turn them into fixed frontiers.

Notes

1. A more extended version of this essay was presented at the International Congress: *The Point of Theory*, Belle van Zuylen Institute, the University of Amsterdam and the Institute of Contemporary Art (ICA), Amsterdam, 10–13 January 1993, under the title 'Matrix: A Shift In-Side the Symbolic'. That presentation included several more sections, but did not include the third section of the present essay.
 This shorter and revised version was read under the title 'Matrixial Borderspace' at *Identity and Display*, UK Association of Art Historians 19th Annual Conference, Tate Gallery. London, 2–4 April 1993.
2. See, *Matrix. Halal(a) – Lapsus, Notes on Painting 1985–1992*, Oxford: Museum of Modern Art, 1993 and *Matrix et le Voyage à Jérusalem de C.B.* (1989), Artist's Book, 1991.
3. As I speak of the pre-natal *I* or *non-I* as a partial subject only at the last stage of pregnancy when the infant is already post-mature, I am

not denying in any way women's fundamental right to make decisions about their bodies, including decisions concerning abortion. Nor do I want to expand the notion of the subject to embrace the foetus entirely.

4. I would like to emphasize that by *Matrix* I do not mean that the body has a hold on the mind in a more 'essentialist' or deterministic sense than is assumed in psychoanalysis (given that 'matrix' means uterus); in other words, they are no more 'linked' to one another than is generally assumed by the structure of phantasy, dealing with psychic relations to the corporal 'thing' and to archaic events. Nor do I mean that this feminine prism belongs solely to women. As a concept, the *matrix* is at the service of both sexes. It should not be reduced to the womb, just as the *phallus* should not be reduced to the penis. As a sub-symbolic web, the Matrix is oriented toward aspects of the feminine in men and women, towards Woman not as Other but as a different kind of relation between the *I* and the *non-I*, to the feminine as an encounter. It is, however, linked to female bodily specificity.

5. Elements of psychoanalysis in Bion's terms are functions of the personality which are unknowable while retaining recognized primary and secondary qualities and having sensible, mythical and passional dimensions. See W.R. Bion, *Elements of Psychoanalysis* (1963) (London: Karnac, 1989), pp. 9–13.

6. Stern and Trevartham (in infancy research), Meltzer and Ogden (in the Kleinian contemporary tradition), Winnicott, Fairbairn, Bollas and Tustin (from the 'object-relations' psychoanalytic tendency), Anzieu, Stern, Bion and others, emphasize the mother-child unity, and Aulagnier remarks on the arbitrary nature of every separation between the psychic spaces of the infant and the mother. The scope of this article does not allow for recognitions of a lot of psychoanalytic material on this subject, related to post-natal experience. This is done elsewhere, in 'The Feminine/Prenatal Weaving in the Matrixial Subjectivity-as-encounter', *Psychoanalytic Dialogues* (New York: The Analytic Press, forthcoming). However, as a general rule, feminine sexuality is not a part of this body of research. My hypothesis is that the mother-to-be has an auxiliary quiet sense of an uncognized *non-I* subject-to-be inside her, inseparable from her and at the same time separate. Her singular positioning in terms of this unconscious psychic ongoing event, which is linked to female bodily specificity and sexuality and to related phantasies, contributes to the infant's matrixial phantasy life.

7. In his analysis of the meaning, for the baby, of the 'transitional object' in D.W. Winnicott, (1951) *Playing and Reality* (New York: Basic Books, 1971) as 'objeu', Fedida extrapolates the problematics of presence and absence in order to clarify what may be the meaning of the expression presence-absence as connotative of the occurrence or creation of meaning. See P. Fedida, *L'Absence* (Paris: Gallimard, 1978), pp. 97–195. The 'objeu', like Lacan's *objet a*, leans on Freud's analysis of

a child's game with a reel. See Sigmund Freud (1920), 'Beyond the plea-sure principle', *Standard Edition*, vol. XVIII (London: Hogarth Press).

8. A pictogram is the representation of the originary psychic space (con-sidered the closest to the body). See P. Aulagnier, *La violence de l'interprétation* (Paris: Presses Universitaires de France, 1975).

9. I have explained elsewhere the reasons why I consider this dimen-sion as feminine. In the ontogenetic and originary spaces which reg-ister affected time-space-body instances, the woman experiences the matrix on two levels: initially as a post-mature infant in the womb with its appropriate psychic development (here *'she'* could be of either sex); and secondly, as someone who has a womb – but is not necessarily a mother – with various levels of development and aware-ness. Since female body specificity participates in structuring the matrixial stratum of subjectivity on the level of the *real*, it may facili-tate a kind of immediate access to the matrix through experience and phantasy, and provide some 'keys' for retroactive meaning attribu-tion. However, the possession of the womb does not induce a differ-ent mode of recognition in a deterministic or essentialist way, since – as a sub-symbolic filter – the matrix is available to anybody and since its ontogenetic history-of-transformations as meaning and its primary representations (pictograms) are carried by both sexes as infants. Having a womb is, to use Lacan's expression, *en plus* (extra). However, I consider that the concept of the Phallus is not entirely neutral, since it relies so heavily on imaginary and real male ele-ments based on different experiences and phantasies related to bodily specificity. Likewise, the concept of the Matrix, which relies so heavily on female real and imaginary bodily specificity and its related phantasies, is not entirely neutral either. Another reason for considering this dimension as feminine is that it is through the phantasy of the feminine-Other – of the mother-to-be as *non-I* – that experiences as 'things in themselves' are transformed to become the subject's (the *I*'s) materials for phantasy. Beyond the culture vs. es-sence debate, in the domain of psychoanalysis, the real body and its *jouissance* contribute to subjectivity. See 'Matrix and Metramorphosis' (1991), *Differences*, vol. 4, no. 3 (Indiana University Press, 1992); and 'The becoming threshold of matrixial borderlines', in *Travellers' Tales: Narratives of Home and Displacement*, Conference, Tate Gallery, Lon-don, 20–21 October 1992 (London/New York: Routledge, 1994).

10. It can be thought of (in psychoanalysis) as a *bi-directional* projective-identification process.

11. We can conceive of this affect as belonging to Bion's K category. Bion breaks through the tyranny of the love-hate phallic dyad, claiming *in principle* that there is a third relational possibility towards the object/ the Other, which he calls 'knowing' (K). The *K* link, whose earliest manifestation occurs on the level of part-object relationships between mouth and breast (post-natal) is, like other analytic elements in Bion's thinking, a logical, classifying, formal category (to be filled in with content in the future). See W.R. Bion, *Learning from Experience*

(London: Karnac, 1962). Shareability of affects is suggested by D. Stern in *The Interpersonal World of the Infant* (New York: Basic Books, 1985).

12. This is a structure suggested by Aulagnier, departing from, yet relating to, Lacan's *real, imaginary* and *symbolic* structures. See Aulagnier *La Violence de l'interprétation*.

13. Refers to the child's game of appearance (here: *da*) and disappearance (*fort*) of the object of a game (the reel), constitutive of the mental object (as recounted in Freud's *Beyond the Pleasure Principle*).

14. On the matrixial uncanny, see (my) *The Matrixial Gaze* (University of Leeds, 1995).

15. F. Varela, *Autonomie et Connaissance* (Paris: Seuil, 1989), p. 180. On the sub-symbolic description in biological systems Varela refers to P. Smolensky, 'On the proper treatment of Connectionism', *Behavior and Brain Sciences* 11 (1988), pp. 1–74; see F. Varela *Connaitre* (Paris: Seuil, 1989), p. 79.

16. Varela, *Autonomie et Connaissance*, p. 170. The connectivity of a system changes in correlation to the ontogenesis of the organism, which is the history of its autopoiesis or the history of its structural transformation. A strict application of Varela's theoretical position would correspond to an autopoietic biological system in which the particularity and the difference of the not-self would represent a disturbance to the self to be overcome, and the law of homeostasis would be the governing principle. 'The ontogenesis of a living system is the history of its identity conservation by the perpetuation of its own autopoiesis in the material space . . . an autopoietic system is a dynamic system . . . without entries or exits . . . The idea of autopoiesis leans on the idea of homeostasis' (ibid, pp. 63, 45).

17. H. Maturana, and F. Varela, *Autopoiesis and Cognition: the Realization of the Living*, Boston Studies in the Philosophy of Science (Boston: D. Riedel, 1980).

18. Jacques Lacan, 'L'Etourdit', *Scilicet*, 4 (Paris: Seuil, 1973), p. 45.

19. Ibid, p. 31.

20. Jacques Lacan, 'Introduction à l'Edition Allemande des Ecrits', *Scilicet*, 5 (Paris: Seuil, 1975), pp. 16–17.

21. On the maternal anticipatory function, see P. Aulagnier, *Les Destins du Plaisir* (Paris: PUF, 1979), pp. 19–36. On the anticipatory function of the *I* in relation to the matrixial *non-I* – linked to a feminine 'future' dimension – see my conversation with Emmanuel Levinas, *Time is the Breath of the Spirit* (Oxford: MOMA, 1993), and my article, 'The Becoming Threshold of Matrixial Borderlines'.

22. In Lacan's terms, the Other shapes the subject's desire. In Bion's terms, the *alpha*-function of the mother structures the phantasy elements (the *alpha*-elements) of the infant. I transfer Bion's ideas from their usual application in maternal/post-natal relations to the prenatal/feminine encounter.

23. (French) In 'an after' time is an expression used by Lacan (following Freud) to describe an aspect of subjective time.

24. In 'Matrix and Metramorphosis'.
25. See Bracha Lichtenberg Ettinger, 'The With-in-visible Screen', in Catherine de Zegher (ed.) *Inside the Visible* (forthcoming, Boston: MIT Press).
26. Jacques Lacan, *The Four Fundamental Concepts of Psycho-Analysis* (1964), trans. Alan Sheridan (New York: Norton, 1981), p. 126.
27. For an introduction and discussion of the *objet a* see Jacques Lacan, *The Four Fundamental Concepts of Psycho-Analysis* (1964). I offer further discussion of the *objet a* in 'Woman as *Objet a* Between Phantasy and Art' in A. Benjamin (ed.) *Philosophy and the Visual Arts*, no. 6 (London: Academy Editions, 1995), delivered at conference *Psychoanalysis* and *Languages*, Faculty of Medicine, Tel Aviv University, December 1993.
28. Fedida, *L'Absence*, p. 111.
29. Jacques Lacan, 'Le Séminaire de Jacques Lacan, 21 janvier 1975', *Ornicar?*, no. 3, University of Paris VIII, pp. 164–5; trans. J. Rose, in *Feminine Sexuality* (New York: Norton, 1982), pp. 163–71.
30. Jacques Lacan, *Encore* (1972–73) (Paris: Seuil, 1975), p. 69.
31. I refer both to a matrixial object and to a matrixial *objet a*. The term matrixial object indicates an inclination towards the pole of presence (appearing) on the presence-absence continuity, while the term matrixial *objet a* accentuates the lack, the trace of an event indicating a loss, or the empty cavity opened by desire (disappearing).
32. Lacan, 'Le Séminaire de Jacques Lacan', English trans., pp. 164–5.
33. Ibid, p. 165.
34. This is a Freudian description of the Unconscious, repeated by Lacan.
35. Lacan, *The Four Fundamental Concepts*, p. 78.
36. This and subsequent unattributed references to Lacan are from unpublished seminars (1961/62; 1968/69).
37. Lacan, 'L'Etourdit', p. 24.
38. See Lacan, 'L'Etourdit' and 'Introduction à la traduction Allemand des Ecrits'.
39. Lacan, *The Four Fundamental Concepts*, pp. 72–3.
40. Sigmund Freud, *The 'Uncanny'* (1919), in S.E., vol. XVII (London: Hogarth Press, p. 248).
41. I would like to emphasize that the 'matrixal' kind does not 'belong' to women, just as the 'phallic' kind does not 'belong' to men.
42. It is there, towards the end of the pre-natal life when the infant is already at full term, that Winnicott sees the beginning of phantasy life; see *The Family and Individual Development* (London/New York: Routledge, 1965), p. 7.
43. It is Lyotard's *figure-matrice* in *Discours, Figure* (Paris: Klincksieck, 1971) which I see as an androgenous *objet a*. For the development of this idea, and discussion of other kinds of aesthetic objects, see Bracha Lichtenberg Ettinger, 'The Matrixial Gaze' delivered at conference *Starting the Dialogue*, Leeds University, Dept. Fine Arts, 1993; pub in limited edn (10) by BLE Atelier, 1994, Leeds University, 1995; and 'The almost-missed encounters as eroticized aerials of the Psyche, *Third Text*, no. 28/29 (London, 1995).

44. In Freud's theory sublimation is Oedipal by definition; my claim for a non-Oedipal sublimation and passage to the *symbolic* will be further developed in the next section.
45. Gilles Deleuze and Félix Guattari, *Mille Plateaux* (Paris: Minuit, 1980), pp. 338–42. I cannot agree, however, with Deleuze and Guattari's claim that 'each multiplicity is symbiotic' (p. 306). I would suggest instead that some multiplicities are symbiotic and some multiplicities are matrixial.
46. Lichtenberg Ettinger, 'The becoming threshold of matrixial borderlines'.
47. Lacan, *Encore*, p. 40.
48. Ibid, p. 69.
49. Lacan, *The Four Fundamental Concepts*, p. 103.
50. Weaning, toilet training, etc.
51. Jean-François Lyotard, *Discours, Figure*, p. 141.
52. Jacques Lacan, unpublished seminar, 1975/76.
53. By 'rapport sexuel' Lacan means a symbolic way of accounting for contact with the *jouissance* of the Other; 'no sexual rapport' means that there is no contact with the Other sex in terms of her Real or her *jouissance* – and there is no way to report on such a contact – even if it occurred. I would suggest a relation between Lacan's enigma of this 'no rapport' and Levinas' considerations on the paradox of a 'rapport sans rapport' with the absolutely Other ('l'absolument Autre', 'l'Autrui'). This question follows from a basic position in Jewish theology concerning the absolute impossibility of knowing anything about God, His absolute alterity and transcendence. The question is posed by Levinas: 'how can the same . . . enter into relationships with an other without immediately divesting it of its alterity? What is the nature of this relationship?' (Levinas, 1961, *Totality and Infinity*, trans. Alphonso Lingis, Pittsburgh: Duquesne University Press, 1969), p. 38. Exploring the implications of this paradox for the rethinking of art practice, Michael Newman indicates its relevance to feminist research in art and theory (in a paper given at the Architectural Association, London, 11 February 1993). On the question of 'no rapport' in its relations to the feminine see also B. Lichtenberg Ettinger 'The With-in-visible Screen'.
54. Transmissions and conductivity are manifested in psychoanalysis through the appearance of traces of passages of unconscious materials from earlier generations to present generations.

8

The Philosophical Brothel

John C. Welchman

The world itself is the world's last judgement.

[Schopenhauer, *Welt als Wille und Vorstellung*][1]

INTRODUCTION

In a previous discussion of borders I concentrated on the necessarily limited goal of sketching a history of the definitional fixation of visual modernism and the avant-garde with the material and discursive production of always-bordered or ever-transgressive practices.[2] I claimed that the territory of visual practice in the quarter century on either side of 1900 is structured around the opposition between boundary-seeking modernist theories of enclosure and self-reference and a heterogeneous field of differently articulated inter-discursive practices that explicitly sought to dissolve the constituency of discrete zones of material signification. Beyond this I contend that the border (as limit and as limitless desire) is actually a site of conjunction in the complex dialectic of modernism/avant-garde in the west. Both emergent modernism and the historical avant-garde are transfixed by the spectacle and productivity of the border. For modernism the border is always a limit that subtends and controls practice. For the avant-garde, on the other hand, it is a special transgressive space whose traversal and (conflictual) re-articulation guarantees the continuity and seriality of avant-gardist rupture. The discourses of both modernism and the avant-garde are secured by the imagination of border, but they are locked in a double spiral which folds together modernist intensity and avant-garde extension. Rather than rehearsing the formal chronology of modernist enframement, I suggest how an institutional history can be combined with a history of forms, focusing on the critical reception of

160

the first of the eight Impressionist exhibitions staged between 1874 and 1886.

Thinking through the historical conditions of the avant-garde revealed three phases of avant-garde enbordering. The first was configured in what I termed the 'transgressive unconscious of the secessionist avant-gardes of the late 19th and early 20th centuries'. The second was bound up with the radical heterogeneity and deterritorialization of the Dadaists and others in the 1910s and early 1920s. And the third, whose end has now perhaps been reached, was staged across the explicit 'transgressivism' of the 1960s and 1970s in which practices beyond the frame became the 'obsessive content of the 'expanded field' of visual practice'.

This discussion concluded with an attempt to think beyond the modernist presence and avant-garde absence of border-fixation, and to reveal these coordinates as the product of a specifically western avant-gardist fantasy. In the process I alluded to historical, theoretical and geographical strategies which converge on Soviet and post-Soviet models of the relation between power, practice and the everyday. It is, I contend, only by looking across to a non-western, or para-western, scene that First World border conditions can be recontextualized and reimagined. It was in the Soviet Union that what remained at the level of fantasy and desire in the west became a catastrophic lived reality.

I want to begin 'The Philosophical Brothel' by returning to the former USSR, but this time I want to read differently around the border between what has been faithfully returned in western accounts as the most transgressive of all the early twentieth century avant-gardes – Constructivism – Productivism – and Socialist Realism, which has habitually been claimed as the ultimate and most powerful failure of avant-gardism and of modernism alike.

In *The Total Art of Stalinism*, Boris Groys argues that the avant-gardist projects of the post-Revolutionary moment (the theory-practice of Malevich, the 'phonetic trans-rational language' of Klebnikov, the theory-practice of Productivism, and the positions adumbrated in the journals *Lef* and *Novi Lef*) are each caught up in a view of the world that is necessarily 'total and boundless'. He also contends that 'by their own internal logic[s]' such artistic projects become 'aesthetico-political'.[3] Instead of construing the avant-garde as embarked on a mission of rational and utilitarian reconstruction, Groys points instead to its collective irrationality, its surrender to ritual and its conception of artistic-political change as driven by a kind of

demiurgic will that is finally and triumphantly exterior to the work and its productive context. This reading of the avant-gardist plan to conquer the material world must, he insists, be conjugated with, rather than crudely opposed to, Stalin's desire to construct and impose a totalitarian political aesthetics.

Groys suggestively contends that the measure of the west's desire to polarize and antagonize the avant-garde 1920s and the Socialist Realist 1930s and 1940s is founded on its privileging of the museum or gallery as the ultimate locus of 'aesthetic' meaning. The west's attachment to what Walter Benjamin called the 'exhibition value' of cultural work may in fact reveal a dependency on the object as irredeemably cordoned off from the 'real world' – from politics, life and the everyday – that is opposite from the total, instrumental, social efficacy of the always-already politicized image. It was this kind of image that the avant-garde theorized, desired and approached, yet it was precisely this kind of image that was finally returned by Stalin and his cultural acolytes in the 1930s.

Groys' argument is revisionary. While not without its own limits and over-statements, it does help us to re-view the relation between avant-gardism and 'propaganda realisms' on the utopian grounds of the border between (the) work, politics and life. In another striking reversal of conventional wisdom, Groys goes on to claim that the post-utopian unofficial Soviet art of the 1970s and 1980s actually 'completed' (rather than simply refuted or repudiated) the Stalinist project by foregrounding its 'internal structure' and thus 'enabling it to be grasped for the first time in its entirety'.[4] His powerful reading of Erik Bulatov's *The Horizon* (1972) demonstrates the ironic equivalence of Suprematist form with the Stalinist bureaucracy through the morphological ambivalence of the looming horizon-bound shape which at first suggests the floating rectangles of Malevich, but which on closer inspection turns out to be a representation of the Order of Lenin.

Similarly, in his discussion of the irreverent, scatological prose of Moscow writer Vladimir Sorokin, Groys carefully distinguishes between the post-utopian deployment of disparate styles, voices and devices (which he describes as 'more realist' than 'postmodernist') and a Bakhtinian 'carnivalesque' predicated on the 'erasure of boundaries' and the formation of a 'grotesque linguistic body'. In this reading 'the writer no longer needs scandal or carnival, nor does he require any collectivist project or appeal to the universal forces of eros'.[5]

As they are simultaneously the most fragmentary and the most complex, Groys' speculative conclusions concerning the relation between the revisionary context of Soviet cultural production and the philosophy of postmodernism are among the most provocative – though least persuasive – moments in his argument. Groys suggests that Derridian 'theories of difference' and Baudrillardian simulacra are 'thoroughly theological' and 'remain utopian because they deny the categories of originality and authenticity intrinsic to our conception of history'. He claims that 'beginning with the Stalin years . . . official Soviet culture, Soviet art, and Soviet ideology become eclectic, citational, "postmodern"'. What this culture represented, was in fact, a thorough 'victory of the avant-garde'. More than this, Russia's post-utopianism witnessed a 'restructuring of the entire Soviet life environment under the influence of its [the avant-garde's] impulse'.[6] The formula Groys uses to clinch his revisionary argument is striking. The Second World, or 'Eastern postutopianism is not a thinking of "difference" or the "other" but a thinking of indifference'. This is the first of the two 'shocks' that structure the cultural politics of the post-Khrushchevian Union.

The second is the realization that the USSR cannot simply take its place in a (western) 'history' that has been waiting for its re-emergence. The west has entered into a transhistorical moment. Its markets and technologies have become globalized. Its teleology is either complete or is vanquished. Softly buffeted by the loss of history and rendered dissolute by the necessary indifference of the post-totalitarian moment, the artists of the post-utopia are not susceptible to the 'mistakes' of western postmodernists. 'Quotation, simulation and the like' are the tokens of a 'thoroughly utopian' 'zero move', 'dictated by' a particular 'sociopolitical oppositionality' for which Groys has nothing but implicit disdain.

The western loss of utopia, its forfeiture of history, its inert spectatorship in front of a fundamental change in the world order (CIS on CNN-Commonwealth of Independent States on cable network news) which it persuades itself it has engineered and not just witnessed: all these conditions of the postmodern moment have enabled the west to project its fantasies on to the endless spectacle of its own border conditions. Stranded without place (Foundationalism) or placelessness (utopia) it is not surprising that much critical and philosophical debate has been articulated precisely on the border.

THE PHILOSOPHICAL BROTHEL

'"The *bord* is thus properly speaking a plank" . . . Brothel (*bordel*) has the same etymology; it's an easy one, at first a little hut made of wood.'[7]

Jacques Derrida, *La Vérité en Peinture*, 1978

Much current discussion across the territory of western 'philosophy' has been explicitly constructed as an 'end-of-philosophy' debate preoccupied with the articulation of the limits and finalities, the transgressions and expansions, that now threaten the (historical) projects of philosophic (and related 'disciplinary') discourse.[8] It is not my intention, here, merely to survey the innumerable and increasingly 'baroque' formulations of the 'end' and 'limit' conditions as they have been visited upon almost every segment of cultural theory and practice in recent years. I wish, instead to offer some remarks reading across and between this range of interventions, remarks that address the implications (including the paradoxical 'centring') of border-dominant and border-assuming critique.

Of course, the spread of ideas concerning the margin, the limit and the border (like the discourses of order represented in the *dictionary* and the *encyclopedia*)[9] has always been articulated in relation to historically specific conditions of reading, writing and producing. The border as returned in the texts of recent critical theory is almost always *measured out* (explicitly or otherwise) against the social and political efforts of centralization achieved (and imposed) in the Enlightenment and its aftermath. One of the most consolidated enterprises of the Enlightenment *philosophes* was to proscribe and efficiently to broker the proper limits, edges and borders of the increasingly institutionalized nation state, and its political, social and intellectual structures. As summarized by Rainer Nagele, Enlightenment discourse sought to legislate for 'centralization (clear hierarchies of center and margin, of inclusion and exclusion, definite boundaries); spiritualization and sublimation; unification of language games'.[10]

Thus from the Kantian articulation of a regime of legitimate moral, metaphysical and rational epistemological frames, which notably embraced his description of the work of art as a 'finality without end',[11] to the deconstruction of the parameters of knowledge (and of the unitary *work*) by Jacques Derrida, the project of western philosophy has consistently taken up the notation (and de-notation)

of the boundary. Derrida poses it as the question 'of the frame, the limit between inside and outside ... the *parergon*' (a 'supplement outside the work').[12]

The border for Derrida offers the (shifting) grounds for an iterated tropic exercise in the exchange of meanings released through the ceaseless movement from text to text, text to context, subject to text. That every text, every sign and every subject is articulated through a procession of borders where there are points of entry and exit, possibilities of transgression, official (symbolic) and unofficial (imaginary) crossings, is to state the criticized *ebbs* and *flows* of Derridian intertextuality in terms in which there appears to be more at stake in the movements of signification than the iterated academic criticisms of Derrida's ramifying 'textualism' would suggest.[13] For Derrida any 'approach [aborder]' to a text presupposes 'a *bord*, an edge'; yet 'no border is guaranteed, inside or out' in the reciprocal movement text/\context:

> what has happened, if it has happened, is a sort of overrun [debordement] that spoils all the[se] boundaries and divisions [of textuality] and forces us to extend the accredited concept, the dominant notion of a 'text' [into] a differential network, a fabric of traces referring endlessly to something other than itself, to other differential traces.[14]

As one of the conclusions of 'The ends of man', a text that originated as a lecture in New York at an international colloquium on 'Philosophy and Anthropology', Derrida outlines 'two forms of deconstruction' that must be produced and thought together ('weaved and interlaced' as 'motifs'). These positions are useful for the present discussion in that they reconvene several of the problematics of border space that I am attempting to negotiate: 'the violent relation of the whole of the West to its other'; the necessary exchange between systemic logic and 'transgression'; the open space of the border and the closed space of the 'house' (structure or 'edifice'); and the paradox of deterritorializations (transgressions) that issue into 'false exits'.

We can imagine two rhetorical figures for these positions: staying at home (remaining inside), and going out ('changing terrain'). The second strategy is 'discontinuous' and 'irruptive'. Yet despite the claim that such a displacement 'brutally places oneself outside' and 'affirms an absolute break and difference', as a tactic it is

indeterminacy

inbetweenness border
always - border

susceptible to 'reinstatement', 'naiveté', and even 'blindness'. At the same time to stay home, to use 'against the edifice the instruments or stones available in the house', 'risks ceaselessly confirming, consolidating, *relifting* (*relever*), at an always more certain depth, that which one allegedly deconstructs ... risks sinking into the autism of the closure'.

Derrida takes up an allusion in Nietzsche, and finds in the *eve*, 'the guard mounted around the house or ... the awakening of the day that is coming', a figure for a dilemma that is read between Nietzsche and Heidegger, between the two deconstructions, between the 'superior man' and the 'superman', and between the house 'as a form of memorial or a guarding of the meaning of Being', and the 'dance, outside the house' staged as 'an active forgetting of Being'). 'Perhaps we are between these two eves', Derrida concludes 'which are also two ends of man'.[15]

Here, and elsewhere, Derrida produces one of a number of what are potentially strong theories of indeterminacy (of always-borderness) in and between the 'classically' articulated specificity of particular orders, or institutions, of knowledge, such as they have been received (and criticized) since the eighteenth century.[16] Gayatri Spivak argues that the possibilities for a 'strong' theory of deconstruction might be found in its potential not so much to 'reverse' but to 'displace' the 'distinction between margin and center': 'Since one's vote is at the limit for oneself, the deconstructivist can use herself (assuming one is at one's own disposal) as a shuttle between the center (inside) and the margin (outside) and thus narrate a displacement.'[17] One of the key deconstructive displacements that concerns Spivak is that between the gender coded spaces of the public and the private, between the house as parliament and the house as home.[18]

Many of the rhythmically iterated concepts – schizoanalysis, territorialization and de-territorialization, becoming-, the fold, even language[19] itself – in Deleuze and Guattari are also organized around notions of the border. Cumulatively they offer the possibility for a reading of the circuitry of border space that is supplementary to and different from Derrida's. This border is processional and spiral, but it is also ventured as definite and determined.

As Brian Massumi has argued, in the activity of becoming-, for example, 'a thing's actuality is its duration as a process – of genesis and annihilation, of movement across thresholds and towards the limit'.[20] He introduces *The Logic of Sense* as 'an extended meditation

reverse? or replace margin + center or?
border as process + spiral

imbrication

on the SEPARATION-CONNECTION of "being" (states of things), thought and language. In it Deleuze repeatedly expresses the autonomy of these "parallelisms" and their simultaneous imbrication ... meaning is the articulation of their difference'; and 'the articulated differentiations constitutive of meaning can be multiplied indefinitely.'[21]

Many of Deleuze's texts are organized around border tropes that open up a productive space in which differentials are simultaneously machined and refused. He argues against any frictionless commutivity of the border condition, and is, like Luce Irigaray and Donna Haraway (whose work is briefly considered below) concerned as much with the border's textures of finitude as with the lines of flight that might traverse it. In *Le Pli* (*The Fold*), for example, Deleuze thinks of the transition between the Classical and the Baroque as a form of the 'reconstitution' rather than refusal of 'classical reason'. 'The Baroque represents the ultimate attempt to reconstitute a classical reason by dividing divergences into as many worlds as possible, and by making from incompossibilities as many possible borders between worlds.'[22] He attempts to circumvent the necessary violence of borders. Violent discords that are the product of conflict within the same world might be *resolved in accords* because the only irreducible dissonances are between different worlds. In short the Baroque universe witnesses the blurring of its melodic lines, but what it appears to lose it also regains in and through harmony.'[23] Deleuze's quasi-utopian, folded, harmony, is finally, one which is imagined by crossing the home with the border: 'Stockhausen's musical habitat or Dubuffet's plastic habitat do not allow the differences of inside and outside, of public and private, to survive. They identify variation and trajectory, and overtake monadology with a "nomadology". Music has stayed home . . .'[24]

These differently developed critiques of finitude and self-contained 'presence' are, however, always vulnerable to the reinscription of an inverted transcendence that answers to the mythology of closure and boundedness with a parable of infinity and repetition. Rather than catching ourselves on the horns of this dilemma, we must attend to the contention that both the concept and the incarnation of borders always challenge the over-zoned and the under-zoned domains of the object/subject; for the border is the visibility of power in discourse. The border is a conduit of power driven across the territory of 'differential traces'; it is always

Borders , no Borders , borders in transition
construct deconstr spiraling
reconstruct

fumining
Layers of borders

a specific intervention in place and in time; it will always interrupt even the most self-interruptive ('laminar') of flows (desire, the corporate economy, the television signal and so on). Yet it will always be rematerialized as a specific function of system, history, language and place. It will flare up lit with these conditions.

Reserving to Derrida and Deleuze, in this discussion, the possibilities of both a critique and a potential repetition of the positivist, atomistic border-function, promotes the corollary observation that in other, less plastic, less intensive, contributions to critical theory a border-thematic is produced that refuses both their border-in-process, as well as any developed notion of the border-in-power.

Jean-François Lyotard's formulation of the postmodern condition might be one such refusal. For him the postmodern is constructed on the model of the counter-modern paradigms of recent science. Most of these discourses are concerned with the transgressive attributes of a 'postmodern' scientific enquiry which concerns itself 'with such things as undecidables, the limits of precise control, conflicts characterized by incomplete information, "*fracta*", catastrophes and pragmatic paradoxes'. In this way contemporary science is held to 'theorize its own evolution' 'as discontinuous, catastrophic, nonrectifiable, and paradoxical'.[25]

By foregrounding his theorization of the border we can interrogate Lyotard's call to return to philosophy ('the time has come to philosophize') or 'to set up a philosophical politics';[26] a call that is structured around an elaborate etymological metaphorics (in the manner of Derrida), but which, in fact, evades the fuller implications of the border-as-metaphor. A key passage in Lyotard's post-Wittgenstinian manifesto runs as follows:

A phrase, which links and which is to be linked, is always a *pagus*, a border zone where genres of discourse enter into conflict over the mode of linking. War and commerce. It's in the *pagus* that the *pax* and the pact are made and unmade. The *vicus*, the home, the *Heim* is a zone in which the differend between genres of discourses is suspended. An 'internal' peace is bought at the price of perpetual differends on the outskirts. (The same arrangement goes for the ego, that of self-identification.) This internal peace is made through narratives that accredit the continuity of proper names as they accredit themselves. The *Volk* shuts itself up in the *Heim*, and it identifies itself through narratives attached to names, narratives that fail before the occurrence and before the

differends born from the occurrence. Joyce, Schönberg, Cézanne: *pagani* waging war among the genres of discourse.[27]

The question must be posed as to whether the 'dispute' of 'phrases' (what Lyotard terms an 'honorable postmodernism') is adequate to subsume, to 'speak for', other disputes, other formations of power between bodies and contexts. Is the 'war' of phrases (Joyce), tones (Schönberg), facets (Cézanne) really a pre-emptive strike against the closures of 'continuity' and the ideology of homeland normalcy? Has Lyotard entered into a new political dialogue in these remarks, or has he merely foreclosed an old one? Is numerical fragmentation and explicit post-Kantian revisionism (such as characterize *The Differend*, here and elsewhere) sufficient to renegotiate the social formation of the subject, or is it merely so much conceptual brocade spun across the corners of a new historicism? How, then, is the border, a particular border, revealed to us in Lyotard's re-philosophy? In his account, the border is mobilized, streamlined, as a no-place of names which are then positioned as a surrogate for the vaunted action of discursive metaphors. The chain-link of no-man's-land becomes the syntactic linkage of conflictual phrases. 'War and commerce' are, in this sense, discursive and not territorial. The border is above all a trope, standing in for all places of exchange, all gradients and passages: it is the place between the ego and the id; between the city and the ghetto; between the *Heim* and the Hun. Lyotard's home is thus different from Deleuze's, it is a refuge from within which external borders and their violence are either consumed, imagined or forgotten (see fig. 17). The border is, finally ('above all'), in Lyotard's understanding, the zone of generic conflict filled out by the men of the modernist avant-garde and their particular materials: text, sound and paint.

The emphasis on 'struggle' and 'violation' exposed here, the sheer violence of the border metaphor, is, in fact, one of the most common critical currencies in recent discussions of the zoning and bordering of discourses and signifying materials. W.J.T. Mitchell concludes his wide-ranging analysis of the relations between visuality, textuality and ideology with a flourish of combative metaphors that have arisen out of a long history of attempts 'to legislate the boundaries between the arts, especially the war-torn border between image and text'. In the course of one paragraph, these terms include 'struggle', 'battle', 'violation' (twice) and 'transgression'.

Nowhere is the problematic of this language of struggle more revealingly rehearsed and developed than in Foucault's essay on Magritte, *Ceci n'est pas une pipe*.[28] This discussion offers a partial demonstration that visual and textual discourse can neither be fully separated (as in 'Western painting from the fifteenth to the twentieth century')[29] nor mutually superimposed. When text and image come together, neither material nor its mode of signification will ever be separable from a supplementary trace of the other. The word-image, then, underlines the difference between a plastic and a visual sign by never fully fusing them or eclipsing one behind the other: 'designation and design do not overlap'.[30]

The language Foucault uses to stage this difference, however, is highly conflictual: 'between the figure and the text [are] . . . a whole series of intersections – or rather attacks launched by one against the other, arrows shot at the enemy target, enterprises of subversion and destruction, lance blows and wounds, a battle'.[31] Although contemporary with the real struggles of the late 1960s, when Foucault was actually shifting his emphasis from the analysis of structures and discourses to that of institutions and the operation of power, his work on Magritte is something of an aberration. The attention he pays in *Ceci* to the works themselves, which are interrogated in a flourish of subtleties and 'ambiguities',[32] and to problems about the nature of representation they signal, makes one more anxious about the status of Foucault's military (avant-gardist) metaphors than one might be over the similar usages of the Dadaists, who were coming out of another (much larger) conflict, and who had put more at stake. There is no vivid attempt in Foucault's discussion of Magritte, except for a few generalizations on 'western painting' and a sketch of the modernist 'breaks' of Kandinsky and Klee, to situate the paintings in relation to the discursive formation of modernism. What Foucault forgets here is also what formalism and structuralism usually ignore: the wider historical and philosophical fields which sustain the signification of art works. What Foucault forgets in his combative excitement on the visual\textual border is also, in large part, what he elsewhere has advised, encouraged and performed.

In Mitchell, on the other hand, the border is highlighted as a (tropic) battlefield in a text that explicitly claims to return the border to its ideological position in the formations and operations of power. Yet the stated project of his 'Iconology', 'to revivify the critical figures of iconology', 'to breathe new life into dead

trope + tropic (2.2)

metaphors',[33] metaphors, we might say, that have perished in the battle over the border, risks stranding Mitchell's concern for ideology and power in the ether of meta-discursive commentary; and risks missing the border as a place of 'real' conflict (and real death).

There are, then, two important consequences of this clustering of violent language around the concept of the border. First, while its deployment reveals the pressures, ruptures and conflicts characterizing the place of the border, its use by Lyotard, Mitchell, Foucault and others, has precisely not engendered the kind of analysis of the clash of power that it should provoke. Secondly, and paradoxically, this neglect often leads to a desire to re-stabilize the conflicted border, to channel and divert the institutional empowerments around which a border is always constructed, always implemented and always maintained. Thus Mitchell's metaphors are prefatory to his (parenthetical) assertion that 'transgressions of text-image boundaries [are], in my view, the rule rather than the exception'.[34] For Mitchell (though not just for Mitchell) the transgressive border becomes normalized through the iteration of linguistic violence.

The Lyotardian border and its kind are thus predicated on a 'weak' theory of the exchange that (re)produces borderness; their border(s) are elaborated through a postmodernism-of-the-edge that transgress the 'rupture' of the modernist 'break' only by their articulation through excess, groundlessness and generality. The 'weak' border theory is one predicated on producing the border or margin or limit as a thematic intensity, and subjecting it to a kind of formalist fetishism. In this reading the border becomes the obsessive object of discourse in the way that the frame or the edge or the surface are the fixations of formalist criticism in the visual arts. Much, though by no means all, of Derrida's work on the margin or border can be read in this way, and the connection of his deconstructive project with the formalist discourse of high modernism has already been suggested by Stephen Melville.[35]

These are also the borders of synthetic postmodernist theory such as it is returned in the summary-texts of the Anglophone academy. Although she makes repeated gestures towards a theory and a practice of postmodernism that negotiates 'the political and the historical',[36] for Linda Hutcheon the texts, performances, structures and objects of the postmodern are nevertheless constituted in a 'poetic' *bricolage* so dense and so heterogeneous that their structural commonality is reduced to a set of generalizations predicated on a model of transgression that privileges and yet does not define or specify

the 'border'. The postmodern here is rehearsed through a litany of its 'ex-centric' devices: it is 'contradictory', 'hybrid, heterogeneous, discontinuous, antitotalizing, uncertain'.[37] Within this systemic equivocation the very 'language of margins and borders' is said to 'mark a position of paradox'.

While Hutcheon (and others) appear to be in search of a socially critical 'edge', and while they importantly reference (so-called) 'marginal' practices (such as the textual practices of contemporary feminisms and those arising from 'postcolonial experience and identity')[38] their methodology of citational and exemplary freefall risks more incoherence and pluralist retreat than it returns an agenda for cultural action or social intervention. In the end such reductions become formulaic, absurd and resolutely apolitical (or rather neo-imperial, almost religious; note the 'hail'): 'perhaps the postmodern motto should be . . . "Hail to the Edges!"'.[39]

Yet it is not just in the summary texts of postmodern theory that the border has been so obsessively foregrounded. A model of its transgressive lustre was incorporated into a whole range of revisionary discourses during the 1980s – especially in those disciplines within the English-language academy that have actively struggled against their founding modern paradigms. While the grounds and the conditions of the struggle are differently worked out in each case, these include the so-called New Art History, the New Anthropology and the New Historicism.[40] The would-be avant-gardism of these counter-traditionalist discussions is explicitly signalled in their designations. As we have already argued in relation to the visual avant-garde, it is possible to understand the 'new' in this sense as measuring out the very place of the border.

To cite just one example, James Clifford's introduction to the key mid-1980s revisionary anthology, *Writing Culture: The Poetics and Politics of Ethnography*, brings together two tropes whose mutual production can be said to structure the field of possibilities for many of the new inter-disciplines. These are the 'border' and the 'poetic'. Clifford claims that 'ethnography is actively situated *between* powerful systems of meaning. It poses questions at the boundaries of civilizations, cultures, classes, races, and genders.' As 'an emergent interdisciplinary phenomenon', the borderlands of the New Anthropology are written across, and activated by, the operation of a 'poetics' that refocuses and rereads the materials of 'history' and 'politics'.

Poetics functions here, as it does in some recent literary and visual

theory – nowhere more so than in Hutcheon's *A Poetics of Postmodern-ism* – as the mechanical fluid that engenders the re-production of historical meaning. The poetic is the agency of the border. It names the ineffability of functions that can only take place in transgressive space. It bespeaks the unknowability of the in-between. It marks out the fuzzy limits of the interstice. It translates everything that is becoming.[41]

The border, then, has become ceaselessly available for critical theory, so that in its differently formulated constitutions we are dazzled by the transgressive rhetoric of a would-be new radicality. Several questions emerge here. What are the limits and, equally, what are the possibilities of using the border as a token for the pro-cess of (ex)change, of translating the border across various theories and practices, of thinking the limits, the edges, of the psychological rather than the nation state? And what are the analogous problems of positing a unique, essential, specific border *experience*?

Fredric Jameson develops a descriptive/critical 'system' to ar-ticulate the 'cultural logic' of postmodernism that can usefully be opposed to Lyotard's interactive 'phrases' and Derrida's [inter]texts. Yet the methodology employed by Jameson is organized around the bound terms body/self/limit. In his essay, 'Postmodernism and Consumer Society', Jameson offers a double articulation of post-modernism as 'the description of a particular style' and as 'a periodizing concept whose function is to correlate the emergence of new formal features in culture with the emergence of a new type of social life and a new economic order'.[42] One of these defining 'fea-tures' 'is the effacement in it [postmodernism] of some key bounda-ries or separations, most notably the erosion of the older distinction between high culture and so-called mass or popular culture'[43]; trans-gressions that are also elaborated by Andreas Huyssen (as deter-minants of the postmodern condition) and by Peter Bürger (as the crucial project, and failed aftermath of the historical avant-garde).[44] Similarly, in a recent interview, Jameson appears to return to the modernist notion of break, rupture or split as a kind of schizo-practice: a terrain of cuts and not a series of cuts in the terrain. Rapidity, repetition and irreplaceable dislocation ('these increasingly rapid and empty breaks in our time')[45] are held to substitute for the modernist culture of the break.

Jameson is not the only theorist to privilege the schizophrenic break as a model for postmodern practice. Craig Owens, for example, developed one of the more critical discussions of the

schizophrenic trope as an articulation of (stylistic) postmodernism. In his essay 'Honor, Power and the Love of Women', he deploys a Lacanian notion of schizophrenic breakdown as a symptom of the 'imploded state of pseudo-Expressionist art' which has lost 'the capacity for negation'; that is, for irony or for critical distance. 'Schizophrenic discourse', he claims 'is paralogical; it does not recognize the law of contradiction'. Owens goes on to state that while 'most of the major symptoms of schizophrenia are to be found in pseudo-Expressionist painting', it is not appropriate either to 'diagnose contemporary artists, on the basis of their work, as schizophrenics' or to 'proclaim schizophrenia, as some have [he is alluding to the *Anti-Oedipus* of Deleuze and Guattari], as a new emancipatory principle'. Owens concludes that 'contemporary artists *simulate* as a mimetic defense against increasingly contradictory demands – on the one hand, to be as innovative and original as possible; on the other, to conform to established norms and conventions'.[46] It is against such 'psychic metaphorization of contemporary cultural and social space' differently organized around schizophrenia by Jameson, Deleuze and Guattari and Lyotard that Jacqueline Rose stages her critique of postmodern theory. By neglecting to articulate the symbolic context of schizophrenic disjunction, Rose claims that each of these theorists forecloses the possibility of a critical sexual politics.[47]

Although it was a key item in the agenda of Abstract Expressionist theory and practice, especially for Mark Rothko, the sublime is another concept which postmodern theory has returned and appropriated under the aegis of transgressive release. Understood as a borderless, illimitable infinity, the sublime is for Derrida a space that has no outside:

If art gives form by limiting, or even by framing, there can be a *parergon* of the beautiful, *parergon* of the column or *parergon* as column. But there cannot, it seems, be a *parergon* for the sublime. The colossal excludes the *parergon*. First of all because it is not a work, an *ergon*, and then because the infinite cannot be bordered.[48]

Poetic dissolution, the unbordered psychic split and the ineffable borderless sublime are just three of many postmodern positions that can be read as a mini-series within the incantatory catalogue of the spectacle (the 'ecstasy' and 'implosion') of inter-communication rehearsed by Baudrillard: a condition of rampant systemic confusion

and collision in which 'the essential thing is to maintain a relational decor, where all the terms must continually communicate among themselves and stay in contact'. In this scenario of the hyperreal 'the body, landscape, time all progressively disappear as scenes ... the theater of the social and the theater of politics are both reduced more and more to a large soft body with many heads'.[49] 'Public scene[s]' or 'the public space' are thus eclipsed by 'gigantic spaces of circulation, ventilation and ephemeral connections'. Private space is likewise rendered as an '[ob]scene' of 'transparence and immediate visibility', with the result (among others) that the subject 'can no longer produce the limits of his [*sic*] being'.[50]

Baudrillard's 'home' is thus evaporated by the glare of its transparency. It has no walls. There are no limits. It is built in a culture grounded only in the production of borders; a culture that will return its practices only and exclusively through theories of transgression and translation; a culture that inhabits a theory/practice of always bordering subjects whose field is catastrophically fixed between the Other and the Same, the centre and the margin, history and desire (see fig. 18).

Several positions emerge, then, among the border-LINES of the writers I have considered here. The first is the postmodern fetishization of the always already bordered and always bordering subject. This 'borderama' is vaunted by survey critics, including Hutcheon, as the governing trope of the postmodern. A version of this position is also the resting place of the Baudrillardian spectacle of ecstatic communicational interactivity. It might be said also to merge with the foundational insistence of modernity on the new as the future of all discourse, its obligation to cultivate sanctioned transgression, its ceaseless obligation to territorial and material reinvention.[51] Elsewhere this first position may be glimpsed in the first world's sense of cultural loss engendered by the globalization and westernization of all other worlds, what Vattimo calls the 'metaphysical homologation of the world'.[52] The absence of borders in this sense is the loss of a saving grace.

The second position is seemingly a consequence of the first, and is, perhaps necessarily, indistinguishable from it at times. However, this position is capable of pushing a description of the world as mesh of borders somewhat further. Derrida and others actually interrogate the scene of the border, asking how either its fixations on, or relegations of, the margins of discourse are finally constitutive of the discourse itself. The border here is the scene of 'différance',

the site of the 'supplement'. Its opposites are modernist utopianism and finality, transcendent presence and theological immanence.

3. The poetic, the sublime, the disappearance of the social, the meltdown of the house: how can we rethink these exemplary postmodern transcendences, while still thinking through the border? If they are effectively to be countered, then the question of the border must be returned to such 'stronger' gestures as that taken up in the Deleuzian sense of the border as a space of *becoming*; but the process-ional border, in turn, must always be laid across the border-in-power. There are many criticisms of the over-elaborated and hence 'weak' boundary conditions of postmodernism. Homi Bhabha, for example, argues that while (in the early 1980s),

> the conceptual boundaries of the west were being busily re-inscribed in a clamor of counter-texts – transgressive, semiotic, semanalytic, deconstructionist – none of which pushed those boundaries to their colonial periphery; to that limit here the west must face a peculiarly displaced and decentered image of itself . . . It is there, in the colonial margin, that the culture of the west reveals its *différance*, its limit-text, as its practice of authority displays an ambivalence that is one of the most significant discursive and psychical strategies of discriminatory power – whether racist or sexist, peripheral or metropolitan.[53]

His call to take up the question of colonial boundaries, whose conditions are generally foreclosed in First World theory, is a crucial one, but to conclude this brief overview of border theory I will briefly outline two useful sites of the conjunction of the processional border laid across the border in power.[54] These are located, first, in Ernesto Laclau's discussion of 'Politics and the Limits of Modernity'; and secondly, in the work of some contemporary feminisms.

Ernesto Laclau's plea for an understanding of the 'postmodern experience' as a dialogical, 'argumentative', reformulation of 'the content and operability of the values of modernity'[55] is elaborately articulated around a (partial) dissolution of the notion of a discursive border. While he never explicitly develops a radical redefinition, Laclau appears to redeploy the concept of the 'border' such that it is conceived outside of the foundational logic of the 'limit' or the 'end' that underwrites modernity's myths of finitude and transcendence. On the other hand, the problematic of the interdiscursive

relation of modernity/postmodernity is initially outlined by Laclau in direct relation to the operationality of the border. In its 'political' formation, Laclau claims:

> postmodernism has advanced by means of two converging intellectual operations . . . [that] share, without doubt, one characteristic: the attempt to establish *boundaries*, that is to say, to separate an ensemble of historical features and phenomena (postmodern) from others, also appertaining to the past that can be grouped under the rubric of modernity.[56]

According to Laclau, this territorialized construction of discursive space muse be resisted because 'the very idea of a boundary between modernity and postmodernity marked by the outmodedness of metanarratives presupposes a theoretical discourse in which the *end* of something is thinkable'.[57] The border, then, must be re-imagined. Less a stable articulation of positivist finitude (a literal limit), the border should be conceived as a kind of holographic projection,[58] or semi-permeable network that can engender the transformatory operations envisaged as in process under its auspices. The border in this sense is a kind of permutational machine, a 'vast argumentative texture',[59] that participates in the selective transmission and re-articulation of discursive formations, their 'modulation' and 'amplification'; their re-insertion into new 'language-games'; their 'polysemic', '*equivocal*', 'unstable', '*ambiguous*' and '*unfixed*' re-inscription in a 'genealogically' contiguous post-modernity.[60] His listing of these transformatory attributes of the deconstructed border risks, of course, precisely the categorical return to modernist formulae rehearsed in other reifications of the lingual tokens of high modernism which are contested by Laclau himself elsewhere in his discussion. Yet, looking equally to deconstruction and to (neo-)pragmatism, the border for Laclau is never returned as a linear division between two absolute categories, but is constituted instead as a spatialized mesh of specific opinions and localized (rather than generalized) conjunctions of 'common sense.' The border itself, then, is recognized as a meta-narrative originating in Enlightenment discourse and fully formed in the modern. Like the other constituents of modernity, however, the border is not simply dissolved or otherwise 'terminated'; instead it is rendered contingent on the scene[s] of its production, and fluid in the space of its operations. No longer a mere threshold or

instrument of demarcation, the border is a crucial zone through which contemporary (political, social, cultural) formations negotiate with received knowledge and reconstitute the 'horizon' of discursive identity.

Some of this critical reconstitution is also attempted in the work of certain contemporary feminisms. Both Donna Haraway and Luce Irigaray have phrased their oppositionality through the trope of the border, and by a recourse to a rhetoric of territorial conflict that is strategically different from those we have so far encountered. Thus Donna Haraway in her signal contribution to the debate concerning technology, communication and gender, 'A Manifesto for Cyborgs: Science, Technology and Socialist Feminism' (1984), argues that the relation between 'organism and machine' must be re-contested in a new 'border war' whose tactics will feedback against western male-bound 'science and politics'. For her, 'The stakes in the border war have been the territories of production, reproduction, and imagination. This . . . is an argument for *pleasure* in the confusion of boundaries and for *responsibility* in their construction.'[61]

This last sentence could stand as the headtext of this discussion. Haraway has not just called for a freeform trans-volitional surrender to border confusion, in the manner of much 'weak' postmodernist theory; nor is she content passively to map that confusion as a symptom of some late-capitalist, hyper-technologized environment. As with each of the 'strong' formulations of the border I am outlining here, the border is a place of feedback, exchange and process. The border is not univocal, or only polymorphous. Its breaks are not fetishized as a final cut: they are instead, or they may be, re-sutured, re-circulated or re-bonded.

In one of the more circumspect moments in his case history of *Dora*, Freud comes quite close to acknowledging the difficulties that attend the definitional articulation of 'normative' sexuality: 'The uncertainty in regard to the boundaries of what is to be called normal sexual life, when we take different races and different epochs into account, [should in itself be enough to cool the zealot's ardour].'[62]

But Haraway goes further than Freud's suggestive caution in the conjugation of sexuality, race and history. Her 'hybrid' cyborg challenge is proposed to gather up the formations of 'women's experience' constructed by 'the international women's movements' in order, precisely, to 'change' and affect that experience in the present techno-social scene. This, Haraway claims, is 'a struggle over life and death, but the boundary between science fiction and social

reality is an optical illusion': 'the cyborg myth is about transgressed boundaries, potent fusions, and dangerous possibilities which progressive people might explore as one part of needed political work'. And these boundaries are everywhere operative if not quite everywhere transgressed, in the text. They elaborate a space of resistance to the social formation and implementation of 'communications technologies and biotechnologies' such that the 'boundary is permeable' between their instrumentality as 'tool[s]' and their ideological formation as 'myth', between 'historical systems of social relations and historical anatomies of possible bodies, including objects of knowledge'. The very enterprise of 'cyborg semiology' (such as it is actually defined) is held to concentrate 'on boundary conditions and interfaces, on rates of flow across boundaries – and not on the integrity of natural objects'.[63]

In Luce Irigaray's writings from the early and mid-1970s, collected 'in *This Sex Which is Not One*, stage a contestation of the bounded subject and of discursive boundedness that resembles Donna Haraway's in *A Manifesto*, though it is differently produced and differently supported. If Cixous argues against the polarizing, binarist, rigidifying logics returned and disguised in patriarchal culture, then Irigaray re-produces an imagination and praxis of 'diffusion' and exchange of/by/and among women that is, as she puts in 'The "Mechanics" of Fluids', 'scarcely compatible with the framework of the ruling symbolics'. Yet, like Haraway, she argues *at the same time* against a kind of 'infinite' surrender to turbulence and mobility that confounds 'that third agency designated as the real': this is 'a transgression and confusion of boundaries that it is important to restore to their proper order'.[64]

In a remarkable passage whose metaphorical intensity is animated by her readings in 'solid and fluid mechanics',[65] Irigaray rearticulates the 'fluid' speech of the 'woman-thing' such that it occupies another space of production and reception even as it is voiced from 'the paralytic undersides' of the 'phallocratic' 'economy': it is heard as 'continuous, compressible, dilatable, viscous, conductible, diffusible' and 'disconcertive' in relation to 'any attempt at static identification'.[66] There is in both Irigaray and Haraway a commitment to a kind of dialogical relation (always worked out across theory and practice, between women and women and between women and other contexts) operative in the pleasuring and confusing of boundaries and their 'responsible' formation.

This might be the place to comment once more on the tactical

feedback and guerilla aesthetics that Boris Groys claims character-
ize the post-Soviet artwork. To acknowledge that there is a blind,
totalizing, monological utopianism, such as that desired and imag-
ined by the strident sector of the 1920s Russian avant-garde, and
such as was delivered by Stalin in the 1930s, does not legislate for
the impossibility or undesirability of thinking through an aspirant
utopia. It is this kind of utopian discourse that Irigaray has been
held to defend, a utopia which does not wish teleologically to pro-
gramme the future in the terms of the present, but which seeks to
transform it in the sight of a better difference. She articulates a
utopia of process, not of perfection.[67]

This also the place to return to the title of my essay, *The Philo-
sophical Brothel*. I have borrowed it, of course, from the original
name of Picasso's *Demoiselles D'Avignon* (1907). Remembering
Derrida's etymological association of the border, the plank and
brothel, Picasso's image can be read as an arrest and incarnation of
the non-processional border, the purest moment of modernist bor-
der fetishism. This border/brothel is a place of violence and con-
sumption which objectifies and consumes both women and others.
It is this *bordello* that is the scene of the masculinist metaphorics of
war and combat, of the appropriative transplantation of so-called
primitive faces on to the already fractured bodies of so-seen deviant
women. It is here that the western fantasies of philosophy, the non-
western other, and sexual violence converge on the territory of the
border.

It is here, also, that Homi Bhabha's call to look over to the final
frontier of post-colonial disempowerments meets a formidable
modernist counter-narrative. In his critical reading of the 1984 MoMA
Primitivism exhibition, Hal Foster notes that 'in its modernist ver-
sion the primitive may appear transgressive . . . , but it still serves
as a limit'.[68] The primitive as motif is trapped in a western brothel
that measures out its own limits, and is fetishized as a threat to the
lost integrity of western culture. As Picasso noted himself, the im-
age was constructed to ward off the demonic presence of the other.

The *Demoiselles* simultaneously forgets this border by appropriat-
ing the other as a motif, and regresses into a paradigm border
fantasy by its display of iconographically split subjects and for-
mally severed pictorial sub-units. The *Demoiselles'* architecture of
forms, its scaffolding of space, its contextless interiority, its broken
names, fractured bodies and split subjects invite us to explore a
counter-metaphor which would answer to its graphic violence with

a more hopeful image of embordering.[69] This border. That border. Lust, consumption, appropriation. Passion, exchange, circulation.

Picasso's *bordello* answers to what Irigaray describes as the *maison close*, the closed house – but also the brothel – of male subjectivity, the place where the male imaginary phantasizes the maternal body as his property.[70] The bordello and the *maison close*, might, again, be read against the soft house of folds, a model of which is proposed by Deleuze as an allegory of the curvilinear universe of the Baroque which pleats 'the fluidity of matter, the elasticity of bodies, and motivating spirit as a mechanism'.[71]

Irigaray explicitly opposes the psychic and social stoppage of the *maison close* to the 'fusional', interactivity of woman as threshold. As Margaret Whitford explains, 'because of the rhythms of male sexuality, men can establish limits, boundaries, punctuation in time. But woman as threshold knows nothing of temporal boundaries: "The *thresholds* do not necessarily indicate a limit, the end of the act."'[72] The dimensions of this border are different from the linear, containerized space of the border/brothel. Here women are not understood *as* border-thresholds (for this collapses and essentializes women-as-fluid), and neither is man considered as only bordered (for this forgets the differences in men); again woman is not simply space itself (for this de-limits women too wildly). Yet if we think somewhere between these disfigurements of the brothel we might find the conditions of possibility for the exchange of passion, for the improbable moment of love; at any rate, the opposite of that which is given or taken in the brothel.

Notes

1. Cited by Walter Kaufmann in *Hegel: A Reinterpretation* (New York: Doubleday/Anchor, 1966), p. 261.
2. See 'Bordering On' in the catalogue for the 9th Biennale of Sydney, 1992–93. These remarks on border fixation and transgression are further developed in my essay, 'In and Around the "Second Frame"' in Paul Duro (ed.), *The Rhetoric of the Frame* (Cambridge: Cambridge University Press, forthcoming).
3. Boris Groys, *The Total Art of Stalin: Avant-garde, Aesthetic Dictatorship and Beyond*, trans. Charles Rougle (Princeton, NJ: Princeton University Press, 1992), p. 21. Future references are in the text.
4. Ibid, p. 75.
5. Ibid, p. 101.

6. Ibid, pp. 107–9.

7. Jacques Derrida, *The Truth in Painting*, trans. Geoff Bennington and Ian McLeod (Chicago: The University of Chicago Press, 1987), p. 54.

8. See the 'General Introduction' to *After Philosophy: End or Transformation*, ed. Kenneth Baynes, James Bohman and Thomas McCarthy (Cambridge, MA: MIT Press, 1987), pp. 1–25. This volume collects some fifteen signal contributions to the 'end-of-philosophy' and related debates from Richard Rorty, Jean-François Lyotard, Michel Foucault, Jacques Derrida, Jürgen Habermas, Michael Dummett and others. Its opening section (with contributions from the first four names listed) is titled 'The End of Philosophy'. The propositions of discursive limits and boundaries represented here are met by, and indeed crucially intersect with, more specific analyses that foreground the end-conditions of 'art theory' and criticism within the domain of visual culture. Victor Burgin's essay, 'The End of Art Theory', in *The End of Art Theory: Criticism and Postmodernity* (London: Macmillan, 1986) offers perhaps the most explicit discussion of this particular 'end' and its implications. See also (exh. cat.) *Endgame: Reference and Simulation in Recent Painting and Sculpture*, ed. David A. Ross (Cambridge, MA: MIT Press, 1987). In *Rethinking Art History: Meditations on a Coy Science* (New Haven, CI: Yale University Press, 1989) Donald Preziosi offers a useful theoretical and contextual corrective to the rhetoric of disciplinary crisis that is frequently invoked in these and other accounts of 'ends'.

9. See Welchman, 'Modernisme à Larousse', in *Modernism Relocated: Towards a cultural studies of visual modernity* (Sydney: Allen & Unwin, 1995).

10. Rainer Nagele, 'The Scene of the Other', in Jonathan Arac (ed.), *Postmodernism and Politics* (Minneapolis: University of Minnesota Press, 1986), pp. 94–5.

11. Frederic Jameson discusses this Kantian formula in relation to the work of Hans Haacke in 'Hans Haacke and the Cultural Logic of Postmodernism', in Brian Wallis (ed.), *Hans Haacke: Unfinished Business* (New York/Cambridge, MA: The New Museum of Contemporary Art/MIT Press, 1986), pp. 40f.

12. Derrida, *The Truth*, p. 55.

13. Derrida's defenders would contend, with Christopher Norris, that 'Derrida thinks of philosophy, not only as a site of institutional struggle, but also as a highly specific discipline of thought whose central texts may indeed be "deconstructed" but *not* given up to any kind of intertextual or undifferentiated "freeplay".'

14. Jacques Derrida, 'Living On: Border-lines', trans. James Hulbert in Harold Bloom *et al.*, *Deconstruction and Criticism* (New York: Seabury Press, 1979), pp. 81–4.

15. Jacques Derrida, 'The Ends of Man', in *Margins of Philosophy* trans. Alan Bass (Chicago: University of Chicago Press, 1982), delivered (or written), at any rate dated 12 May, 1968.

16. Martin Jay is one of a number of recent commentators who have pointed to the ethical dimensions of post-structuralist indeterminacies.

In his essay 'Is There a Poststructuralist Ethics?', he does so by opposing two aesthetic logics, one predicated on closure and enframement, the other celebrating dissolution and 'crisis'. Connecting the notions of aesthetic closure and openness and taking up the question of ethics, these remarks are situated at one of the crucial meeting places (border-lines) discussion: 'Rather than praising the work of art as an organic, beautiful whole, an autotelic structure providing a sensuous manifestation of an Idea, a boundaried object following its own immanent laws, the poststructuralists embrace instead the modernist (or in certain cases, postmodernist) work "in crisis".' (In *Force Fields: Between Intellectual History and Cultural Critique*, New York: Routledge, 1993, p. 45.)

17. Gayatri Chakravorty Spivak, 'Explanation and Culture: Marginalia', in Russell Ferguson, Martha Gever, Trinh T. Minh-ha and Cornell West (eds), *Out There: Marginalization and Contemporary Cultures* (New York/Cambridge, MA: New Museum of Contemporary Art/MIT Press: 1990), p. 381.

18. Spivak argues for a displacement rather than a 'reversal of the public-private hierarchy . . . The peculiarity of deconstructive practice must be reiterated here. Displacing that it initially apparently questions, it is always different from itself, always defers itself. It is neither constitutive of nor, of course, a regulative norm . . . It is in terms of this peculiarity of deconstruction that the displacement of male-female, public-private, marks a shifting limit rather than the desire for a complete reversal': ibid, p. 377.

19. See Gilles Deleuze, *The Logic of Sense*, trans. Mark Lester with Charles Stivale, ed. Constantin V. Boundas (New York: Columbia University Press, 1990 (French edn *Logique du sens*, Paris: Minuit, 1969), p. 2: 'Language sets limits (for example the point at which *too much* is reached), but it goes beyond limits, restoring them to the infinite equivalence of an unlimited becoming.' This translation follows that of Brian Massumi, *A User's Guide to Capitalism and Schizophrenia: Deviations from Deleuze and Guattari* (Cambridge, MA: MIT Press, 1992), p. 149, n. 23.

20. Massumi, *A User's Guide*, p. 37.

21. Massumi in ibid, p. 148, n. 18.

22. Gilles Deleuze, *The Fold: Leibnitz and the Baroque*, trans. Tom Conley (University of Minnesota Press, 1992), p. 81.

23. Ibid, p. 82.

24. Ibid, p. 137.

25. Jean-François Lyotard, *The Postmodern Condition: A Report on Knowledge*, trans. Geoff Bennington and Brian Massumi (University of Minnesota Press, 1984), p. 60.

26. Jean-François Lyotard, *The Differend: Phrases in Dispute*, trans. Georges Van Den Abbeele (Minneapolis, University of Minnesota Press, 1988), p. xiii.

27. Ibid, p. 151.

28. *Ceci n'est pas une pipe* (Montpellier: Éditions fata morgana, 1973); trans. and ed. James Harkness (Berkeley, CA: University of California Press,

1983). The English translation also reprints Magritte's two 1966 letters to Foucault. First published in *Les Cahiers de chemins*, 1968.

29. Ibid, p. 32.

30. Ibid, p. 27.

31. Ibid, p. 26.

32. 'About even this ambiguity, however, I am ambiguous', in ibid, p. 17.

33. W.J.T. Mitchell, *Iconology: Image, Text, Ideology* (Chicago: University of Chicago Press, 1986), pp. 158–9.

34. Mitchell, pp. 154–5.

35. See Stephen W. Melville, *Philosophy Beside Itself: On Deconstruction and Modernism* (Minneapolis: University of Minnesota Press, 1986).

36. Linda Hutcheon, *A Poetics of Postmodernism: History, Theory, Fiction* (London: Routledge, Chapman & Hall, 1988), p. 23.

37. Ibid, p. 59.

38. Ibid, p. 68.

39. Ibid, p. 73. 'Hail to the Edges!' is a quotation from Tom Wolfe's *The electric kool-aid acid test* (New York: Farrar Straus and Giroux, 1968).

40. A discourse of the transgression and reinvention of received generic borders informs many other positions within and between the 'disciplines' of art history, anthropology and historical studies. In an attempt to rethink 'public art', Rosalind Deutch, for example, insists that the parameters of aesthetic discourse and 'critical urban discourse' are resituated such that the resulting 'shift in perspective erodes the borders between the two fields, disclosing the existence of crucial interfaces between art and urbanism in the subject of public art'. See 'Uneven Development: Public Art in New York City', in Russell Ferguson Martha Gever, Trinh T. Minh-ha and Cornell West (eds), *Out There: Marginalization and Contemporary Cultures* (New York/ Cambridge, MA: New Museum of Contemporary Art/MIT Press, 1990), p. 114.
 Writing on the theory-practice of 'collecting art and culture' in relation to Walter Benjamin's essay 'Unpacking my Library', Clifford himself cites Susan Stewart on the public (systematic) and private (secret) mediations that relay between the activities of collecting and fetishizing: 'The boundary between collection and fetishism is mediated by classification and display in tension with accumulation and secrecy', in ibid, p. 144. Benjamin is explicitly preoccupied with the instability that is measured out between order and chaos in the constitution of a personal library: 'Every passion borders on the chaotic, but the collector's passion borders on the chaos of memories.' Cited in James Clifford, 'Collecting Art and Culture', in ibid, p. 166, n. 6.

41. See also *Modernism Relocated*, chapter 3, 'After the Wagnerian bouillabaisse: Critical theory and the Dada and surrealist word-image', under 'Pensée/Poésie', for a discussion of the metaphor of the *poetic*.

42. Frederic Jameson, 'Postmodernism and Consumer Society', in Hal Foster (ed.), *The Anti-Aesthetic: Essays on Postmodern Culture*, p. 113.

43. Ibid, p. 112.

44. See Andreas Huyssen, *After the Great Divide: Modernism, Mass Culture,*

Postmodernism (Indiana University Press, 1986); and Peter Bürger, *Theory of the Avant-garde*, trans. Michael Shaw (Minneapolis: University of Minnesota Press, 1984). Several writers (including Grossberg) are suspicious of the unanalytical and unengaged rhetoric that foregrounded the transgressed border between 'high' and 'low' in many theories of postmodernism. See, e.g., Lawrence Grossberg, 'Putting the Pop back into Postmodernism', in Andrew Ross (ed.), *Universal Abandon?: The Politics of Postmodernism* (Minneapolis: University of Minnesota Press, 1988), p. 177.

45. Anders Stephanson, 'Regarding Postmodernism – A Conversation with Fredric Jameson', in Andrew Ross (ed.), *Universal Abandon?: The Politics of Postmodernism* (Minneapolis: University of Minnesota Press, 1988), p. 5.

46. Craig Owens, 'Honor, Power and the Love of Women', *Art in America* (January, 1983); reprinted in Richard Hertz (ed.), *Theories of Contemporary Art*, 2nd edn (Englewood Clitts, NJ: Prentice-Hall, 1993), pp. 62–3.

47. See Jacqueline Rose, 'The man who mistook his wife for a hat', in *Universal Abandon?*.

48. Jacques Derrida, *The Truth in Painting*, trans. Geoff Bennington and Ian McLeod (University of Chicago Press, 1987), pp. 127–8.

49. Jean Baudrillard, 'The Ecstasy of Communication', in *The Anti-Aesthetic*, p. 129.

50. Ibid, pp. 130, 133.

51. Gianni Vattimo describes 'modernity' as 'primarily the era in which the increased circulation of goods (Simmel) and ideas, and increased social mobility (Gehlen), bring into focus the value of the new and predispose the conditions for the identification of value (the value of Being itself) with the new': 'The Structure of Artistic Revolutions', in *The End of Modernity*, trans. Jon R. Snyder (Baltimore, MD: Johns Hopkins University Press, 1988), p. 100.

52. Gianni Vattimo, 'Hermeneutics and Anthropology', in *The End of Modernity*, p. 159.

53. Homi K. Bhabha, 'The Other Question: Difference, Discrimination and the Discourse of Colonialism', in Ferguson *et al.*, *Out There*, p. 71.

54. There are many more conjunctions than these of course. In a recent discussion of the relation between science and power, for example, Stanley Arronowitz notes that 'disciplines outside the boundaries of science, consigned since the eighteenth century to the margins of intellectual life, are permitted to explore truth in the traditional, prescientific sense of the term': *Science as Power: Discourse and Ideology in Modern Society* (Minneapolis: University of Minnesota Press, 1988), p. vii.

55. Ernesto Laclau, 'Politics and the Limits of Modernity', in Ross (ed.), *Universal Abandon?*, p. 66.

56. Ibid, p. 63.

57. Ibid, p. 64.

58. Emily Hicks offers a brief outline of a holographic model of the border constructed by the 'interaction' of patterns of interference.

See 'Deterritorialization and Border Writing', in Robert Merrill (ed.), *Ethics/Aesthetics: Post-modern Positions* (Washington, DC: Maisonneuve Press, 1988), p. 56.

59. Laclau, 'Politics', p. 79.
60. Ibid, pp. 65–6, 70.
61. Harraway, 'A Manifesto for Cyborgs'.
62. Sigmund Freud, *Dora: An Analysis of a Case of Hysteria* (New York: Macmillan, 1963), p. 67.
63. Ibid, pp. 71, 81.
64. Luce Irigaray, *This Sex which is not One*, first pub. by Editions de Minuit, 1977, trans. Catherine Porter (Ithaca, NY: Cornell University Press, 1985), p. 106.
65. Ibid (footnote no. 1).
66. Ibid, p. 111.
67. Margaret Whitford develops this point in 'Feminism and Utopia', chapter 1 of her study *Luce Irigaray: Philosophy in the Feminine* (London: Routledge, 1991), pp. 9–25.
68. Hal Foster, 'The "Primitive" Unconscious of Modern Art, or White Skin Black Masks', in *Recodings: Art, Spectacle, Cultural Politics* (Port Townsend, WA: The Bay Press, 1985), p. 196.
69. Even though he interprets the *Demoiselles* in scrupulously formal terms (cataloguing its 'revolutionary stylistic innovations', p. 51), John Golding also allows that Picasso 'approached Cézanne in a spirit of anarchy, one might almost say of aggression'; John Golding, 'Cubism' in Nikos Stangos (ed.), *Concepts of Modern Art* (London: Thames & Hudson, 1981), p. 55. In addition, the formal description itself is predicated on creative/appropriative violence, especially in the figures that are supposedly most 'African'. Describing these, Golding notes the 'savagely distorted and gashed faces of the two figures at the right' (p. 52).
70. See Whitford, *Luce Irigaray*, p. 159ff. for a discussion of the opposition between the 'closed house' of the male subject and the *fusional* subjectivity of woman as 'threshold'.
71. Deleuze, *The Fold*, p. 4.
72. Ibid, p. 162.

Response to The Philosophical Brothel

David Avalos with John C. Welchman

(Speaking from San Diego)[1]

We must think of the relative strength of both sides. The border is the demarcation of power, and power is the crucial issue. Power is the exercise of power, and the feedback of powers locked in an arbitrary scenario of mastery and disenfranchisement.

(David Avalos, San Diego, 1989)

INTRODUCTION

(Speaking from San Diego) offers this book a final section that foregrounds the border-as-power, at the calculated risk of, in some sense, *forgetting* 'border-theory'. This will be a risk taken up by David Avalos, whose comments constitute more an intervention than a response to the questions we have posed to the construction of border space. What follows is a loose, mutually revised, draft of an extended conversation between David Avalos and myself on the border, which began in March 1989 and still continues. This 'transcript' represents just a few of the topics we have touched upon. I began by asking Davis a series of questions about his understanding of, and long-standing participation in, art-work on the border. Two of our points of departure are represented in my discussions of modernism, the avant-garde and transgression in *Modernism Relocated,*[2] and the border theory of Jean-François Lyotard and others debated in Chapter 8, 'The Philosophical Brothel'. The following is a brief list of the questions I noted down on our first meeting. Thinking through some responses to these questions marks a place of beginning.

How is the border mobilized and renegotiated in cultural practice?

Was there a sense in which art practices undertaken in the Mexico–USA border region, including those of the Border Art Workshop/Taller de Arte Fronterizo, have dispensed with the modernist notion of the border as a 'break', a notion to which Lyotard returns when he speaks of the discursive disruptions of the modernist greats, and taken on a more 'postmodern' understanding of the border as a zone of pulsion, exchanges, interactions and 'free'-flow?

If we seek for boundaries, limits, or edges in our concept of borders, what specificities are lost or endangered in these constructs?

In the cultural practices with which we engage, how can a counter-spectacle of the border be produced, one that resists as well as celebrates the poeticization and postmodernization of the border?

Can there be a counter-theatre to the theatre of control?

Is modernist-like contradiction or post-surrealist obliquity, are frivolity and humor, adequate for the new theatre?

How can the technologies of surveillance and closure be resisted?

What dent can be made against the imaginary abstract flows of post-corporate international capital that are audibly conducted across the border between the pylons of high finance?

We found that these questions posed peculiarly contemporary issues that challenged the whole foundations, the very territoriality, of the border. When we pushed them further still we found that they challenged the political contiguity of nations. It seems to us that versions of a 'border-theory' (*the new 'thing-of-joy'* for contemporary critical theory) and are being answered by new cultural practices that are crucially informed by a large number of different understandings of the border. There are important issues at stake here concerned with the re-theorization of postmodernism and the ability of cultural activity to intervene from the 'margins'. The time is right for an extended consideration of these matters.

We also realized that we couldn't only legislate for a border zoned as 'social blight'; we refused merely to document pessimism. To play and to be grim: the border fixes the mask of the first on the face of the second. We asked how can both these attitudes and practices be joined and repelled?

We agreed that the national/political border always exceeds the conceptualization of theory and the operations of cultural practice. Such borders are the furthest places to which the regimes of national power are calculated to extend; and the places where such

power finally dissolves. The border is thus the locus of the greatest operative visibility and the most tenacious eclipse of the appurtenances of the state: a place where power starts and finishes at once, where power is crudest, most absolute and then most abandoned. The border is a moment of initiation into the ritual of nationality, its necessary rite/right of passage.

There is, of course, no (unitary) *border*, just as there is (say) no singular *vision*; rather there are borders (and visions) whose constitution is the product of specific institutions and discourses, including the formation and implementation of national legislations, the social and economic differential that straddles the border hinterland and the resultant *pressure* on the use of the border (by both sides). There is no one (official) border, then; but always two, corresponding to its axiomatic points of control. And there is the unofficial border convened as the myriad points of crossing that traverse that unfathomable 'line' achieved by the social cartographers of Euclidian statehood (where it is not abetted by the 'natural' partitioning of seas, river valleys and mountain ridges).

For the state itself the border is a necessary fiction. More a staged event then a particular place, the border is *put forward* as a theatre of purity and legitimacy, a kind of semi-permeable membrane whose gauze is woven by the officers and apparatuses of State surveillance who are at once the instruments of centrist control and the agents of documentary identity. Yet the official border has no narratives, there is no space for story-telling or personal experience, and time for nothing except accreditation or interrogation.

The border functions as an accumulation of symbolic capital as it is mythologized (televized, reported) by the media, as it is spectacularized by the *in situ* agit-prop theatre of the Border Patrol, and as it is made fantastically literal (marked, lined, constructed) according to a policy of border-building in special, designated places. The border is not unaccountable outside its particular zone of origin. Equally, lives are lost or are at stake in the immediate locus of the border. How do we negotiate between all these borders – the irreal border, the simulated border, the border abroad, and the border at the border – as: the idea and the instrument of policy? Can we conceive of one of these terms without the others? And what are the struggles of the cultural practices that are staged on the border, practices that can always be recuperated by the centre (New York, The Museum), but which can never, quite, be reconvened (see fig. 19)?

BORDER/PLACE/PRACTICE

(a) The Fantastic Border

To take up our specific case, the border as Fashion Valley, the border as a shopping mall, is also to take on the implication of this place (San Diego) in the formations of international power, in particular, the power of Mexico and the power of the USA. Yet the border is always more fantastic than it can ever be portrayed, or enacted. In December 1986, for example, the police force here went into an area called the 'soccer field', a place where undocumented Mexicans mill around, 'assemble' and 'disassemble' in preparation for night-time crossings. The soccer field is actually in US territory, and the police went there, one of their 'finest' dressed in a Santa Claus outfit, to distribute presents to the brown-faced kids, to embrace Mexico's needy, to give the gift of tinsel and glitter to these otherwise bleak and joyless celebrants of Christmas. There was a public announcement of this official act of generosity, and the men and women wore their police uniforms. Why couldn't they put on their civilian clothes, cross the border, go into the neighbourhood of Colonia Libertad and effect their laudable humanism there? Why? Because this side of the border has the power to give and to take away the border, and it must be shown, it must be related publicly, it must be staged. Look through the spectacle, look beyond the giving of candy and trinkets, and you will find enticement. The little children were tempted by a Santa Cop to cross the border and to cross it under the watchful eye of the INS (Immigration and Naturalization Service). Where was the official border when the first child touched the Santa Cop's fake beard?

Two weeks later a patrol of police and border patrol units engaged some suspected illegals in the border zone. One man was apparently shot in the back, according to a coroner's report. Mexico protested, but he was 'obviously' a 'bandit'. He was threatening the lives of the border patrol agents.

Tie these cases together and you have a demonstration that the official border is maintained by the exercise of a power that says, hey, we can erase it when we want to hand out candies and Christmas sugar canes; but we can assert it in a flash when we sight a bandit, and we can summarily execute the bandit.

(b) Imagine-No-Line

During the Reagan administration the INS became much more so-
phisticated in marketing its agenda in the lobbies of power and
much more adept at public relations; in consequence, it managed to
promote a real increase in its budget, manpower and bureaucratic
pretensions. The so-called border 'fence' is nothing more than a
simulation of a border; a theatrical production entitled IMAGINE
NO LINE or A MAGINOT LINE. The border between the USA and
Mexico is 2000 miles long. This fence is (intended to be) less than
ten miles long. In a period of six months they're saying they appre-
hended a total of 1500 vehicles carrying undocumented workers
and contraband of all sorts. There's millions of crossings made every
day at the legal ports of entry and if you think they're catching
everybody you're crazy, because when they really clamp down at
the legal ports what happens is that the traffic stops. That's when
they really do careful searches, which is quite rarely. Most of the
time they're not doing careful searches. So this Maginot Line that
the INS is proposing is nothing more than a new backdrop for their
ongoing agit-prop theatrical campaign. But despite the fence, de-
spite this 'formidable' barrier, this four-mile surveillance strip which
is completely under their control, for every undocumented worker
they apprehend two or three or more get by. This is triumphantly
admitted even by the authorities in their press releases and inter-
views.

Now on the platform of this simulated border what are we really
being told? What they're telling us is that there is no border. That
for all intents and purposes more people are coming in than are
being stopped. And why is there an admission by the custodians of
the official border of their failure to apprehend those it is purposed
to constrain? In fact the border is imploded. It still exists as an *idea*
as some kind of a pillow on which the American public can rest
their terrorized heads. But economically, socially, culturally it is *also*
a figment. The Immigration Reform and Control Act of 1986 allows
the border to be removed from the edges of the map, and to be
relocated simultaneously in every office, shop, field and place of
business or labour in every city and every locality in the USA. That
law enables INS agents to enter any workplace anywhere in the
country to determine the immigration status of any employee. That's
something that the American public, if they truly understood the
ramifications of the law would shriek about, and would be up in

arms against. But the law enforcement agencies now operate with sufficient managerial discretion to limit its activities to Mexican-looking 'foreigners', at least in a way disproportionate to their presence in US society.

The fence says, look, there are still defenders of the Alamo, maintaining a noble fight on behalf of America's sovereignty, virginity even. But its also an item of terror. It says look what we can't stop, look at this steady aggression against our patrimony, this water torture on the body of our commerce. This is the scene of the implosion of the border, its collapsing inwards toward the civic centres of the heartland. But some of the critics of the fence have suffered from their desire, their need to make it into a Berlin Wall, to see it as rendering the border like a cul-de-sac. We have seen to the contrary that it is only another act in the simulated theatre of the border as a powerful instrument of control; and, further, that it is a monument to the failure of the Simpson and Rodino Immigration Reform and Control Act of 1986 (constructed precisely to en-act the frontier: to re-confirm it, to bring it back to the public imagination, to scatter the border into the filing cabinets of the nation) to reimpose the border as a (numerical) limit.

(c) A Chicano Border

The border is also important to me as a Chicano; it positions me within the whole drama of the US negotiation with the 'outside' world. The drama is more like a Morality Play that iterates the hierarchical structure of continents and nations. The Anglo, Germanic, Euro, apostles are full of speech and wisdom and the rest of us are left as by-standers who might throw down a palm or two on to the road, who might raise the occasional shout – though not a shout that becomes a sentence, or gets recorded – and that's all. The manifest destiny of the Anglo-Saxon is to conquer and manage the world, to demonstrate what no other race has been able to demonstrate before, a kind of techno-dominion. You know, people talk about the Catholic church as able to recuperate, to go out and appropriate the so-called pagan beliefs of a society and integrate them into the complex weave of Catholic ritual (see fig. 20). The Anglo-Saxons have achieved a similar absorption and syncretism in the secular domain, in the world of commerce and capital. An Anglo can conquer people and get down with people and still maintain a rigid sense of purity in the very mechanisms of his control. The

peculiarity of a border region is that despite an incredible diversity and multi-cultural mix, the closer you look the more you see the mechanisms of purity at work all around you. This has ramifications in the heartland, and especially in the cities, but it's intensified into a strange chemistry amidst the cross-gazes of the borderlands. The border in this sense, then, is the heart of US culture, and not the skin.

Separate cultural positions will not help.

'Here, I'm a Chicano, let me show you some art so you know how I feel.'

But I'm never going to convert you. If instead you and I set a common goal and work towards it, the reciprocity of making the goal and of working towards it will give us some basis of commonality, some vestige of identity and cooperation. You don't have to worry about how I felt when I was 12 years old, but we'll have a common activity in which we can share our differences. It's by fucking each other, by interacting with each other, by working with each other, rubbing up against each other (even the wrong way), refusing absolute separation: its through all these means that we were negotiating a new sense of what the border can be.

(d) Captivity

In relation to the defence of the home, the *heim*, that Lyotard writes of, a San Diego artist, Deborah Small, did piece on captivity narratives, the stories of white women being captured by Indians that go all the way back to Plymouth Rock. Here the woman is a symbol of the 'home', and the Indian 'savages' (precisely 'pagans') are the subverters and transgressors of this central Puritan-American value system. Then there's Crocodile Dundee. Australia now represents the west, and we import Australia to maintain our fantasy of the west. Crocodile Dundee comes to New York City and who's he dealing with? A perfectly blond girl-friend who at one point is abducted by Latin-American drug dealers who are completely indigenous looking; they have long hair and Indian features. There's one scene where she's walking down the street and this guy comes out and is on the point of kidnapping her. They walk down the street, side by side. You've got it right there – the 'black' rapist; this is another captivity narrative, the urban equivalent of the Indian and the frontiers-woman.

(e) The Bus Poster Project

There is an attempt to get at a sense of community identity that recognizes the *mestizaje* of the USA. The USA wants to tell us that it's a 'melting pot': well, like the Chicano artist Gronk says, if you put milk into coffee you don't get white, you get something in between, and the melting pot theory is that you can put milk into coffee and you're going to get milk. You don't. And part of the practice here is to show that. And part of the practice is to show how, in the case of the Bus Poster, for example, which was a collaboration between Elizabeth Sisco, Louis Hock and myself, how a legal fiction allows us to pretend that the undocumented worker is outside the institutions of power, just as slavery laws allowed black people to be outside the institutions of power in the south. That doesn't mean they weren't an integral part of the plantation; and that doesn't mean that the undocumented Mexican worker isn't an integral part of the San Diego community. One of the things we were trying to say with that piece was, hey, recognize the reality. The border doesn't exist where you have 50 000 people (according to estimates from researchers in Tijuana) crossing that border every day to work in the USA. Tijuana is a bedroom community for the USA and we have to take that into account.

(f) The Border Art Workshop (BAW)/Taller de Arte Fronterizo (TAF)

When the Border Art Workshop began (in 1984), the idea was to demonstrate that you do not get at some 'intrinsic' problem of the border through a cultural pluralism in which a Chicano cultural institution is next to, but separate from, a Mexican organization, and separate again from Anglo, so-called mainstream, institutions. We wanted to form a group that included Mexican citizens, US citizens, Chicanos and non-Chicanos, because the border is a place and an issue that affects us all. The border is people, the people that occupy the particular space of the border. But the border was initially peopled by the expendables, those who can be lost. The undocumented Mexican worker is expendable. The Japanese manager sent over from Japan to operate the *maquiladoras* here on the border or to work behind a desk in the Golden Triangle (a corporate/bio-tec zone in La Jolla, near San Diego), complain about their exile, and that their children can't attend the superior high schools of Tokyo,

and that their opportunities for advancement are much less, stuck as they are on this spur line of corporate advancement. This is the place where the expendables come. This is the place of the fast buck. This is where they say the action is. But this is where the odds are against the majority. We were trying to speak as expendable people, as those who have nothing to lose. And we were saying this is not the periphery of US history; this is the centre of that history. We are here now by accident of birth or profession.

Columbus Day in the USA – Dia della Raza everywhere else on the continent – is 12 October. In 1986 on that day we went down to the border region right where the fence ends at the Pacific Ocean and we had a performance event that included sharing a meal. About 100 people were on the Mexican side, about 50 on the US side, and the performance was designed to create an atmosphere where people began just walking around, intermingling, discussing, eating a simple meal of corn, in an everyday manner. We asked and we got no written permission, no documents, no permits. We went to demonstrate that at a time when the *San Diego Union* was declaring that this border was the most dangerous border in the world that the border is also what you make it. This group made a place of exchange and nurture. We were saying that we can only 'come together' on the basis of a shared goal, a commitment to work towards that goal. That's the only possibility of meaningful relations in this place. The Border Art Workshop wanted to get away from an idea of cultural exchange and re-engage in cultural production arising from a common (if always differing) experience of the border-land.

It must be said that in one sense there was nothing political in what we were doing. We had some shared ideology, some mode of organization, and some motivation to overcome the kind of obstacles you encounter in the political arena. We didn't, however, work directly with undocumented people, and we didn't work in electoral campaigns. Instead we said that as artists we are not going to confine ourselves to these venues, and the ideas that you are parcelling out. We have our own ideas, we have our own places of activity. Others may have a more grandiose interpretation of what we were trying to do in those years. I tend to be sceptical of artists who present themselves as political activists, just as you tend to be sceptical of a theorist who tries to present the trials and tribulations of a Cézanne as in some sense the equivalent of the making and re-making of a border. What the BAW/TAF has done so successfully

in San Diego is make it impossible for people to talk about USA–Mexico cultural relations without considering our point of view. We have been vocal and effective to this extent.

Once we began to do shows outside San Diego I knew we had to be careful not merely to export the 'border experience' of our city as a cultural circus set up by New York or Heartland ringmasters. We emphatically shouldn't become a kind of carnival side-show. A weekend on the streets of San Diego offers the vicarious experience of homelessness, or becoming-alien. Spend the week in an AIDS halfway house and find out what it's like to have AIDS. Well you can't do it. My feeling was that in going to other cities you can only get at was is essentially their border experience. You can't export some of these concerns. There's something that's specific to our particular place; and we are trying to affect the attitudes of this place. You can travel elsewhere and you can try to understand how a specific issue relates to *their* local or regional agenda, and even their take on national concerns, but you can't simply replicate how tough it is to be an undocumented worker in front of a hip, shiny-shoe'd New Yorker who occasionally checks out the liberal spaces.

(g) Frontier

Historically, within US society, the border conceived as the frontier has always been the place of greatest opportunity, the place of growth, the place of resources and surveys, gold and minerals, and rivers and ports. (California and space are, if you like, the 'final frontiers'.) The edge has in these senses been absolutely central to the formation of US consciousness. But the borders have also, of course, been the points of entry for European and Latino non-North Americans, impelled by the American dream for which they alone can be held accountable, which they alone cannot refute. Immigrants have to be more American than the Americans.

Can I go back to the nineteenth century, to James Fenimore Cooper? When you talk about a disturbance within the cultural arena, one of the things we find in Fenimore Cooper, something that has been recognized by 'literary experts' in their own way, is that while he was not the first person to try to invent the American novel, he was the first person to get away with it. He not only wrote novels; he simultaneously created an audience for those novels. His novels were about a number of things such as his experience as a seaman, but also his experience as man on the frontier,

even though at that time the frontier was not much further away than western New York State. He incorporated into his novels, particularly a series of five novels called the Leatherstocking series (1823–41), a figure, Natty Bumppo (also known as Deerslayer and other names) based on his interaction with the border. This figure became the prototype of the frontiers-man, of the lonesome cowboy, and perhaps of today's detective or spy. You can look at US culture and you can see these developments and inventions taking place. They are cultural practices that are not confined to arena of culture alone.

After Natty Bumppo there was the creation of a figure such as Davy Crockett, a politician from Tennessee (which was considered the frontier while he was there), who was used by the US Whigs in their attempts to consolidate the power of the Eastern businessman. Crockett, then, was transposed from a frontiers-man and an Indian fighter to the Alamo, whose 'sacred name' was recently employed in the Tower hearings, where Tower himself announced that he was going to be as staunch a defender of his right to become Secretary of Defense as those at the Alamo were in defence of their nation, only he was reminded that the Alamo fell. Then this white supremacist group of skinhead knuckleheads up in Napa County planned some rally in conjunction with celebrations of the defence of the Alamo. They got fewer people at their Arian Woodstock than had actually defended the Alamo. The ratio of skinheads to law enforcement officers was probably similar to the ratio of defenders and aggressors at this symbolic event.

(h) Mex-America

Mex-America is a distinct region. LA is the capital city of Mex-America, and Texas is 'the space between' the nations. It was established as independent following a large, often politically sponsored, influx of US settlers. These settlers and Mexican-descended people fought together for the nation-status of their territory; but Texas soon became a state. History will not allow 'another' space to come into being; the destinies of the USA and Mexico are inextricably linked. What does 'free-flow' mean in a world under satellites? How is the Third World placed under these skies? It's like the so-called Green Revolution. It's great to have all these hybrid grains; great, that is, if you have a capital-intensive means of production. Who benefits in the end from such technological and agricultural revolutions?

(i) 'Different dust'

Well, some resistance to the BAW/TAF came from Tijuana artists. They said, hey, we don't think that the border is this wonderful place of exchange. We can't dispense with our nationality, we can't join the parade. The border in Mexico is seen as a place of loss; in the USA it has been seen as the place of opportunity. There are more people in Tijuana that speak English than there are in San Diego who speak Spanish. This and other border conditions are the product of sheer economic imbalance. The BAW/TAF has the perspective of the USA, as do so many of the notions of border that we consume.

It's a bit like Brer Rabbit and the tar baby; whatever you do don't throw me in the briar patch. They throw him in the briar patch. But, hey, I was raised in the briar patch. Romping in the border is a strange idea for me, nearly impossible to conceive or practise. But play is very important because it's life-affirming; though the risks it involves are much lower for professionals (and artists are usually professionals with résumés and teaching positions and so forth) than they are for people who are undocumented yet tossed nevertheless into the border region.

Maybe you don't begin by focusing on the border; maybe we have to start with the border at the centre of US society, the place where decisions are made. We have to take note of how it is that nations establish themselves, take power, and form their own self-image. Being this all-powerful thing, what use is it if you can't go out into the playground of nations and play in the sandpit, and bully some people? In this sense we have to think not only of the borders we cross, but of relations between powers whose borders we don't usually cross, between the USA and the Soviet Union, and the borders in space. We have to think of mapping from space and the satellite eye. Every parcel of land, and also what is under it, is identified, marked and owned. So, as rich as the spectacle of border life is, the real location of a theory of border is not within that spectacle but in a place of different routines and different dust.

Notes

1. The texts that follow are the result of a conversation between Chicano artist David Avalos and myself begun in Spring 1989. We have dispensed with the usual interviewer/interviewee, question and answer format, so that what you will read is a combination of my enquiries and suggestions, and David's narratives, opinions and conjectures. The shape and direction of the text are David's, and I want to thank him for his time, patience and powerful insight.

2. See John C. Welchman, 'BORDERING-ON I: modernism, avant-garde, transgression' chapter 2 of *Modernism Relocated: towards a cultural studies of visual modernity* (Sydney: Allen & Unwin, 1995), pp. 38–59.

Index